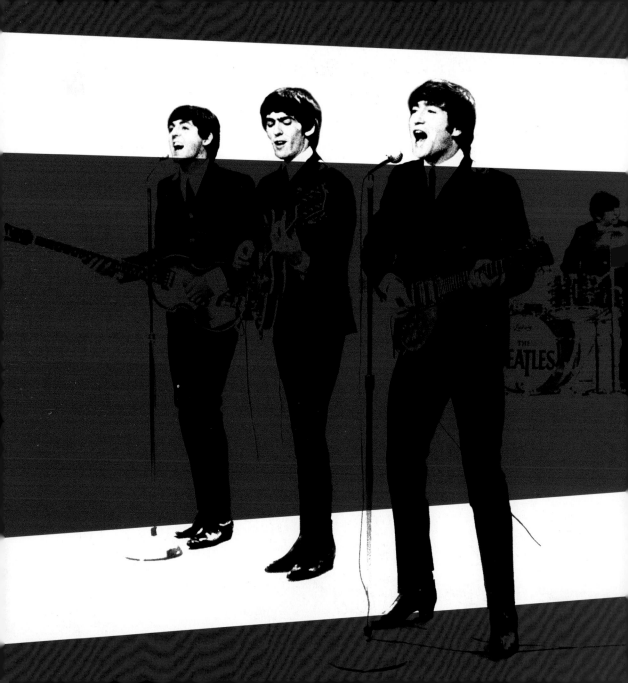

Alan J. Whiticker

BRITISH POP INVASION

HOW BRITISH MUSIC CONQUERED THE 1960s

The Ready Steady Go Mod Ball at Wembley Empire Pool, 8th April 1964.

Robin McDonald

Cha... Wa...

Paul Jones

Manfred Mann

Mike Millward

Mike Maxfield

Billy Hatton

Mike Hugg

Patrick Kerr
dancer/co-presenter, Ready, Steady, Go!

Keith Richards

Mick Jagger

Kenny Lynch

Tony Jackson

Freddie Garrity

Kathy Kirby

Ke... Ford

Rea... Steady

Pete Birrell

Roy Crewdson

The Rolliing Stones Freddie and the Dreamers The Fourmost The Dakotas

Dave Lovelady
Griff West
Brian O'Hara
Aaron Williams
John Banks
Tony Bookbinder
Barrie Cameron
Derek Quinn
Bernie Dwyer
ris rtis
Tony Newman
Tony Crane
Alan Holmes
Cathy McGowan & Michael Aldred
co-presenters, Ready Steady Go!
Billy J. Kramer
Bill Wyman
Mike Pender
John McNally
Cilla Black
Brian Jones
John Gustafson

Sounds Incorporated The Merseybeats The Searchers

5

CONTENTS

THE BEATLES

4TH NOVEMBER 1963 AT THE ROYAL COMMAND PERFORMANCE
AT THE ROYAL ALBERT HALL LONDON

THE ED SULLIVAN SHOW
★ PRESENTS PREMIER PERFORMANCE OF ★
The BEATLES

"SHE LOVES YOU"
♫
"I WANT TO HOLD YOUR HAND"
♫
"ALL MY LOVING"

A HARD DAYS NIGHT

HELP!

St. PEPPERS LONELY HEARTS CLUB BAND

EPSTEIN
(The Beatle-Making Prince of Pop)
DIES AT 32

THE BEATLES IN AMERICA

● Cliff Richard with The Shadows ● Billy J. Kramer with The Dakotas ● Cilla Black ● The Dave Clark Five ● Helen Shapiro ● The Honeycombs ● Freddie and the Dreamers ● The Swinging Blue Jeans ● Millie ● Brian Poole and the Tremeloes ● The Searchers ● Peter and Gordon ● Dusty Springfield ● Wayne Fontana and the Mindbenders ● The Zombies ● Georgie Fame ● Jackie Trent and Tony Hatch ● Donovan ● Manfred Mann ● Sandie Shaw ● The Yardbirds ● Lulu ● Petula Clark ● Tom Jones ● Marianne Faithfull

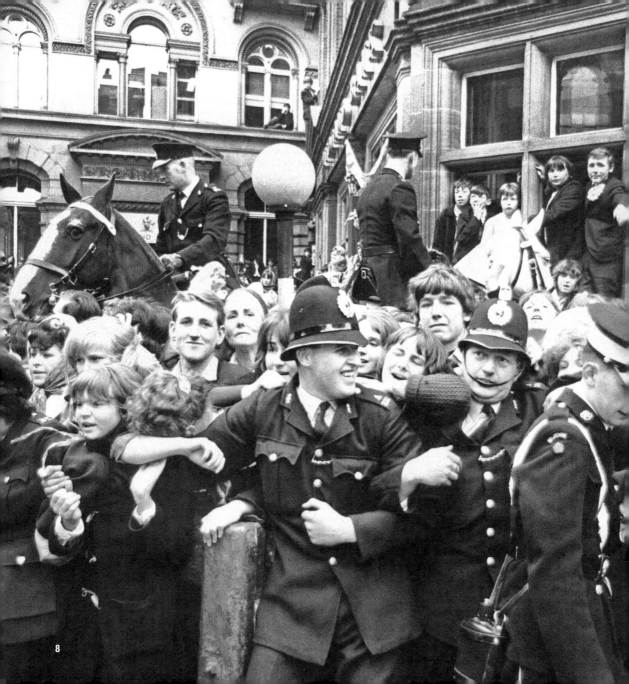

Introduction

In the early 1960s, capturing the North America music market was considered the holy grail, guaranteed to bring international stardom and magnificent riches to musicians. The US had a population of almost 200 million people, about a third of whom were born between 1945 and 1964.

This post war 'baby boomer' population had money to spend and poured millions of dollars into the record industry, yet the North American market remained tantalisingly out of reach for successful British artists who had found chart success in their homeland.

After the first revolutionary rush of rock and roll music in the mid 1950s, the North American music scene had become big business. Elvis was still the 'King', but he was followed by a series of imitators, Fabian, Frankie Avalon, Ricky Nelson and Tommy Sands, who homogenised rock and roll into mainstream 'pop' (popular) music.

Then, in the years following Buddy Holly's tragic death in 1959, American rock and roll bands were poorly represented in the US charts. California's The Beach Boys stood out from a myriad of doo-wop bands because of their harmonizing and songwriting, rather than their musicianship. 'Guitar' groups appeared to be a thing of the past. By 1964, the only UK artists to have topped the North American charts had been jazzman Acker Bilk's *Stranger on the Shore* and The Tornados' *Telstar*, both instrumentals, in

The Tornados, an English instrumental group, were the last British band to have a US#1 (1962's *Telstar*) before the British 'pop' invasion in 1964.

1962. In the same year, of the 12 singles that made #1 in the UK half were US artists (Elvis Presley scored four #1s alone) and two were Australian. Flying the flag for the home team was Cliff Richard (*The Young Ones*), The Shadows (*Wonderful Land*), Milton Sarne's *Come Outside* and The Tornados' *Telstar*.

In England, Elvis-inspired artists such as Cliff Richard, Billy Fury, Adam Faith and Marty Wilde enjoyed tremendous success, but even they couldn't crack a saturated North American music market. Then in the early 1960s, something unique was happening in London coffee houses and in jazz clubs and church halls in the north of the country. Black North American-inspired rhythm and blues bands were booming, while traditional rock and roll groups incorporating two guitars, bass, drums and a singer, were forming in Liverpool, Manchester, Birmingham and Newcastle.

So why did a drab northern port city such as Liverpool lead a music revolution of 'beat' bands? At that time, Liverpool was a major world port on the Atlantic Ocean and an import trade link to North America. 'Cunard Yanks', Liverpool lads who worked on the Cunard Line of ships to New York, brought back all sorts of North American contraband in the 1950s, including highly influential jazz, blues, and rock and roll records.

As a result, Liverpool developed a vibrant music scene with jazz clubs, coffee houses and even basements and cellars

Lonnie Donegan (1931–2002) was the most successful and influential home-grown musical artist of the 1950s with his 'skiffle' craze, inspiring a generation of British teenagers to make music.

being converted into live music establishments. By the end of the decade, places such as The Cavern in Mathew Street, Liverpool, gave local bands the chance to develop and play a uniquely English form of rock and roll.

Most of the band members and solo artists who started out in the late 1950s were 'war babies', born in England in the early 1940s while the country was being bombed in World War II. Many British bands had their geneses in the skiffle movement of the late 1950s; a simple, semi-acoustic style of folk music promoted by Scot, Lonnie Donegan. His 1955 hit *Rock Island Line* inspired a generation of British youngsters to pick up a guitar and try to make their own music.

The 1960s was a revolutionary decade in music, politics, attitudes, fashion and culture. In Britain, after 13 years of Conservative government, the country's young people were ready to rebel. The British may have been class conscious, but they were also less race conscious than their North American counterparts and embraced black North American 'blues' music … but then great music was always colourblind. Lastly, compulsory national service ended in England at the end of 1960, meaning young men born after 1 October 1939 did not have to complete their two years' training in the armed services. As a result, many had the freedom to start 'beat' groups.

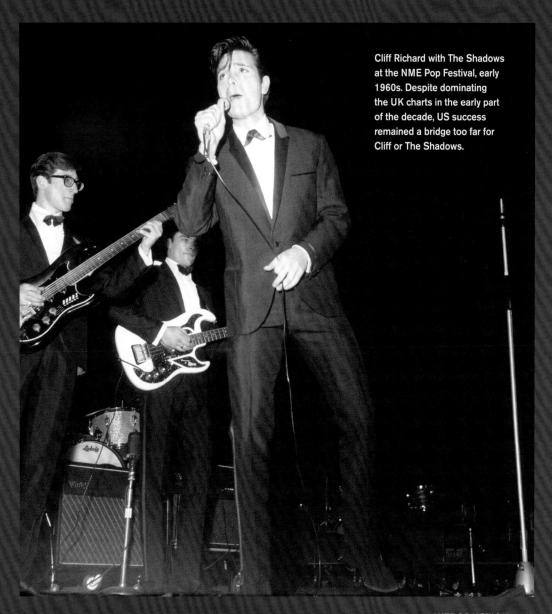

Cliff Richard with The Shadows at the NME Pop Festival, early 1960s. Despite dominating the UK charts in the early part of the decade, US success remained a bridge too far for Cliff or The Shadows.

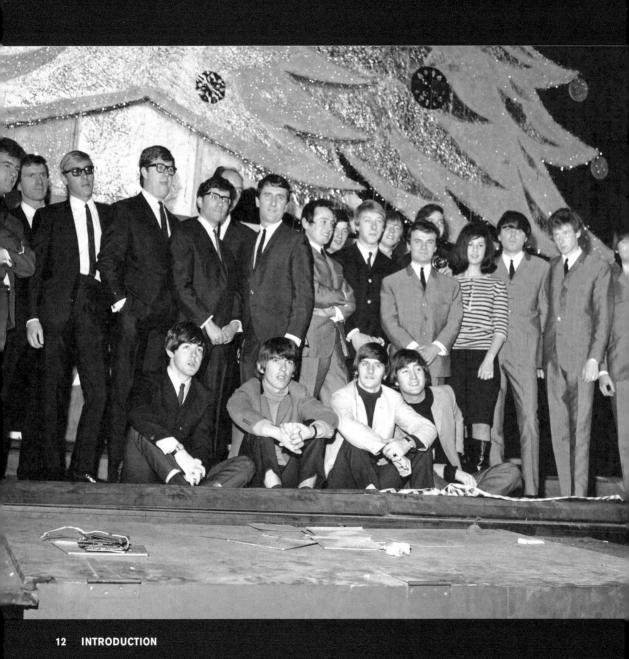

Manchester, 30 miles east of Liverpool, promoted an equally competitive music scene in the late 1950s, producing The Dakotas, The Four Pennies, The Hollies, Wayne Fontana and the Mindbenders, Freddie and the Dreamers, and Herman's Hermits. Freddie and the Dreamers followed in the tradition of Tommy Steele and other English dance hall entertainers, but The Hollies were influenced by North America's Everley Brothers.

Birmingham produced The Moody Blues, The Spencer Davis Group and The Move, who all started out as rhythm and blues outfits. Newcastle gave the world The Animals, a hard driving rhythm and blues band, who challenged the London-based R & B groups for supremacy on the UK charts in the mid 1960s.

London was the centre of the 'rhythm and blues' boom in the early 1960s, with bands such as The Rolling Stones, The Yardbirds, The Kinks, and The Who breaking away from their blues roots to achieve mainstream pop success on both sides of the Atlantic. The

proliferation of blues bands in and around London in the early 1960s, however, had as much to with traditional North American blues music as with The Beatles. What did middle class kids in London have to be 'blue' about? Like The Beatles in the north of the country,

Chad and Jeremy, 26th October 1963.

however, these R & B bands put a uniquely English spin to their music and ultimately proved immensely popular with North American audiences.

In 1963, not one UK hit cracked the US Top 100 songs of the year. The following year, there were 27 songs in the Top 100, with The Beatles holding the top two positions with *I Want to Hold Your Hand* and

She Loves You. The Beatles had nine singles in the Top 100 that year, and were joined by bands including The Searchers, Billy J. Kramer with The Dakotas, Manfred Mann, The Dave Clark Five, The Kinks, The Animals and even The Honeycombs.

Out of the pack of 'guitar' groups searching for success came The Beatles from Liverpool. A band that could not only write their own material but perform it live with intricate three-part harmonies and a driving back beat that was indeed revolutionary in the early 1960s. The members of The Beatles also projected four separate personalities, unlike teen heartthrob Cliff Richard who was backed by the talented but largely anonymous The Shadows; they looked different and they sounded unlike anything North America had heard since the halcyon days of rock and roll.

After three UK#1s in 1963, *From Me to You, She Loves You* and *I Want to Hold Your Hand*, The Beatles went to the USA after the latter single topped the North American charts on were poised to conquer that

Opposite: The Beatles pose with Elkie Brooks, The Yardbirds, Freddie and the Dreamers, and Sounds Incorporated for their Christmas Show on 22 December 1964. At the end of a fantastic year, The Beatles had quickly surpassed their contemporaries in terms of success, popularity and creativity.

country – and the world – and a virtual tidal wave of British bands, solo performers and novelty acts followed.

The British 'pop' invasion of the 1960s comprised classic bands such as The Beatles, the driving musical force of the decade, fellow Liverpool travellers Gerry & the Pacemakers, 'pop' favourites Herman's Hermits, rhythm and blues outfits The Animals and The Rolling Stones, and uniquely British bands such as The Kinks, The Hollies and The Who. Artists as diverse as Petula Clark, already a music veteran in 1964, teenage pop duo Peter and Gordon, and novelty band The New Vaudeville Band also found chart success in the States as North America embraced everything British. North America lapped up the faux English music hall sound of the Herman's Hermits (*I'm Henry VIII, I Am*), the zaniness of Freddie and the Dreamers (*I'm Telling You Now*) and even the soft harmonies of Chad (Stuart) and Jeremy (Clyde), who never had a UK Top 20 hit but were so big in North America that they appeared on TV (*The Dick Van Dyke Show* and even *Batman*) and were photographed in bowler hats to accentuate their Englishness.

But then, in 1964, American audiences were ready for a revolution. The assassination of President John F. Kennedy on 22 November 1963 had left a nation in mourning and a generation of young people searching for a hero. When The Beatles arrived in New York on February 7, 1964, North

Despite phenomenal success in the UK after being managed by Eve Taylor and produced by John Barry, Adam Faith (1940–2003) had only a minor hit with *It's Alright* in the US in 1964. Faith went into cabaret before retiring as a singer and concentrating on acting.

America had never encountered anything like them ... John, Paul, George and Ringo were unique personalities who, with charm, wit and youthful exuberance, held the hardened press corps in the palm of their hands. North America quickly discovered that the 'longhaired beat groups' that came out of England in the 1960s were better educated and more articulate than their homegrown counterparts, that they were creative, thoughtful, funny and polite, except, perhaps, for The Rolling Stones, who refused to play nice for the camera.

Beatles' manager Brian Epstein snapped up most of the Liverpool bands, including the Beatles frequent support act Sounds Incorporated, before London managers could get to them. For a while, Liverpool bands could do no wrong on the US charts ... Gerry & the Pacemakers (*Don't Let the Sun Catch You Crying* and *Ferry Cross the Mersey*), Billy J. Kramer with The Dakotas (*Little Children* and *Bad to Me*) and even Cilla Black (*You're My World*) enjoyed success. Cannily, Epstein compelled his star songwriting team of John Lennon and Paul McCartney to provide hits for the other acts in his stable such as The Fourmost and Peter & Gordon. Not that Epstein had a monopoly on success. The Searchers, one of the few Liverpool groups not managed by Epstein, had hits with *Needles and Pins* and *Love Potion Number 9*, while other

groups around the country built their own pathways to the top of the charts.

The Dave Clark Five was the second British band to break into the US charts in 1964. An actor and part-time stuntman, Dave Clark formed, managed and produced the band, which were originally formed in Tottenham, North London, to raise money for a soccer trip. Superbly promoted by Clark, for a short time the 'Tottenham sound' (which didn't actually exist ... there were no other bands from Tottenham) competed with the 'Mersey sound' for the top of the US charts and made Clark a millionaire at age 21. The 'DC5' even outdid The Beatles ... appearing on *The Ed Sullivan Show* a record 18 times during the decade and playing Carnegie Hall 12 times in a row.

The Dave Clarke Five also led the first 'invasion' tour of the US – several months before The Beatles returned for their fully-fledged tour in August 1964 – and went on to enjoy seven Top 20 singles in the US over the next year. North American audiences transferred their 'Beatlemania' onto these other British bands, not that they all found the US easy going. When Billy J. Kramer with The Dakotas supported Gerry &

the Pacemakers at Long Beach, California, in 1964, local police forced them – at gunpoint – to stop playing because the music was too loud. When Gerry Marsden tried to record a live album at that same concert, the sound of 35,000 screaming

John Mayall aged 23 with his wife Pamela in May 1956. He went on to form John Mayall & the Bluesbreakers in 1963 and was a huge influence in the British blues scene.

fans ruined the recording and cost the band tens of thousands of dollars. The Rolling Stones failed to make an impact on their first US tour in 1964, and were hated by the US media. 'Who would want their daughter to bring home a Rolling Stone?' the press asked. Who indeed.

The Rolling Stones had at-

tracted an ardent live following in London, but originally lacked songwriting clout to tackle the US charts, especially as a pure rhythm and blues band. Like many groups of the era, they started out with a series of cover songs, *Come On* (Chuck Berry), *I Wanna Be Your Man* (The Beatles), *Not Fade Away* (Buddy Holly) and *It's All Over Now* (Bobby Womack) – but it wasn't until Mick Jagger and Keith Richards developed their own songwriting talents that the band became worthy rivals for The Beatles in the US.

The Kinks, along with The Who, provided the second wave of British bands to find success in the US. Both lower to middle class London bands, The Kinks from Muswell Hill in North London and The Who from Acton, in west London, took longer to take off in the States despite the fact that The Kinks had a Top 10 hit with *You Really Got Me* in the breakthrough year of 1964. On tour in the US the following year, The Kinks declined to join the American Federation of Television and Recording Artists (AFTRA) and on the set of Dick Clark's show in June 1965, leader Ray Davies punched a representative of the union after refusing to pay union fees. As a result,

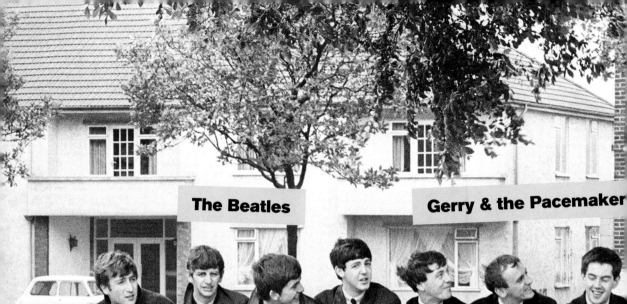

The Beatles

Gerry & the Pacemaker

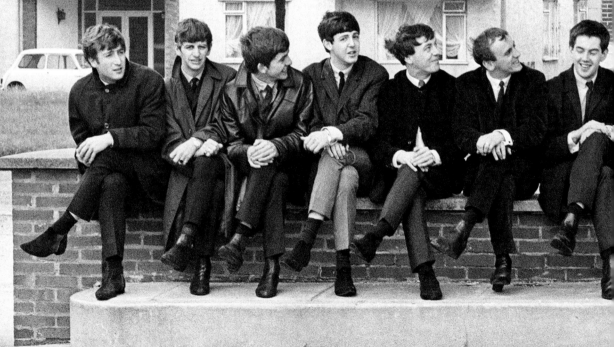

Brian Epstein with some of the groups he managed
in June 1963.

Pictured from left: John Lennon, Ringo Starr,
George Harrison and Paul McCartney (The Beatles);

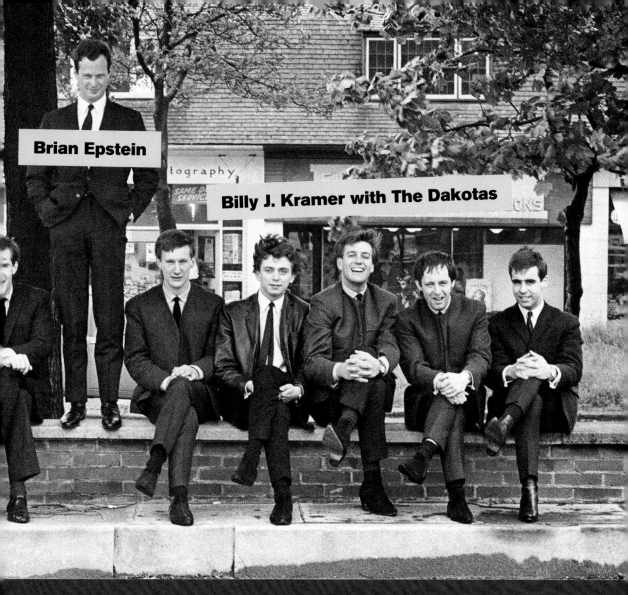

Brian Epstein

Billy J. Kramer with The Dakotas

Gerry Marsden, Freddie Marsden, Les Chadwick and Les Maguire (Gerry & the Pacemakers); Brian Epstein; and Robin McDonald, Mike Maxfield, Billy J. Kramer, Ray Jones and Tony Bookbinder (Billy J. Kramer with The Dakotas).

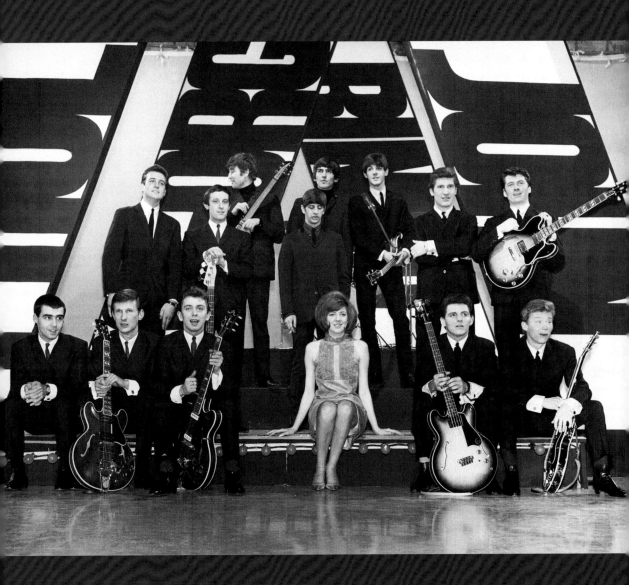

The all-Merseyside edition of *Thank Your Lucky Stars* at ABC's Alpha studios, Birmingham.
From Left: Billy J. Kramer with The Dakotas, The Beatles, Cilla Black, and The Searchers, 15 December 1963.

The Kinks were banned from touring the US for four years.

The Who had a string of Top 10 hits in the UK in the early 1960s, but conquered North America through the force of their live performances in the mid 1960s, especially their breathtaking set at 1967's Monterey Pop Festival. That their breakthrough hit in the US was a concept album – 1969's Tommy – shows how much the once single-oriented record industry had changed by the end of the decade.

The British pop invasion peaked in 1965, with so many bands touring the States that the US Labor Department stepped in to stem the flow of foreign musicians taking the potential jobs of their members. British acts appeared on US TV shows such as *Hullabaloo, Shindig!, Where the Action Is* and *Hollywood A Go Go*. In July 1965 the Ministry of Labor and the Variety and Allied Entertainments Council announced new restrictions on North American entertainers, limiting them to one television appearance per month. The Nashville Teens, The Zombies and The Hullaballoos even had their visa applications rejected; they could only travel to the US on limited visas restricting

their performances to New York City. The bands appeared at Murray the K's Show at the Brooklyn Fox, playing six shows a day from 8 am in the morning to 11 pm at night. That's showbiz!

In April 1965, the top three songs on the North American charts were by British bands ... and none of them were The

The Yardbirds, Wayne Fontana and the Mindbenders, and The Rolling Stones joined established stars The Beatles, The Kinks and The Dave Clark Five in the US Top 100 songs of the year. Tom Jones broke through with *What's New Pussycat?* and Petula Clark had hits with *Downtown* and *I Know a Place*.

But the emergence of Brit-

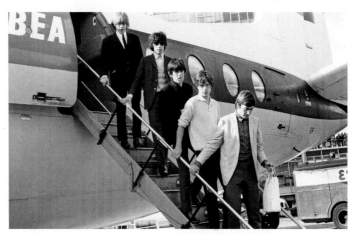

The Rolling Stones arrive at Manchester Airport, 11 August 1964.

Beatles. *Game of Love* by Wayne Fontana and the Mindbenders, *Mrs. Brown, You've Got a Lovely Daughter* by Herman's Hermits and *I'm Telling You Now* by Freddie and the Dreamers, held the top three spots, with all three bands having grown up in Manchester. That year The Zombies, Herman's Hermits,

ish-inspired North American bands – The Byrds, Buffalo Springfield, The Young Rascals and The Turtles, slowly swung the musical momentum back to the US in the mid 1960s. While the peerless Beatles continued to lead the way, many of the original British 'invasion' bands started to break up or stagnate

through lack of new material. Bands that could write their own material and develop their recording craft survived the 1960s; groups trapped in the initial British 'beat boom' of 1964–65 fell by the wayside as the times began to change. When The Swinging Blue Jeans, Billy J. Kramer with The Dakotas, The Searchers and even Gerry & the Pacemakers faded after 1965, Herman's Hermits and The Hollies survived the mid-decade 'psychedelic' era on the strength of their pop singles.

In 1966, The Troggs (*Wild Thing*), The Mindbenders (*Groovy Kind of Love*), The Yardbirds (*Shapes of Things*) and The Hollies (*Bus Stop*) joined perennial chart-toppers The Beatles and The Stones in the US Top 100 for the year. Dusty Springfield made a welcome return to the charts after hassles with her North American record label with *You Don't Have to Say You Love Me*, but the British influence on North American charts dropped noticeably in the late 1960s. Lulu (*To Sir with Love*) and The Beatles (*Hey Jude*) provided the biggest selling singles in the North American market in consecutive years (1967–1968) but by the final year of the decade, only The Beatles (*Get Back* and *Come Together /*

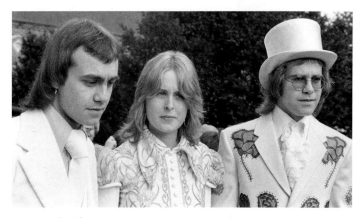

Elton John (right) was best man to his songwriting partner Bernie Taupin, who married 19 year old American student Maxine Feibelman on 27 March 1971.

Something), The Rolling Stones (*Honky Tonk Woman*), The Zombies (*Time of the Season*), The Foundations (*Build Me Up Buttercup*), Donovan (*Atlantis*) and US-favourite Tom Jones (*I'll Never Fall in Love Again* and *Leave Me Tonight*) made the US Top 100 charts.

Where The Rolling Stones ultimately found US success by embracing rock and roll, other rhythm and blues bands struggled for chart success in the mid 1960s. While The Yardbirds, The Animals, and The Spencer Davis Group were successful in the US, especially as touring acts, artists such as Cyril Davis, Graham Bond, John Mayall and Alexis Korner did not achieve mainstream chart success.

These artists remained highly influential, however, and led to the formation of such bands as Cream, Pink Floyd, Fleetwood Mac, Jethro Tull and finally Led Zeppelin, at the end of the decade, which in turn changed the rules of what defined popular music in the 1970s.

Many of 1970s superstars, David Bowie, Elton John and Marc Bolan, for example – had their origins in the 1960s pop scene and, with the break-up of The Beatles at the start of the decade, the charts belonged to a new generation of British musicians.

Opposite: In 1964, The Beatles conquered America, and the pop music world changed forever.

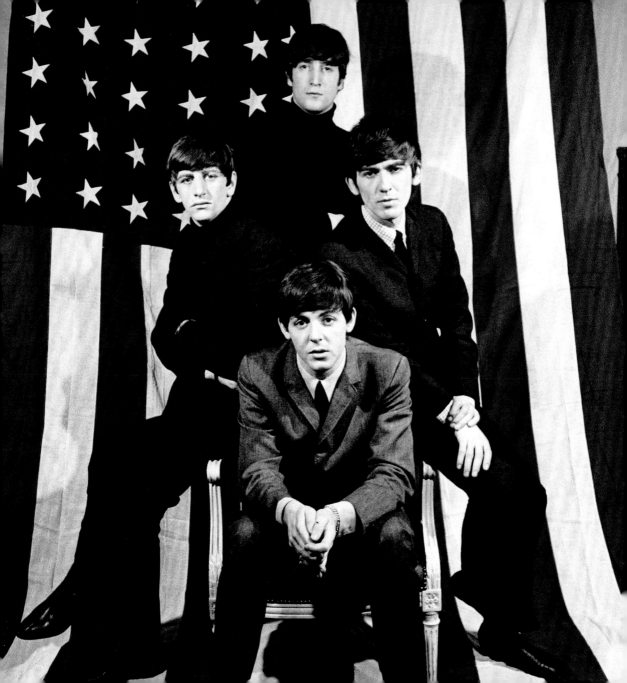

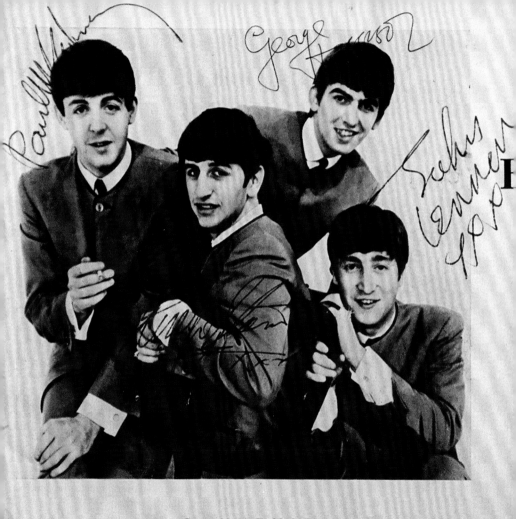

SOUVENIR

CHAPTER 1

The Beatles

That The Beatles would be the culture bearers and musical ambassadors for a new baby boomer generation was extraordinary, given their working class backgrounds in the northern English port of Liverpool. But then, The Beatles were unique – four distinct personalities with immense musical talents – not least the songwriting abilities of John Lennon and Paul McCartney, but also their vocal harmonies with George Harrison on guitar and Ringo Starr's underrated drumming.

As a pop phenomenon The Beatles broke all the rules of popular music of the time. Why, then, were they so successful, especially in America, when other British acts had failed?

For one, the timing was right. When The Beatles went to North America in early 1964, they found a country in mourning for an assassinated president (John F. Kennedy had been shot just ten weeks before), and a young, predominantly female, audience ready to let their hair down. John,

Paul, George and Ringo looked and sounded different – their northern English accents, their long hairstyles (for the time) and even their name (a clever play on the 'beat' phenomenon with a nod to their heroes Buddy Holly and The Crickets).

Their songs were original and they could play them live, a feat that inspired a new generation of musicians across the world to follow their lead.

The Beatles were the biggest thing since Elvis – and there were four of them! These English lads, however, were witty and intelligent, and before long they had the hard-headed and cynical American media in the palm of their hands.

The Beatles represented an entire new ballgame, to use an Americanism, in that they wrote and performed their own music. They also took the best of the burgeoning black music scene and, like Elvis in the 1950s, reinterpreted songs for a mainstream white audience. After their initial wave of success, they developed musically and creatively under the watchful eye of producer George Martin and soon surpassed the limitations of

Opposite: A souvenir of The Beatles' tour of Scotland, January 1963. Today, the autographs are worth a small fortune.

their rudimentary instrumentation, and rendered live performances superfluous.

Even in their early records there were subtle touches ... Lennon's harmonica on *Love Me Do*, McCartney's doe-eyed romanticism on *PS I Love You*, Harrison's wonderful guitar lick on *Can't Buy Me Love* and Ringo's always steady beat. The band also had the confidence to back themselves. They turned down the chance to record Mitch Murray's *How Do You Do It* – a sure-fire hit, as Gerry & the Pacemakers proved – in order to record *Please, Please Me*, which introduced the band internationally but was fated to be neither a UK or US#1.

Lennon and McCartney's early compositions were personal and direct; *She Loves You, I Want To Hold Your Hand, From Me to You*. There were two dynamics happening here ... The Beatles sang incredibly personal and intimate music but with a mass market appeal. After meeting Bob Dylan in 1965, however, they started to write songs outside the 'love' formula. *You've Got to Hide Your Love Away* and *Norwegian Wood (This Bird Has Flown)* were not like other standard love songs of the early 1960s. Increasing confidence in the recording process led to greater experimentation ... the feedback at the beginning of *I Feel Fine*, the fade-in on *Eight Days a Week*, and the orchestration on *Eleanor Rigby*, were all ground-breaking in their own way. Throw in country and western musical influences (George and Ringo were huge fans) and The Beatles had all their musical bases covered. The Beatles mastered three-part harmonies and produced a biting back beat to their music. They embraced American dance music ... Chuck Berry, Leiber and Stoller, Goffin and King, even Burt Bacharach ... and as a result, US audiences welcomed them with open arms.

When The Beatles arrived in New York in February 1964,

UK	Song	US
UK#17	Love Me Do	US#1
UK#1	From Me to You	US#16
UK#1	She Loves You	US#1
UK#1	I Want to Hold Your Hand	US#1
–	Twist and Shout	US#2
UK#1	Can't Buy Me Love	US#1
–	Do You Want to Know a Secret?	US#2
UK#1	A Hard Day's Night	US#1
UK#1	I Feel Fine	US#1
–	Eight Days a Week	US#1
UK#1	Ticket to Ride	US#1
UK#1	Help!	US#1
–	Yesterday	US#1
UK#1	We Can Work It Out	US#1
UK#1	Paperback Writer	US#1
UK#1	Yellow Submarine	US#2
UK#2	Penny Lane	US#1
UK#1	All You Need Is Love	US#1
UK#1	Hello, Goodbye	US#1
UK#1	Lady Madonna	US#4
UK#1	Hey Jude	US#1
UK#1	Get Back	US#1
UK#1	The Ballad of John and Yoko	US#8
UK#4	Something + Come Together	US#1
UK#2	Let It Be	US#1
	The Long and Winding Road	US#1

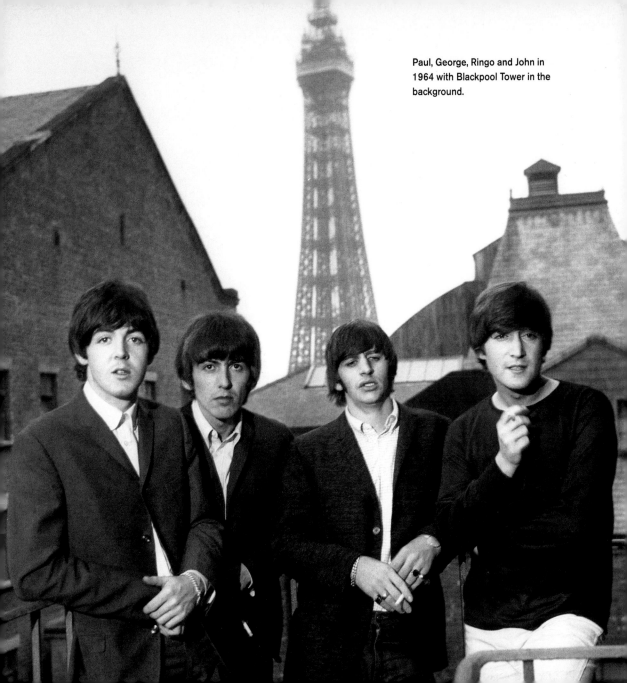

Paul, George, Ringo and John in 1964 with Blackpool Tower in the background.

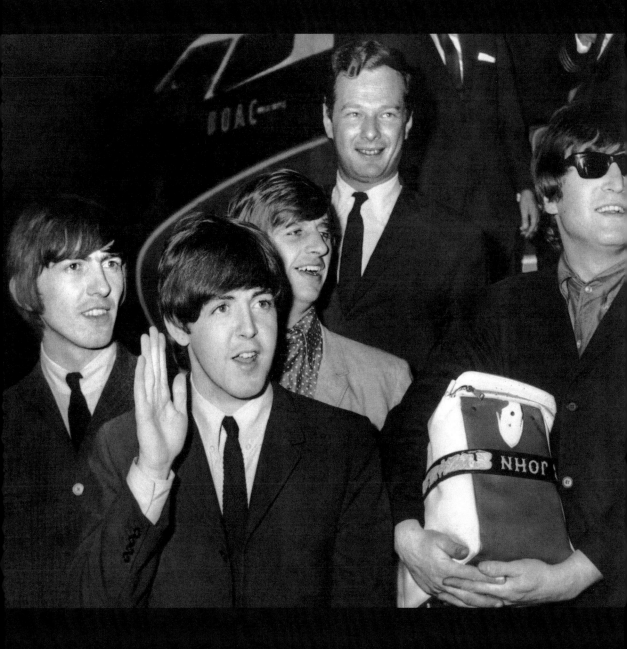

America was already in the early throes of Beatlemania. *I Want To Hold Your Hand* was top of the US charts, and the hysteria that surrounded the band had already started on the Jack Paar Show the previous month. Ed Sullivan paid Beatles' manager Brian Epstein US$50,000 for The Beatles to make three appearances on his show, the first of which would be taped and shown after the band had left North America. The Beatles appeared live on *The Ed Sullivan Show* on Sunday, 9 February, and the world was never quite the same again. The Beatles' jangly, Rickenbacker guitar sound was incredibly influential at the time; Starr's idiosyncratic drumming (a natural left-hander playing right-handed fills), Harrison's musical counterpoints on lead, McCartney's melodic, inventive bass lines and Lennon's rock steady rhythm guitar. After the band appeared on *The Ed Sullivan Show*, a whole generation of young men formed bands in the US.

The Beatles' first live concert in the US was held on 11 February 1964 in Washington. There they played on a poorly-lit square stage and after every three songs they had to physically move their equipment 90 degrees to face another section of the audience. Given the mayhem generated by the audience, The Beatles' concerts were orderly affairs – a series of warm

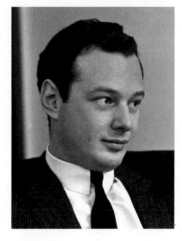

Beatles' Manager Brian Epstein in October 1963. As head of NEMS Music in Liverpool, Epstein was drawn to the unknown Beatles by requests of their German recording of *My Bonnie*, when they backed singer Tony Sheldon in 1962. After watching one of their lunchtime shows at The Cavern Club, he signed the band to a contract and within six months had secured them a recording contract – but not before cleaning up their onstage image.

up acts played before the boys came on for about 30 minutes only; poor sound and lighting could not diminish their impact on both girls and boys in their young audience.

The following night they played Carnegie Hall twice, at 7 pm and 9.30 pm, although The Beatles didn't come on stage for the second show until well past 11 pm. Brian Epstein turned down US$25,000 to play one concert at New York's Madison Square Garden because there just wasn't enough time. Resting in Miami at the end of their whirlwind tour, The Beatles continued to charm the US media, met heavyweight contender Cassius Clay (later known as Muhammad Ali) and performed live on *The Ed Sullivan Show* on Sunday, 16 February. Thousands of fans applied for seats in New York to be in the show's audience, not realising that The Beatles were performing from Miami.

By April 1964, the band held an unprecedented top five spots on the US Top 100 – *Can't Buy Me Love, Twist and Shout, She Loves You, I Want To Hold Your Hand* and *Please Please Me* (the latter never made #1 in the US because the band's other songs

Opposite: With manager Brian Epstein at Heathrow Airport, on 22 September 1964, after their North American tour.

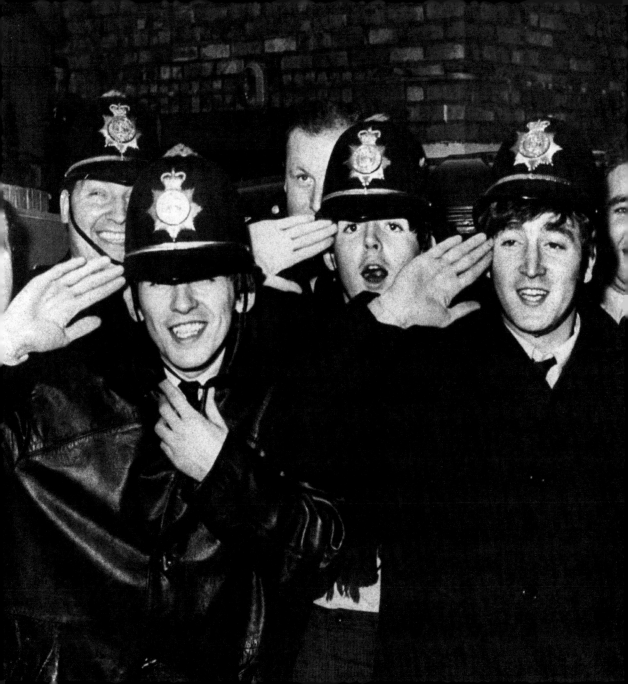

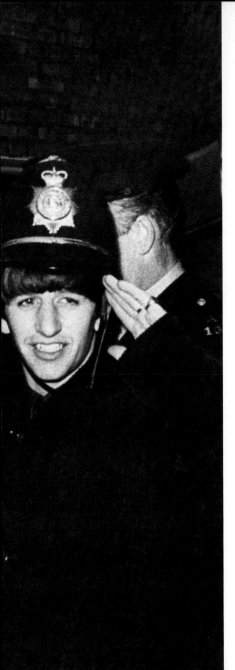

held it out. The Beatles were a commercial rarity ... over-exposure and over-commercialism didn't ruin the magic because they had such undeniable talent and kept evolving as a musical force. For the rest of the decade, The Beatles remained one step ahead of the popular trend, providing the soundtrack for an entire generation.

In June 1964, The Beatles travelled on their short European and Australasian tour without Ringo, who was struck down with tonsillitis. With unknown session drummer Jimmy Nicol filling in on some early dates, The Beatles were swamped by a crowd of 250,000 in Adelaide, South Australia. The laidback Australian press saw the boys at their best – able to easily handle the public and the press after their success in the US, and brimming with confidence after completing their first movie *A Hard Day's Night*, which would be released upon their return to London. The Beatles were relaxed and happy, with none of the jaded cynicism they

acquired in ensuing years.

On 19 August 1964, The Beatles began a mammoth 25-date tour of America. The band started in San Francisco and systematically worked their way across the continent, including dates in Canada (Vancouver, Montreal and Toronto). Brian Epstein chartered a private plane for their tour, another first. The band was supported by American Jackie DeShannon, The Righteous Brothers, Bill Black's Combo, and The Exciters, the band which had the original hit *Do-Wah-Diddy* in 1963.

Beatlemania peaked in 1965, the year the foursome starred in a second film, *Help!*, were awarded MBEs from the Queen and toured North America for a second time. This tour comprised 14 dates from August 15–31, opening with a concert at Shea Stadium, home of the New York Mets, in front of 55,000 screaming fans. The Beatles taped another performance for *The Ed Sullivan Show*, which was shown on September 19, again after the band had left the

Left: Meet the Beatle Bobbies. When the Merseyside group arrived at the stage door in Bath on 10 June 1963, they stepped out of a police van wearing helmets. Left to right: George Harrison, Paul McCartney, John Lennon and Ringo Starr. The Beatles' UK tour with Roy Orbison had finished the previous night, but already the group was back on the road.

country. Sounds Incorporated, also managed by Brian Epstein, were the support band, along with American singer Brenda Holloway, Cannibal & the Headhunters, and King Curtis.

By 1966, however, touring the world and playing live concerts had lost its glamour. Tours of Japan and The Philippines were met by protests, respectively over the use of 'sacred' venues and perceived snubs of the ruling Marcos family, while Lennon's contentious remarks that The Beatles were 'bigger than Jesus' created a furore in the US before their third and final tour there in August of that year. The Beatles' final UK concert – not counting their rooftop showing at the Apple office in Savile Row in 1969 – was the New Musical Express Poll Winners Concert at Wembley on 1 May 1966. Their final concert, anywhere in the world, was at Candlestick Park, San Francisco on 29 August 1966. There, The Beatles played the same set as on their Japan and Philippines tour – a bare 11 songs, including *She's A Woman* and *Nowhere Man* – but nothing from their latest album *Revolver*. As a musical group The Beatles had already surpassed the technical limitations of performing live.

Looking back, The sheer variety of The Beatles' musical output in the 1960s is astonishing, with each single and album progressing in complexity and experimentation. *With The Beatles* (1963), the group's second studio album, was a quantum leap from their first effort, *Please Please Me*, which was recorded in a single day. For 1964's *A Hard Day's Night*, the group's third album, all 13 songs were written by Lennon and McCartney, a phenomenal achievement for the time. Their next offering, *Beatles for Sale*, filled with songs from their live shows, sounded a little tired but it didn't stop 750,000 advance orders from being placed in the UK alone for Christmas 1964.

After the first wave of Beatlemania finished with the 1965 release of the album and film, Help!, a second era of studio-orientated music and personality-driven songs took precedence. *Rubber Soul* (1965) and *Revolver* (1966) fed into the success of *Sgt. Pepper's Lonely Hearts Club Band* (1967) and took The Beatles to an entirely new artistic level. The double EP *Magical Mystery Tour* (1967), which was turned into an LP by an insatiable American market, may have been a flickering afterglow of that 'summer of love', but the 1968 album, *The Beatles* (the 'White Album') – 30 tracks that reaffirmed the band's collective genius – also exposed the first cracks in the band. John Lennon later commented that the recording of that album was like four separates artists working with a backing group.

The Beatles myth was souring. After Lennon's comments about religion caused mass demonstrations in the US 'Bible Belt' in 1966, the death of manager Brian Epstein the following year left the band rudderless. McCartney's naïve revelations about the group's LSD usage, the poor reception of the *Magical Mystery Tour* movie and John Lennon's marriage breakdown (and his new relationship with artist Yoko Ono) chipped away at the public's affection for the band.

Is it any wonder then that McCartney tried to chart the band's musical direction? *Sgt Pepper, Magical Mystery Tour* and *Let It Be* were each undertaken at his initiative, which was not always appreciated by the rest of the group. The use

Opposite: The Beatles at Twickenham Studios in June 1965 to view preliminary material for their new film *Help!*

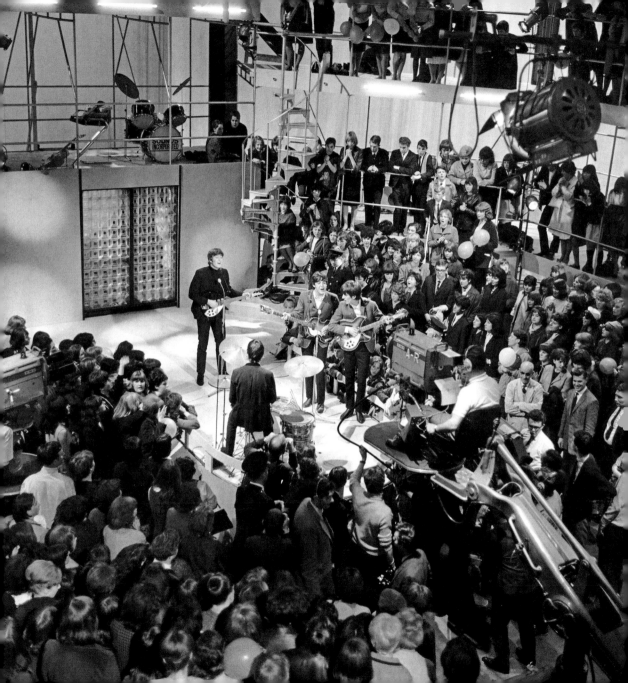

of alter egos on the cover of *Sgt Pepper* should have been enough of a sign that the group was outgrowing their Beatles' personas. *A Day in the Life*, the last track on the album, can be seen as the highpoint of the group's career both musically and technically but the band's musical genius can also be heard in such songs as *Penny Lane, All You Need is Love* and *Hey Jude*, which seemed to encapsulate the spirit of the late 1960s.

The aptly named *Abbey Road* (1969) was the last studio album recorded by the band and showcased the emerging talent of George Harrison, who wrote the album's two standout tracks, *Something* and *Here Comes the Sun*. The second side of the album stands testament to the skill of producer George Martin who took a series of semi-realised songs and turned the album into a tableaux of memorable music that was to become widely regarded as The Beatles' final opus.

The 'posthumous' album *Let It Be* (1970), recorded in 1969 but released after Paul's announcement that he was leaving the band, displays a band fraying at the seams

Opposite: On *Around The Beatles* on 6 May 1964.

and finally breaking up. The original sessions, filmed for a poorly realised documentary, were given a polish by producer Phil Spector and released with unnecessary hype. The Beatles really were finished, but it had been a slow death. Lennon later stated that he knew the band was 'doomed' as

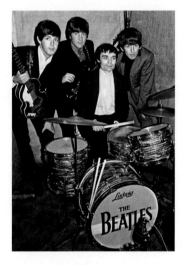

John, Paul, George and Jimmy? When Ringo came down with a bout of tonsillitis on the eve of the band's European and Australasian tour in June 1964, unknown London drummer Jimmy Nicol performed in a number of concerts before Ringo was able to re-join the band in Australia. Nicol returned home with £500 and a watch from a thankful Brian Epstein, and to complete obscurity.

soon as they stopped touring.

Drugs may have initially freed their imaginations but they also cast individual members adrift. Lennon and Ono became involved in an increasing number of political causes; George searched for a spiritual route to personal happiness in response to worldwide fame and success; Ringo pursued an acting career as a media personality in his own right; and Paul embraced the music industry as a producer, songwriter and publisher, becoming the most successful pop music artist of the 20th century.

By the end of the decade John, Paul, George and Ringo had grown up before the eyes of the world. No longer the 'lovable moptops' of the early 1960s, The Beatles were now serious artists, each with diverse musical and personal interests. Increasingly complex and frustrating business matters over the administration of their company Apple, and the selection of American Allen Klein as their business manager, merely hastened their split.

Ultimately, The Beatles tired of their goldfish bowl existence – although never truly escaping it – and each went their own way in the 1970s. But what a musical legacy they left us.

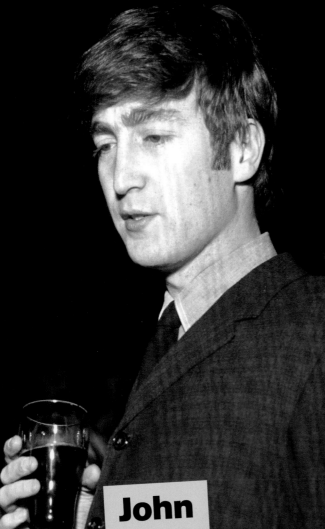

John

Paul

George

Ringo

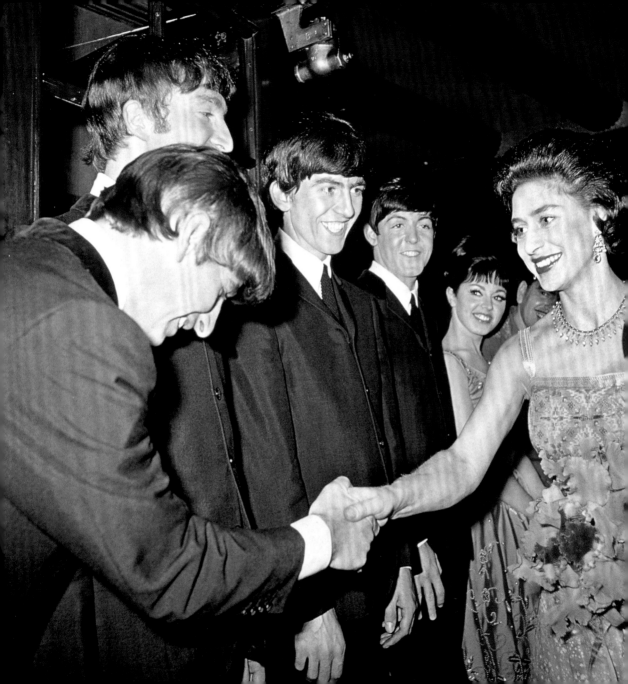

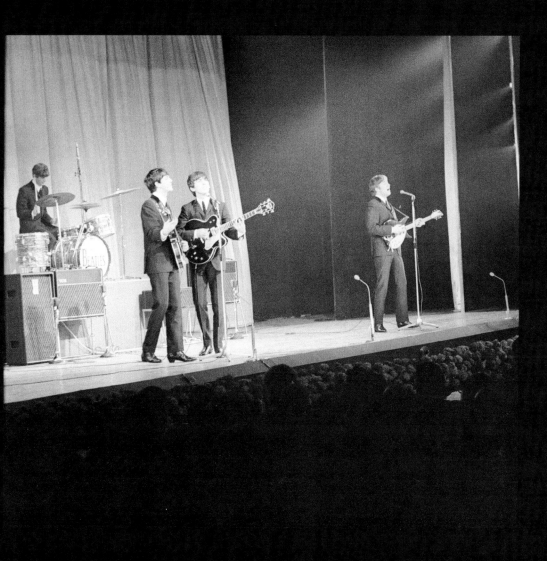

Above: On this famous occasion, Lennon addressed the audience: "For our last number I'd like to ask your help. Will the people in the cheaper seats clap your hands. And the rest of you, if you just rattle your jewellery." Opposite: HRH Princess Margaret meets The Beatles at the *Royal Variety Show*, 4 November 1963.

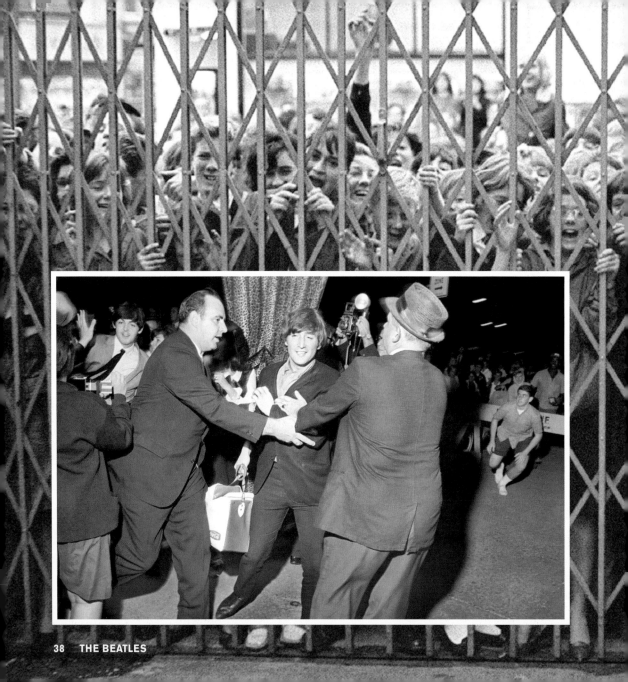

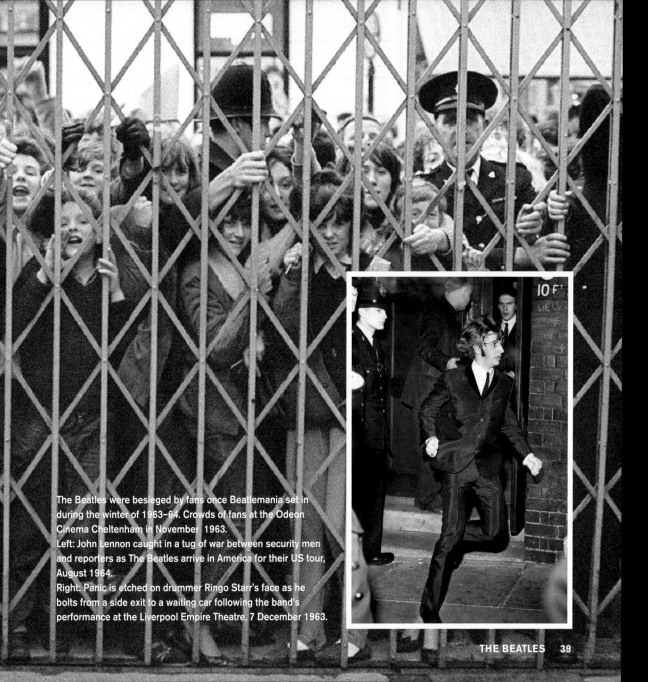

The Beatles were besieged by fans once Beatlemania set in during the winter of 1963–64. Crowds of fans at the Odeon Cinema Cheltenham in November 1963.

Left: John Lennon caught in a tug of war between security men and reporters as The Beatles arrive in America for their US tour, August 1964.

Right: Panic is etched on drummer Ringo Starr's face as he bolts from a side exit to a waiting car following the band's performance at the Liverpool Empire Theatre, 7 December 1963.

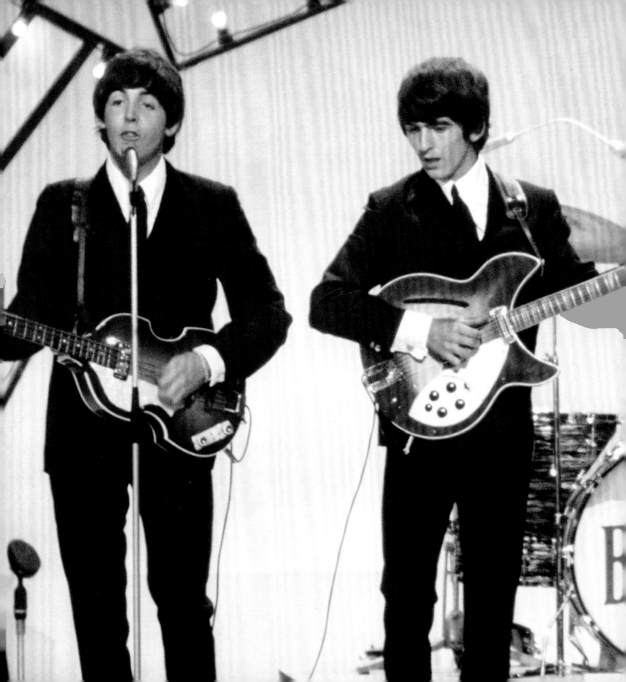

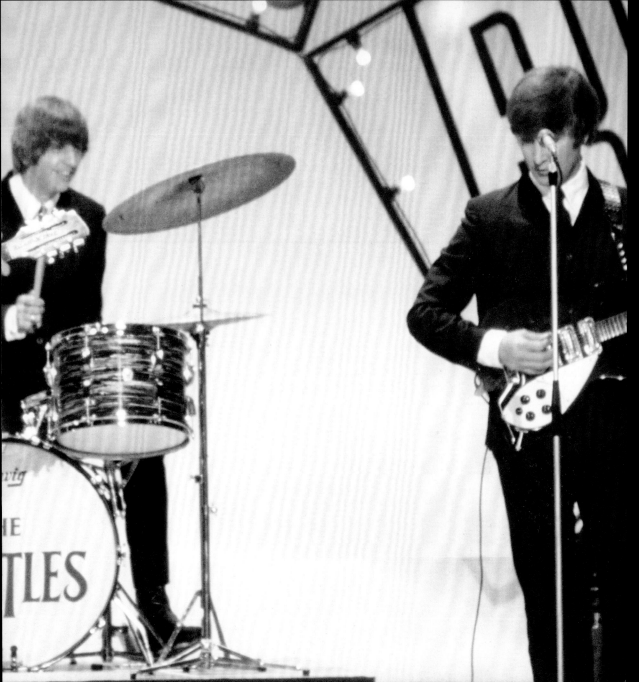

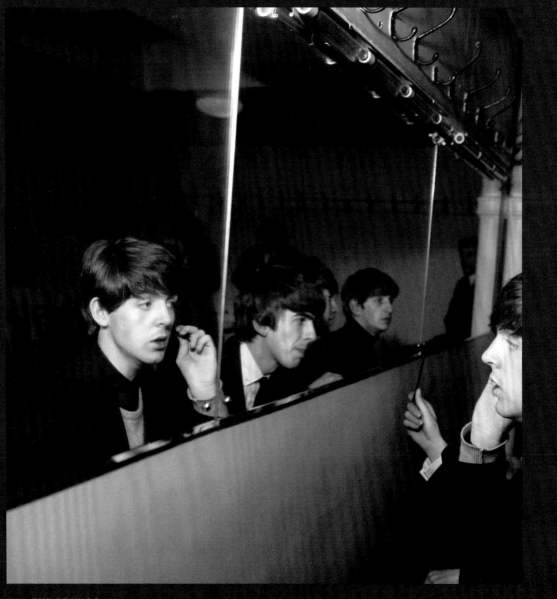

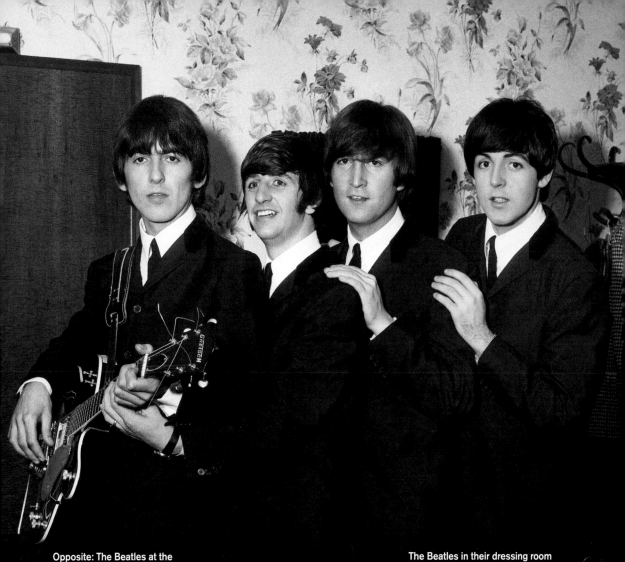

Opposite: The Beatles at the
De Montfort Hall in Leicester,
10 October 1964, reflected in the
dressing room mirrors.

The Beatles in their dressing room
of the De Monfort Hall, Leicester on
10 October 1964. Their popularity
quickly outgrew the small venues and
theatres of northern England.

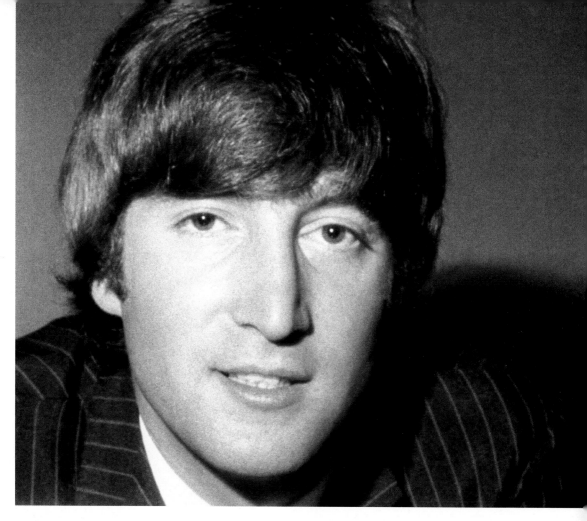

Above: John Lennon (1940–1980), pictured at the height of Beatlemania in 1964. Fiercely intelligent, a best-selling writer (Lennon published two books of prose, *In His Own Write* and *A Spaniard in the Works* in the early 1960s), and a uniquely talented musician, the self-appointed leader of the band became a cultural icon in the 1960s and remained so in the years leading up to his tragic death in 1980.

Opposite: Paul McCartney (born 1942), the other half of the Lennon/McCartney songwriting team. Acknowledged now as the most successful songwriter in popular music history. Incredibly McCartney wrote the lyrics for *Yesterday* (1965) at just 22 years of age. Upon its release it set a standard for many artists, and was followed up with material as diverse as *Eleanor Rigby*, *Michelle*, *Penny Lane*, *She's Leaving Home* and *Hey Jude*.

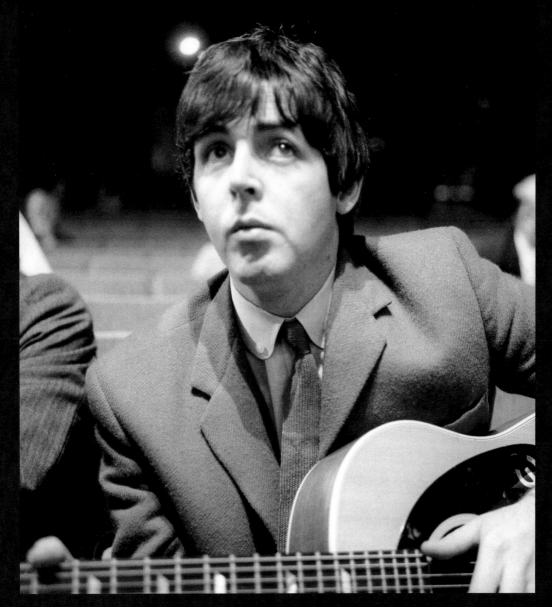

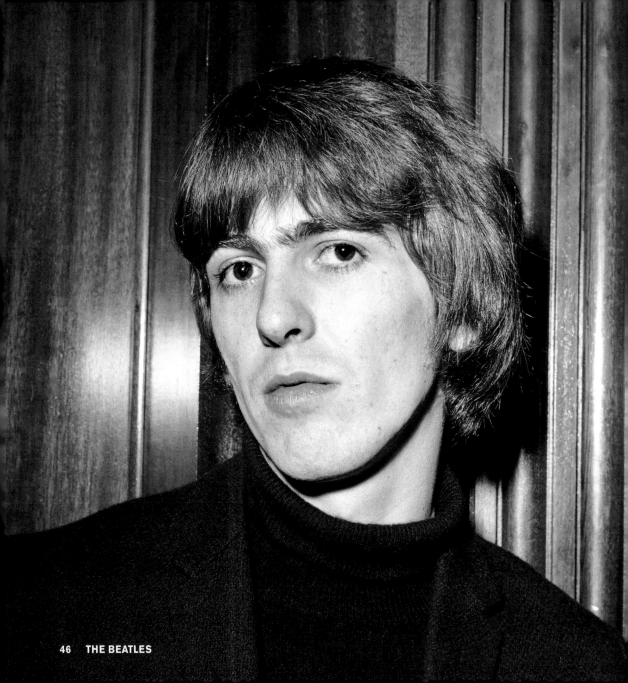

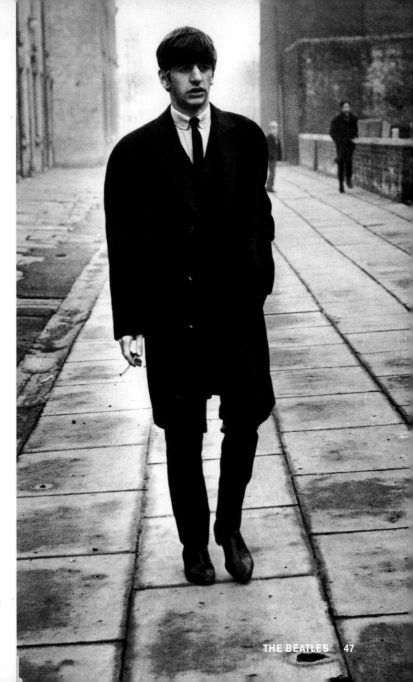

Opposite: George Harrison (1943–2001) at the Gaumont State Cinema, Kilburn, north-west London, October 1964. Labelled the 'quiet Beatle' by the verbose US media, Harrison merely waited to speak until he had something important to say, and when he did, he displayed a dry wit. The youngest of four children brought up in a semi-religious family (Harrison was a Catholic), he pursued a deep interest is Indian spiritualism right up to his death from cancer in 2001, aged just 58.

Right: Ringo Starr (born 1940) pictured leaving his family home in Admiral Grove, Liverpool, in December 1963. The eldest of the four Beatles, and the last to join, Starr was born Richard Starkey and had already made his musical reputation in Liverpool with Rory Storm and the Hurricanes before being invited to join the band in August 1962. An only child, and a sickly one at that, Ringo provided the 'X' factor for The Beatles in terms of popularity and musicianship. Every mum loved him.

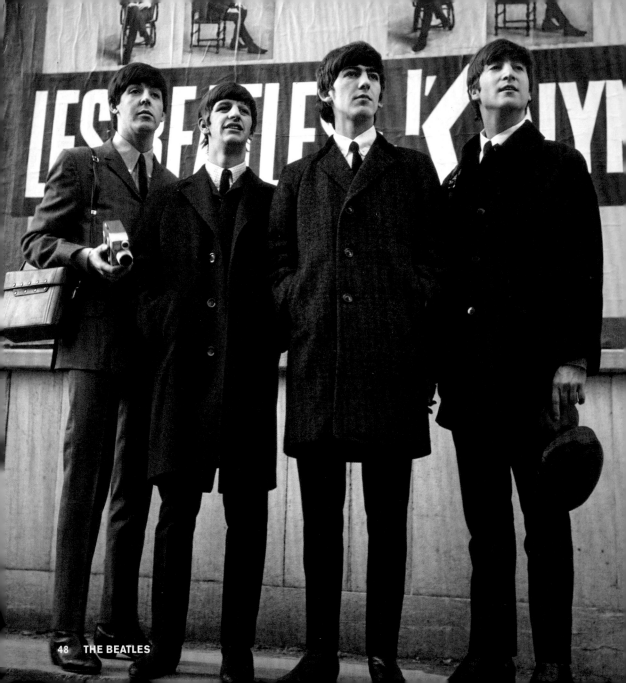

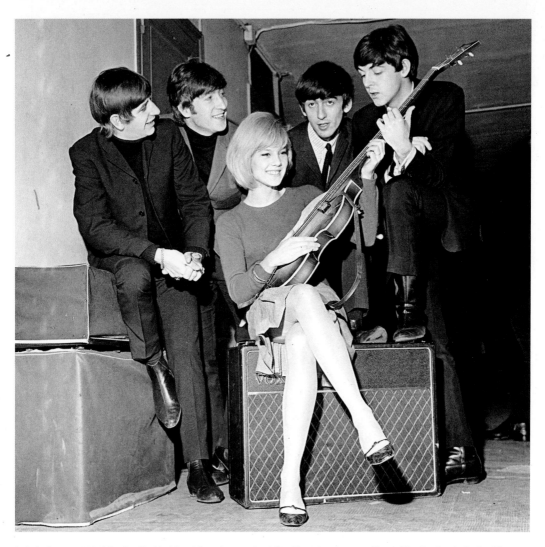

Left: In January 1964 The Beatles' held a string of concerts at the Olympia Theatre, Paris. While they were there, *I Want to Hold Your Hand* went to #1 in the popular charts in North America. Left to right: Paul, Ringo, George and John.

Above: The Beatles in Paris with Bulgarian-French singer Sylvie Vartan, January 1964.

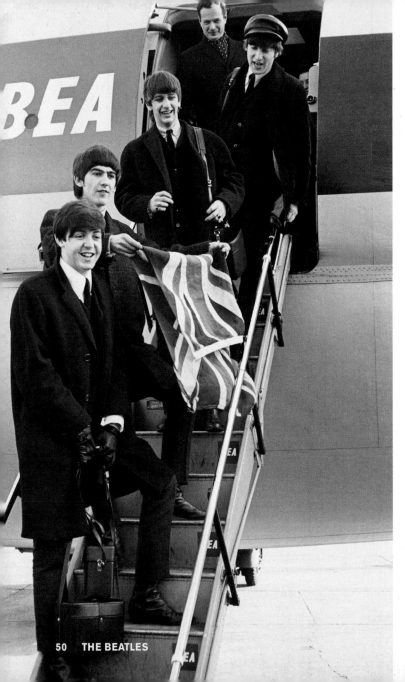

Left: The Beatles return from Paris, landing at London's Heathrow Airport on 5 February 1964. From top to bottom: Manager Brian Epstein, John Lennon, Ringo Starr, George Harrison holding the Union Jack and Paul McCartney. Within days The Beatles flew to America.

Opposite above and right: The Beatles' press conference at Kennedy Airport, New York, February 1964. Far from being overawed by the occasion, the four young men look as if they are enjoying putting the New York pressmen through their paces.

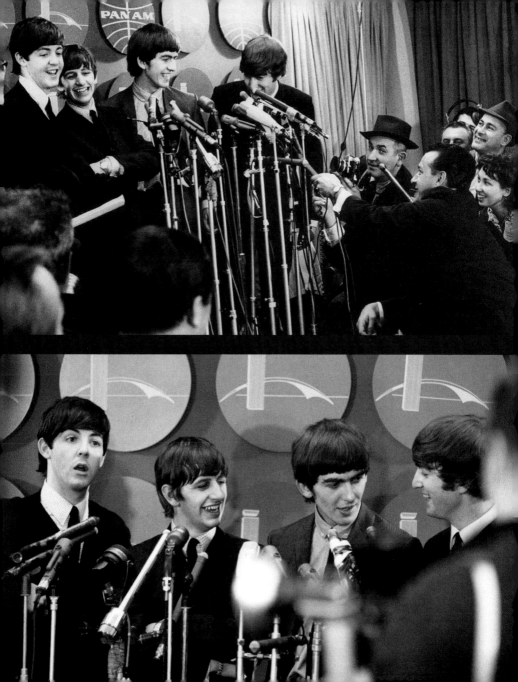

The Beatles' responses to press questions in America won over hardened newsmen.

Q: *In Detroit Michigan, there handing out car stickers saying, 'Stamp Out The Beatles.'*
Paul: Yeah well... first of all, we're bringing out a Stamp Out Detroit campaign.

Q: *A psychiatrist recently said you're nothing but a bunch of British Elvis Presleys.*
(John and Ringo shake like Elvis)
Ringo: It's not true! It's not true!

Q: *How many of you are bald, that you have to wear those wigs?*
Ringo: All of us.

Q: *Are you going to get a haircut at all while you're here?*
George: I had one yesterday.

Q: *Why does it excite them so much?*
John: If we knew, we'd form another group and be managers.

Q: *What about all this talk that you represent some kind of social rebellion?*
John: It's a dirty lie. It's a dirty lie.

Q: *What do you think of Beethoven?*
Ringo: Great. Especially his poems.

Q: *Have you decided when you're going to retire?*
Ringo: Any minute now.

Q: *Your program was reviewed by a music critic, and he said that you had 'unresolved leading tones, a false modal frame ending up as a plain diatonic.' What would you say to that?*
John: He ought to see a doctor about that.

Q: *What do you think about the criticism that you are a bad influence?*
Paul: I dunno, you know. I don't *feel* like a bad influence. Do you?
John: Nah, I think you're a *good* influence, Paul.
Paul: Thank you, John.

Q: *Is there any chance of the Beatles becoming knighted?*
Paul: No, you may be, though.
John: Can you imagine, Sir Ringo?*

* Paul was knighted in 1997. Ringo in 2018.

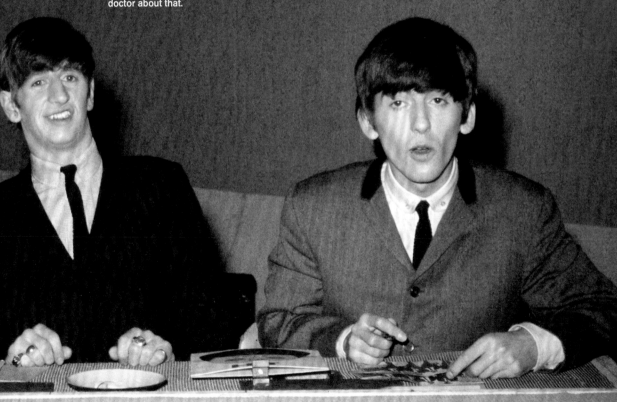

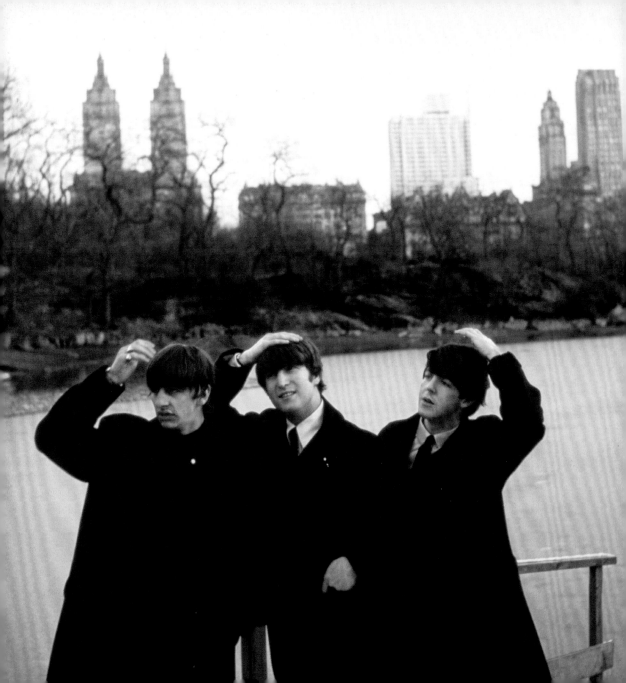

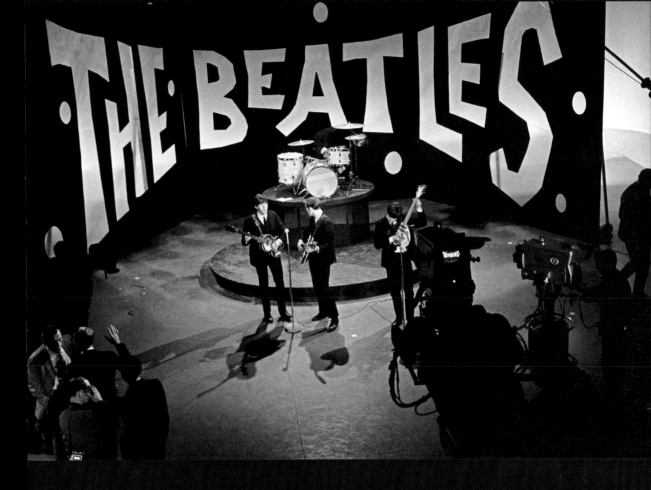

Opposite: Paul McCartney, Ringo Starr and John
Lennon in New York's Central Park prior to the group's
performance on *The Ed Sullivan Show*, 9 February 1964.
George was in bed, resting his problematic tonsils.

Above: The Beatles rehearse their initial appearance on
The Ed Sullivan Show on 9 February 1964. George missed
this rehearsal and his place was taken by road manager
Neil Aspinall.

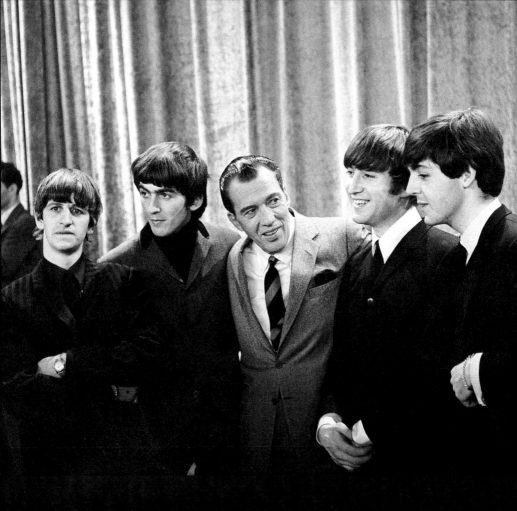

Above: The Beatles with veteran compère Ed Sullivan after their appearance on his show. Host CBS received 50,000 requests for just 728 tickets.

Opposite: The Beatles' first live US performance on CBS's *Ed Sullivan Show*, 9 February 1964. The Beatles performed five songs and recorded an additional performance for the show, which was shown a week later.

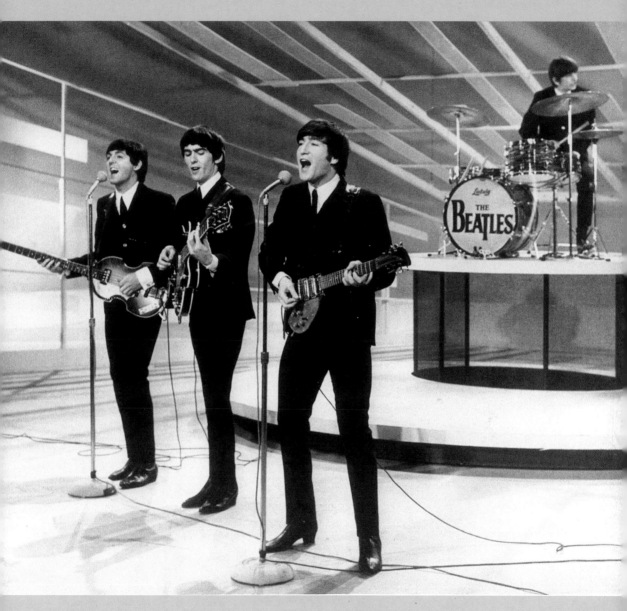

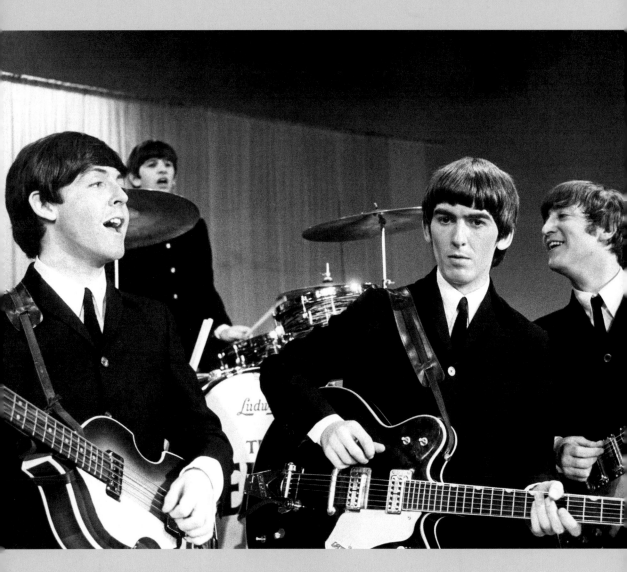

Above and opposite: The Beatles performed live on *The Ed Sullivan Show* for a second time on 16 February, which was broadcast from the Deauville Hotel.

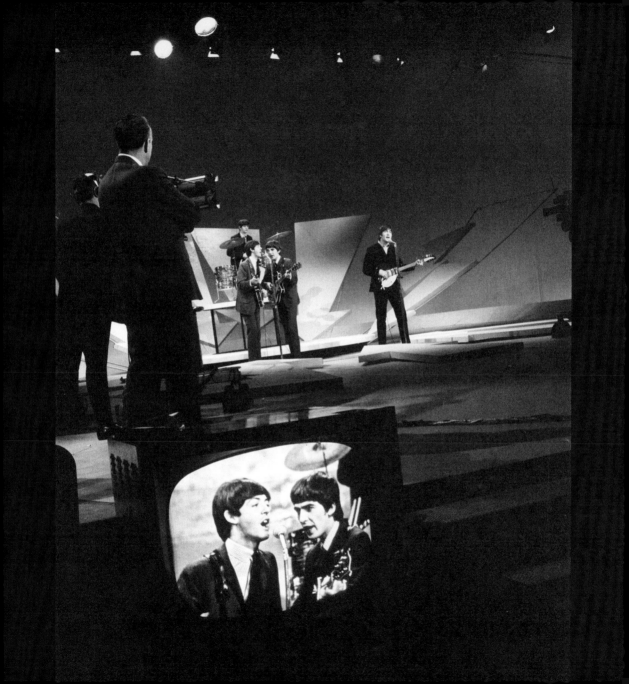

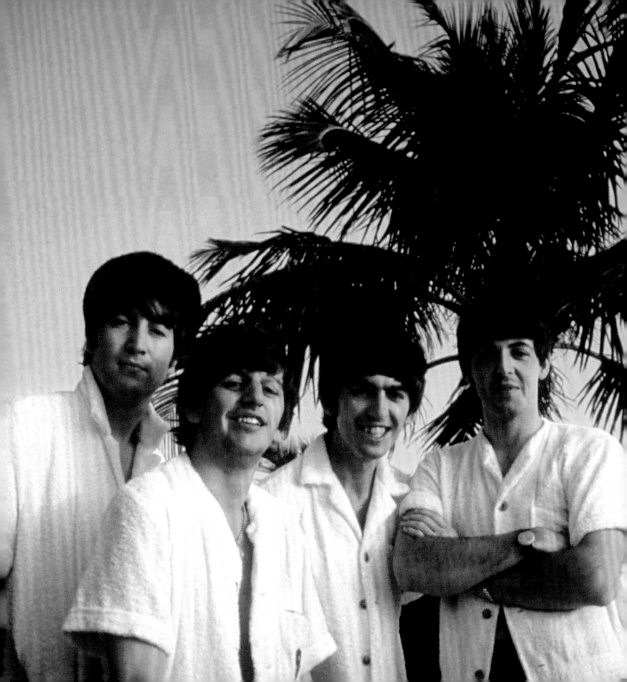

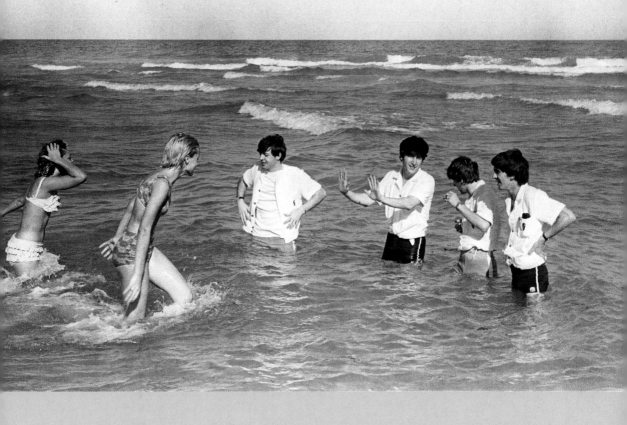

Above: The boys having some fun on a beach in Miami, Florida as local girls rush to join them, 18 February 1964. Note John's faint objections.

Opposite: The Beatles pose for a group photograph in Miami during their initial trip to the USA in 1964.

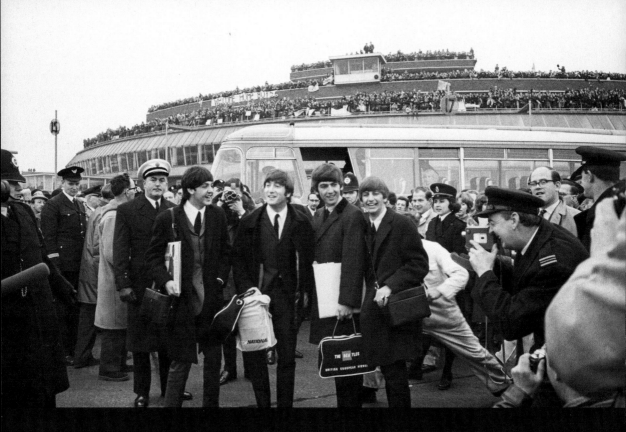

Above: The Beatles at Heathrow Airport in front of a packed terminal roof top following their return from touring the USA, 22 February 1964. The four lads from Liverpool achieved chart success not enjoyed by any other English rock 'n' roll band.

Opposite: John Lennon and Ringo Starr can be seen in the back of a black limousine. After the US trip, The Beatles became increasingly estranged from their Liverpool origins and their original fans.

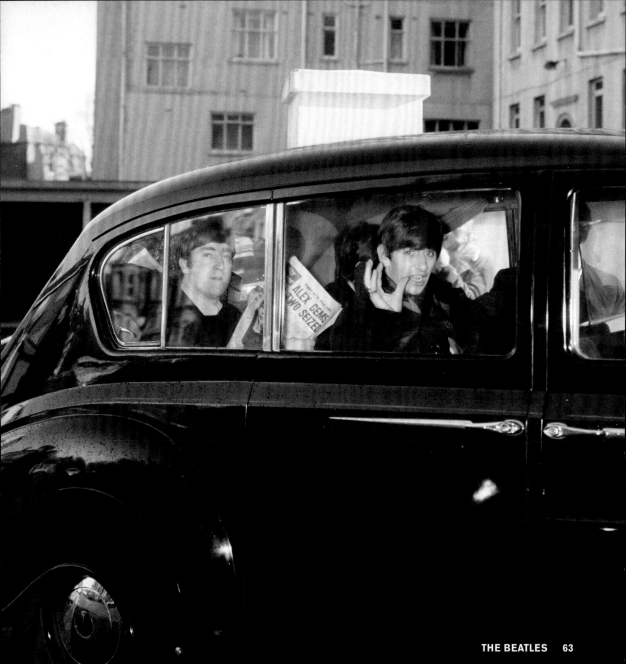

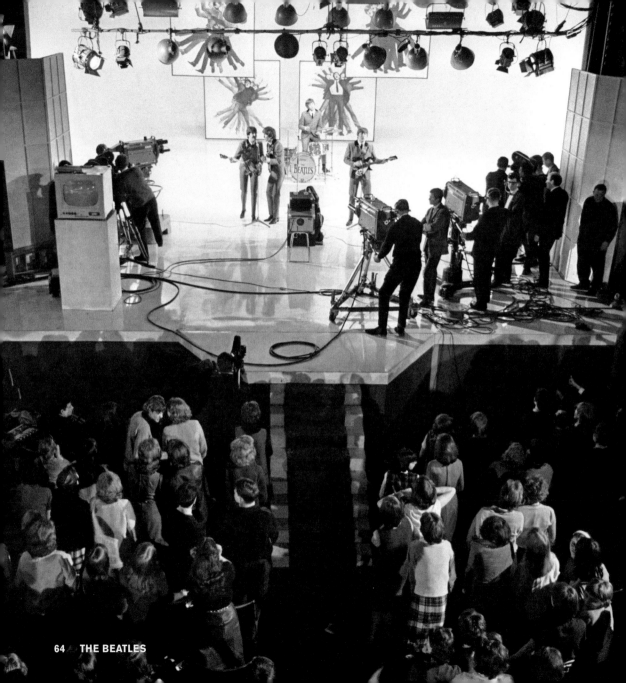

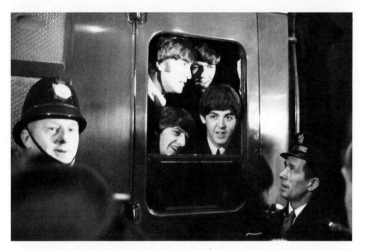

Left: The Beatles peer from a train carriage window at Paddington Station, London, on the first day's shoot of their film *A Hard Day's Night*, 2 March 1964. The film was an extraordinary success … The Beatles were compared to The Marx Brothers; the film inspired *The Monkees* television show and the film's success launched the career of director Richard Lester.

Opposite: The Beatles filmed the finale for *A Hard Day's Night* at The Scala Theatre, London, on 31 March 1964.

Below: The Beatles being groomed at Twickenham Studios by Pattie Boyd (left) and three extras, Tina Williams, Pru Bury and Susan Whitman, in March 1964. Two years later Boyd and George Harrison married.

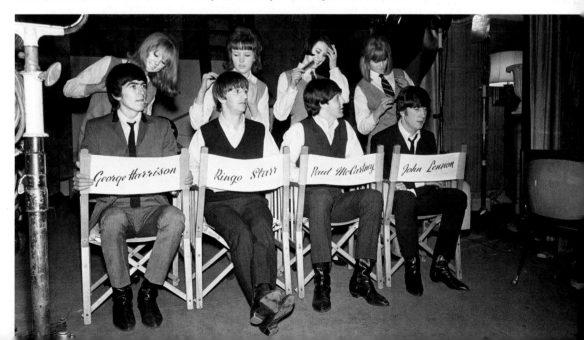

Four days after the world premiere of *A Hard Day's Night* in London, The Beatles arrive in their home town for the Liverpool premiere and wave to gathered fans from the steps of the plane, 10 July 1964. The airport was renamed Liverpool John Lennon Airport in tribute to one of the city's greatest stars at the start of the new millennium.

Opposite: At the premiere of *A Hard Day's Night* crowds gather to catch sight of The Beatles in Liverpool.

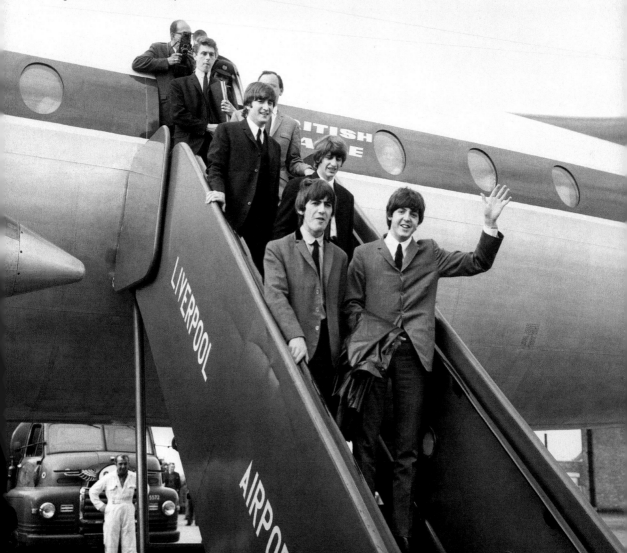

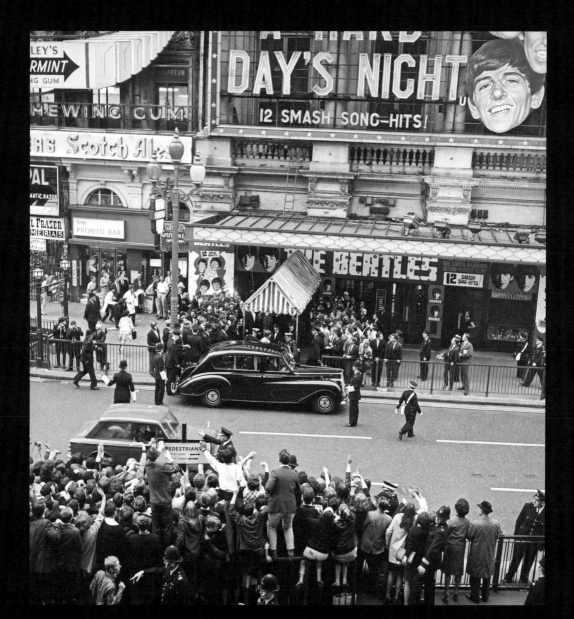

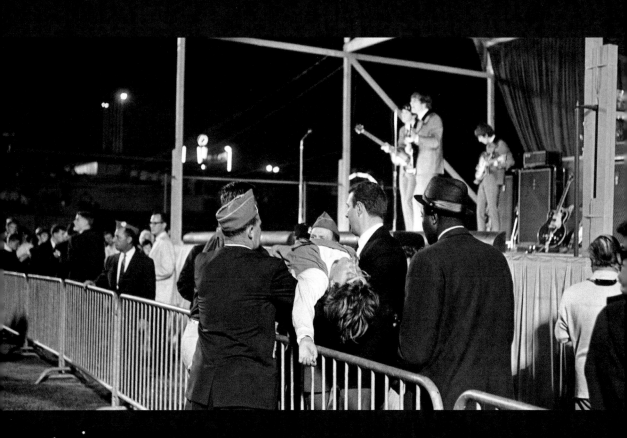

Above: The band on stage at the Empire Stadium, Vancouver, Canada, as distressed fans are helped out of the crowd, 22 August 1964.

Left: Two policemen try to block out the noise of the band playing and fans screaming at a Beatles' concert during the USA tour, 1964.

Opposite above: The Beatles in Las Vegas play on their North American Tour in the Convention Hall, 20 August 1964.

Opposite below: The Beatles on stage at the Forest Hills Tennis Stadium in New York during the tour of the USA, 28 August 1964.

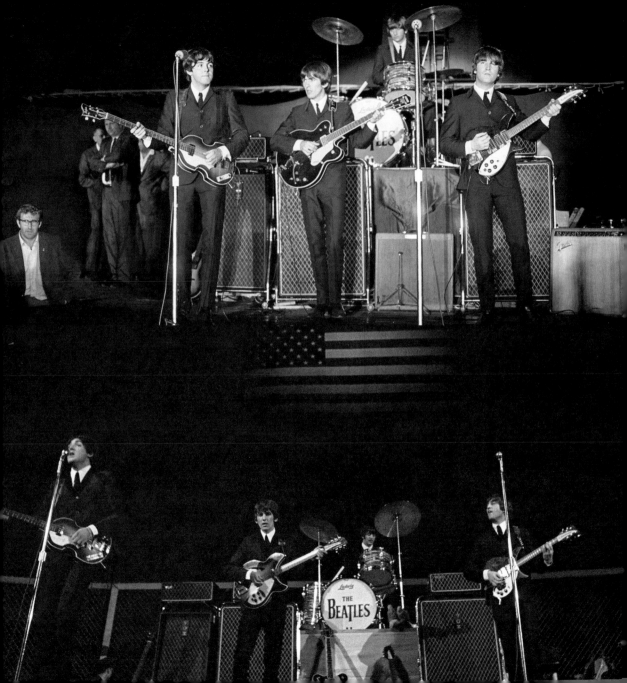

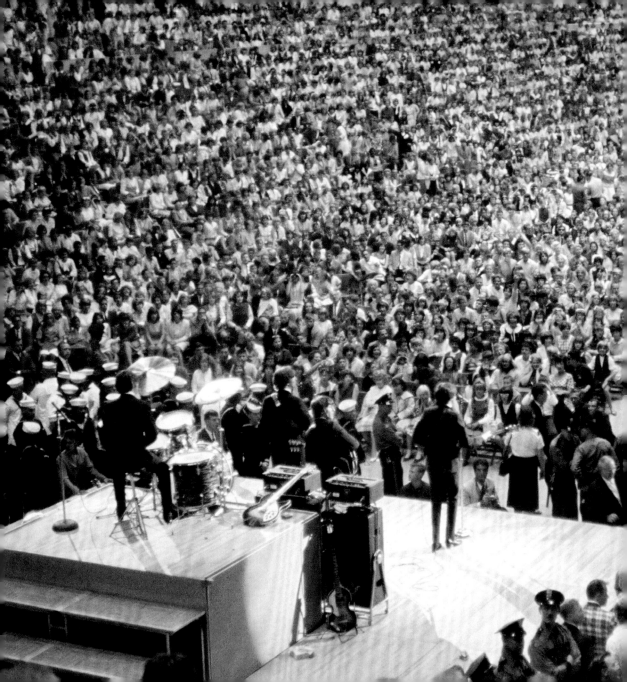

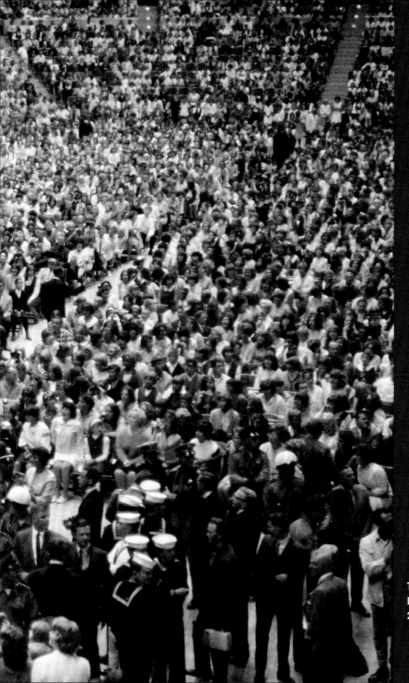

The Beatles performing at the
Las Vegas Convention Hall,
20 August 1964.

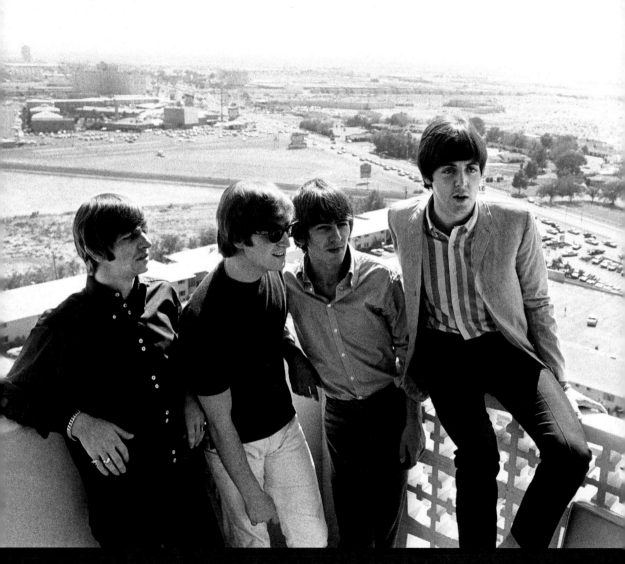

Above: Left to right: Ringo, John, George and Paul on the roof of the Sahara Hotel in Las Vegas, 20 August 1964.
Opposite: Rehearsing on stage in Blackpool for their appearance on the *Blackpool Night Out* television show, 19 July 1964.

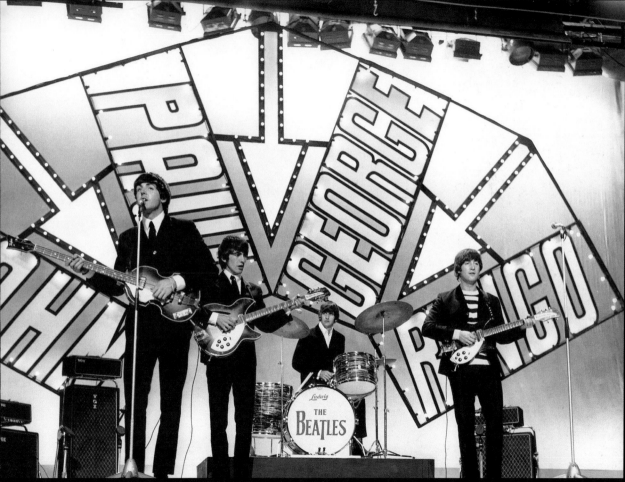

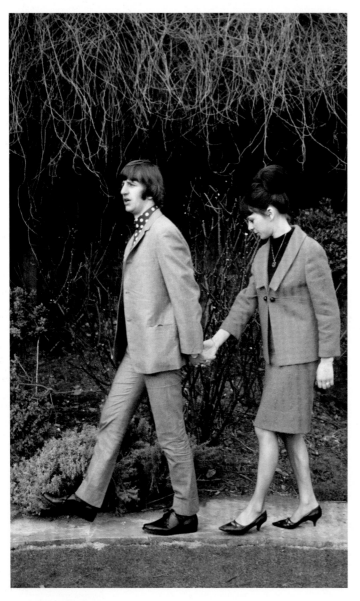

Left: Ringo Starr walks hand-in-hand with his bride Maureen Cox on 11 February 1965. Starr was the second of The Beatles to marry, breaking hearts all over the world, and would follow John Lennon into fatherhood before the end of the year.

Opposite top left: John Lennon with wife Cynthia in New York, February 1964. Lennon's marriage was kept secret for some time because it was thought that news of her existence would damage the group's popularity.

Opposite bottom left: George Harrison and his bride, former model Patti Boyd, after they were married at Epsom Register Office, Surrey, on 21 January 1966.

Opposite far right: Paul McCartney with girlfriend Jane Asher at his brother Mike's wedding in Carrog, North Wales, on 8 June 1968. McCartney's engagement to Jane Asher ended soon after, and he formed a relationship with American photographer and journalist Linda Eastman.

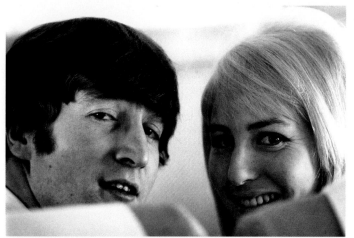

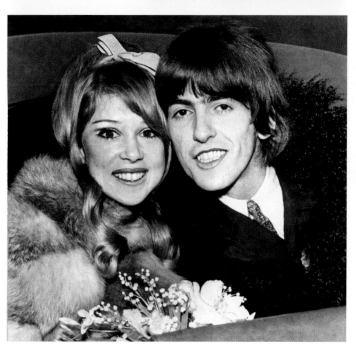

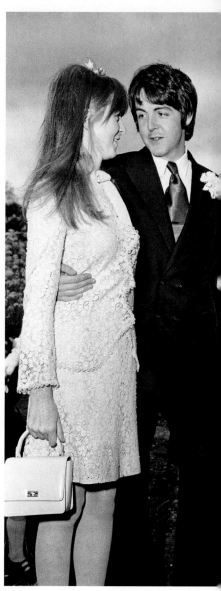

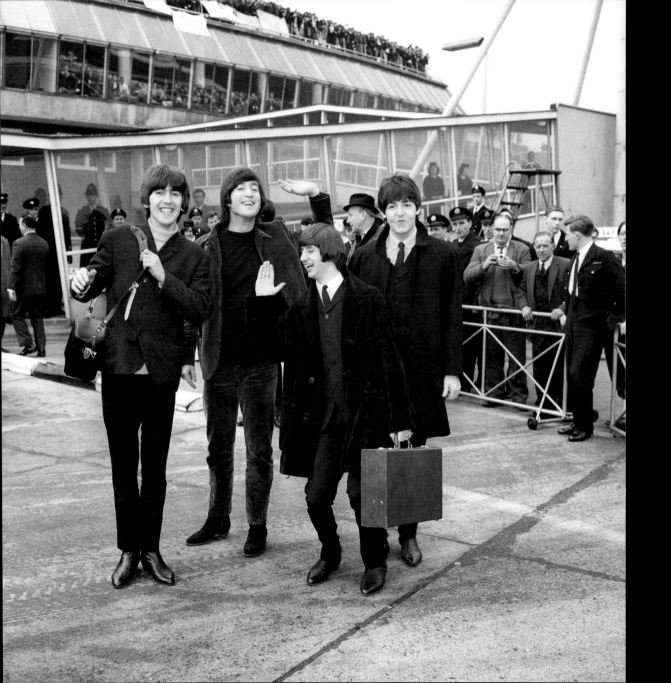

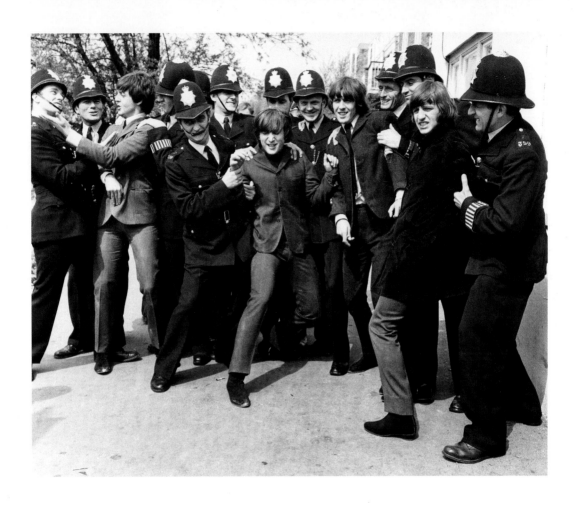

Opposite: The Beatles leave London
bound for the Bahamas to commence
filming their second movie, *Help!*, 1965

Above: The Beatles in the strong
arm of the law while filming *Help!*
outside The City Barge public house,
Chiswick, 24 April 1965.

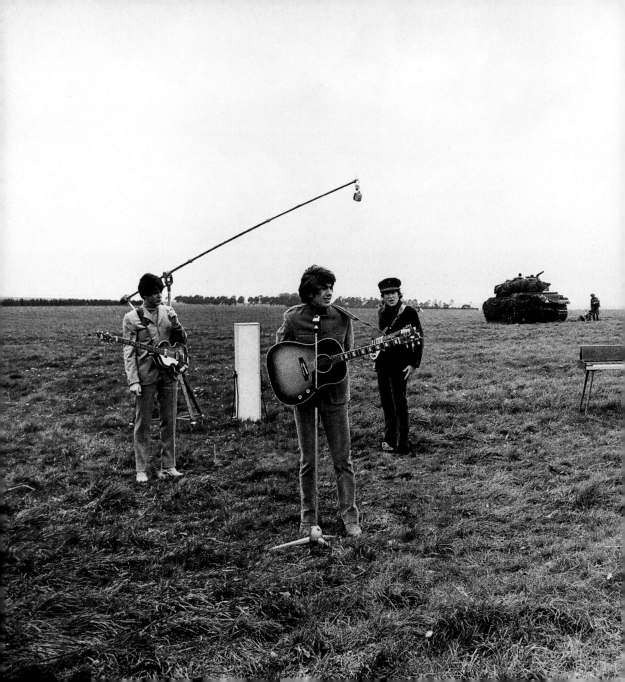

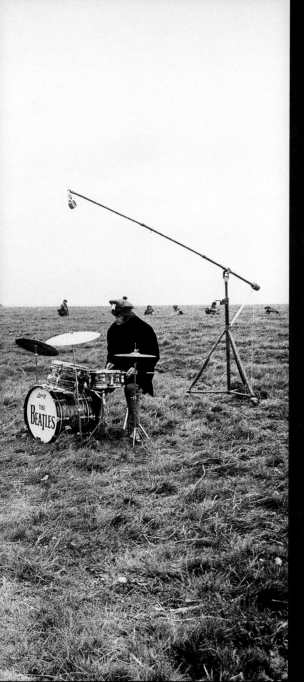

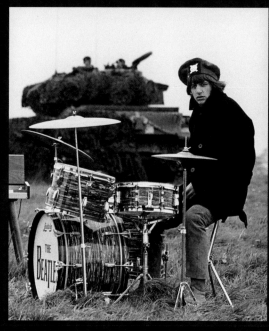

Left: The Beatles during the filming of their latest film *Help!* on Salisbury Plain, May 1965.
Top: Ringo Starr, stranded on a desolate Knighton Down on Salisbury Plain with the army for company, 3 May 1965.

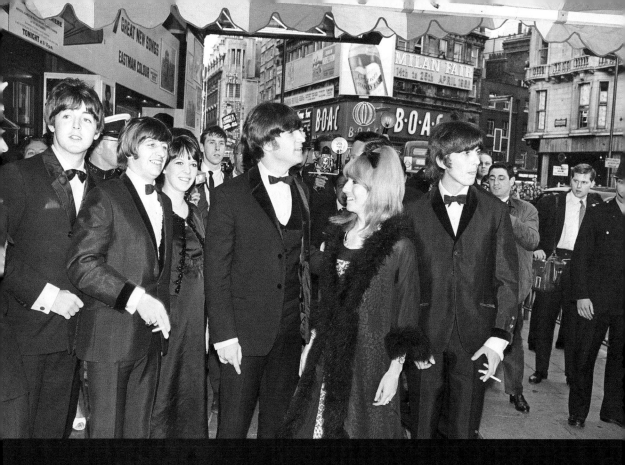

Above: The royal premiere of The Beatles' film *Help!* was screened at the London Pavillion, Piccadilly Circus, on 29 July 1965. It was the second film to feature The Beatles, and their first in colour. The theme was one of espionage, which was popular in the 1960s, and featured the band travelling around the world attempting to avoid an Indian cult that was determined to sacrifice Ringo. John Lennon later complained that The Beatles had been reduced to being "extras in our own film".

Right: The Beatles toast their success with glasses of champagne, 1965.

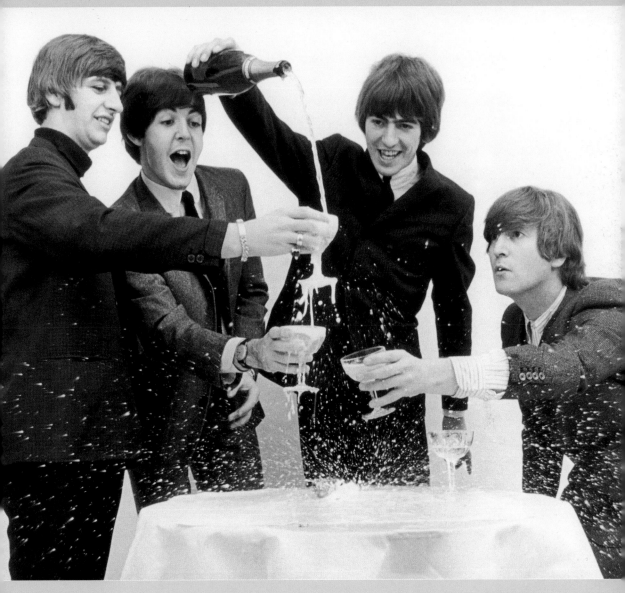

The annual New Musical Express pop concert at Empire Pool (now Wembley Arena), Wembley, on 11 April 1965, featured poll winners and guest artists headlined by The Beatles.

NEW MUSICAL EXPRESS

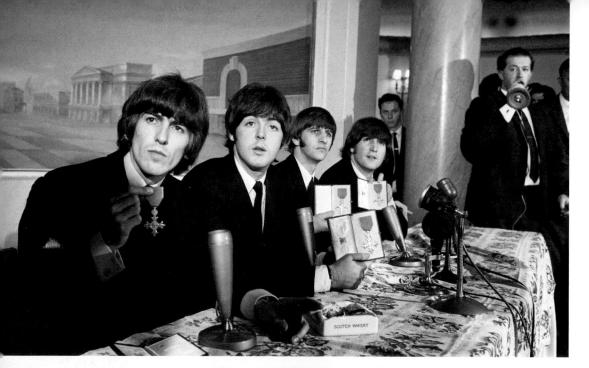

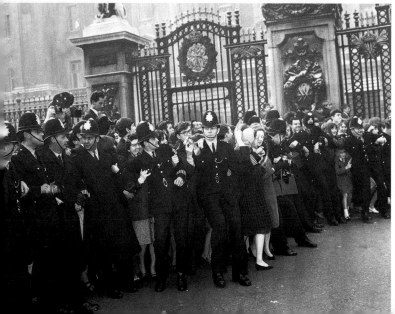

Above: The Beatles pose with their MBEs at a press conference held at the Saville Theatre, London, following their investiture at Buckingham Palace on 26 October 1965. The decision to award a pop group such an honour was criticised in some corners of British society with several war veterans and politicians returning their MBEs in protest.

Left: Outside Buckingham Palace the police hold back the crowds hoping to catch a glimpse of The Beatles after they received their MBEs.

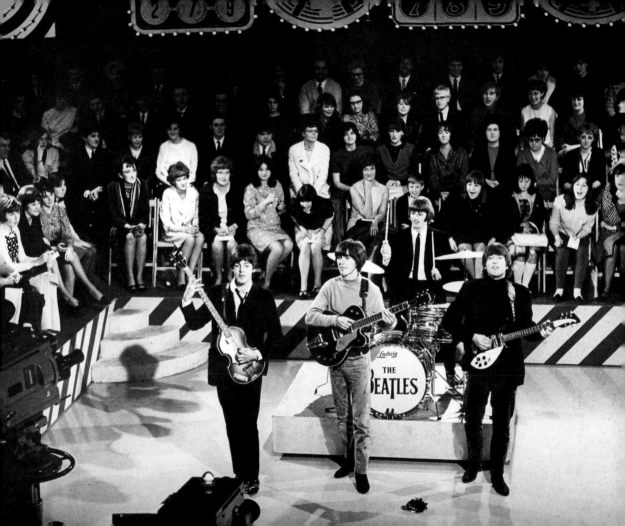

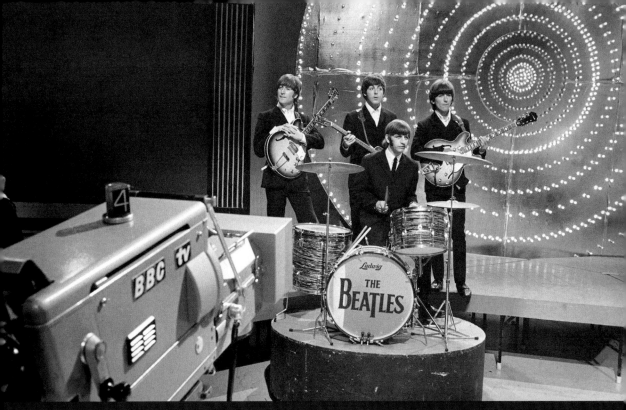

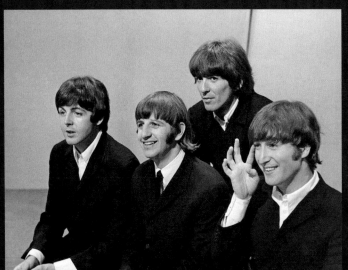

The Beatles on the set of the popular television chart show *Top of the Pops*, where they played both sides of their new single, *Paperback Writer* and *Rain*, on 16 June 1966. The group had previously appeared on the show, but this was their only appearance live in the studio.

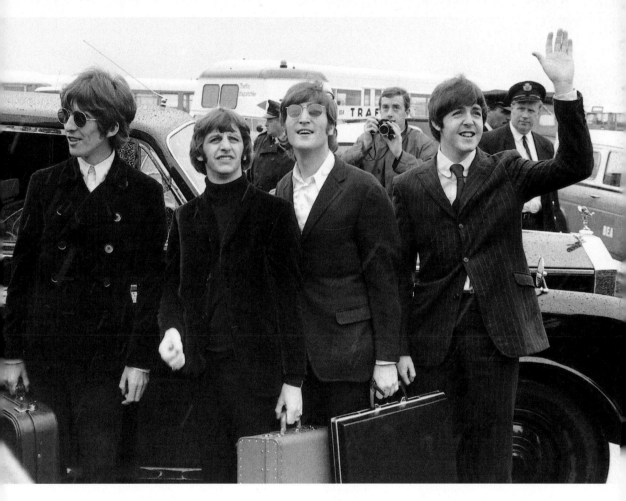

The Beatles arrive at Heathrow Airport to fly out to the USA, in August 1966. John Lennon flew into a firestorm whipped up by the American press over comments he made in March of that year. In an article that appeared in the popular press and which discussed the decline of Christianity, John Lennon had claimed that The Beatles were more popular than Jesus. The comment didn't raise an eyebrow in England, but in the USA the comments were seized upon by The Bible Belt. Lennon was forced to publicly apologise after demonstrations, radio bans and even bonfires of Beatles' products threatened to derail the tour.

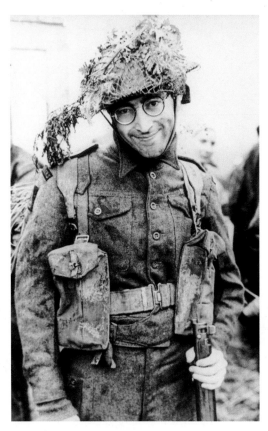

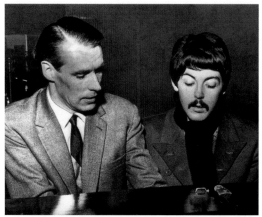

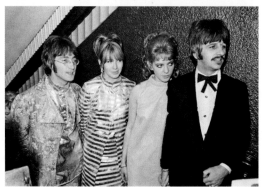

Above left: John Lennon dresses in army uniform for his role as Musketeer Gripweed in the Dick Lester film *How I Won the War* during filming near Celle in Hanover, West Germany, on 6 September 1966. Lennon was keen to try his hand at acting but later complained that too much time was spent sitting around between takes for his liking.

Top right: Paul McCartney plays the piano in the Abbey Road studios with producer George Martin, 1967. More than any other Beatle, McCartney's musical prowess blossomed in the recording studio after The Beatles ceased touring. It was inevitable that he would attempt to lead the band's musical direction in the years leading up to their break up in 1970.

Above right: John and Cynthia Lennon, Ringo and Maureen Starr arrive at the film premiere of *How I Won the War* at Piccadilly Circus, 18 October 1967. Opposite: At the press launch of *Sgt. Pepper's Lonely Hearts Club Band*, the band's eighth studio album, 19 May 1967, The Beatles are pictured in hippy finery at manager Brian Epstein's house in Belgravia, London.

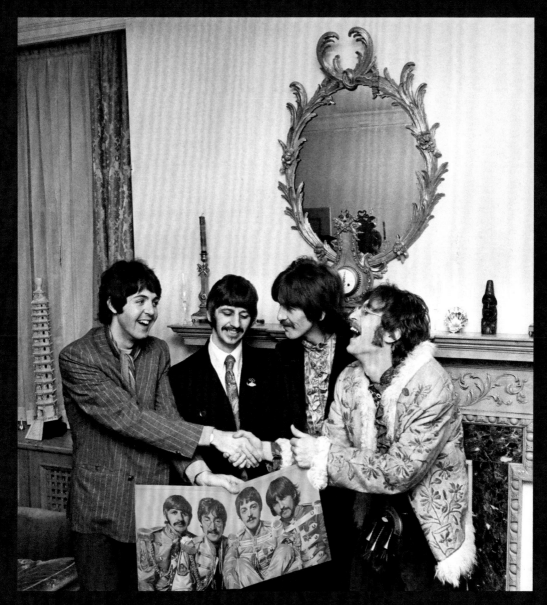

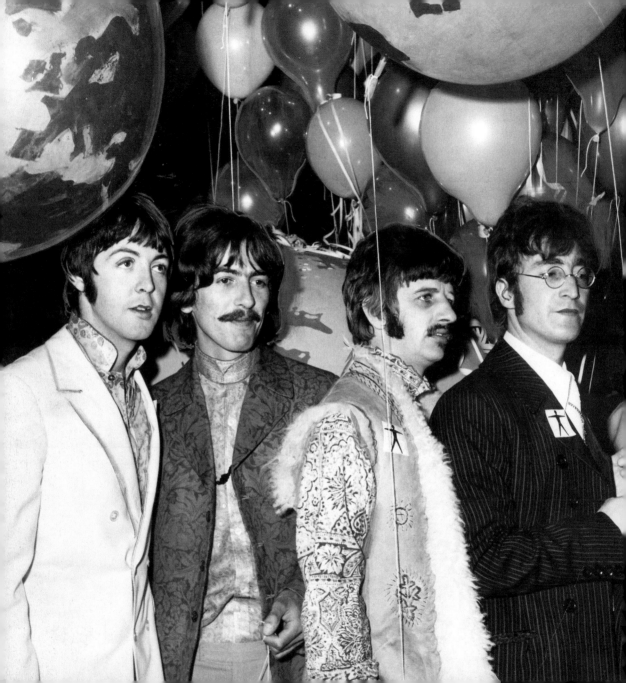

Opposite: The first ever live global television link was broadcast to 26 countries and watched by 400 million people on 25 June 1967. For the *Our World* programme, to be broadcast via satellite, the BBC had commissioned The Beatles to write a song to represent the UK's contribution. *All You Need Is Love*, a song written by John Lennon, was first performed by The Beatles at this event before being released as a single the following month.

Above right: On 11 September 1967 The Beatles set out on their *Magical Mystery Tour*, filming in the west country. The 52-minute television film of the tour depicted a magical coach in which strange things happened to the passengers. The film was shown on the BBC on Boxing Day, 1967. Much of the footage from the west country never made it into the recording.

Right: The Beatles finish their film *Magical Mystery Tour* in the studio in Soho. The music was marvellous, including *Magical Mystery Tour*, *I Am The Walrus* and *The Fool on the Hill*, but the finished film was their first to draw criticism for being amateurish. The fact that the BBC showed the fanciful colour production in black and white may have been a contributory factor to its poor reception.

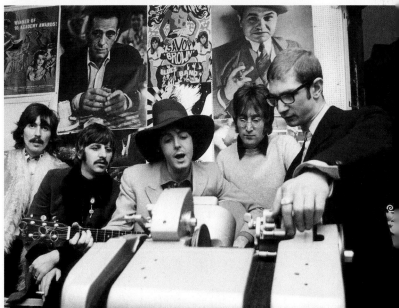

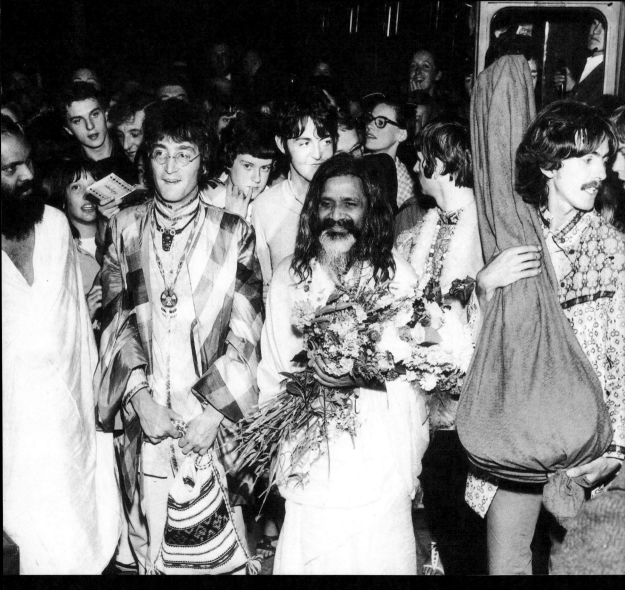

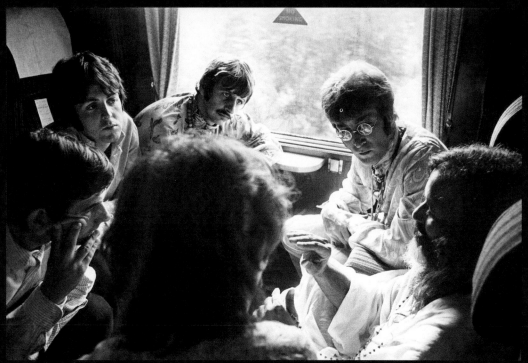

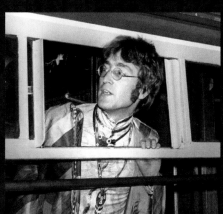

Left: John Lennon leans out of the window of The Beatles' specially chartered train to Bangor, after wife Cynthia was accidentally left behind.
Above: The Beatles on board a train with the Maharishi Yogi.
Opposite: The Beatles pictured with the Maharishi Mahesh Yogi on their trip to a meditation retreat in Bangor, North Wales, on 25 August 1967.

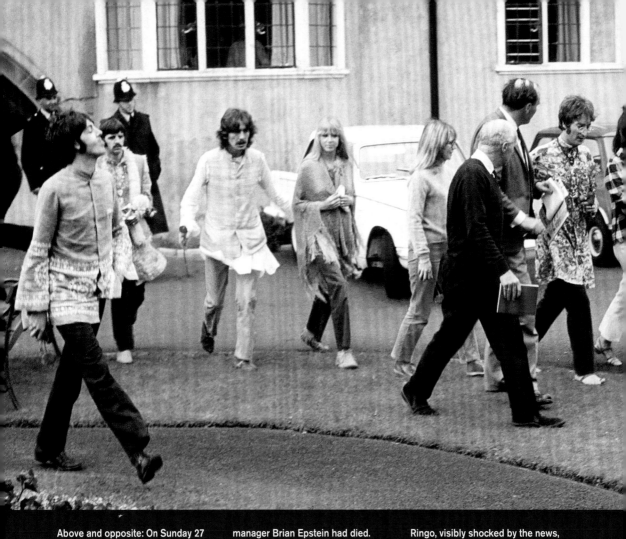

Above and opposite: On Sunday 27 August 1967, two days after their arrival in Bangor, the news broke that manager Brian Epstein had died. Paul immediately made his way back to London, but John, George and Ringo, visibly shocked by the news, spoke briefly to reporters before leaving Wales.

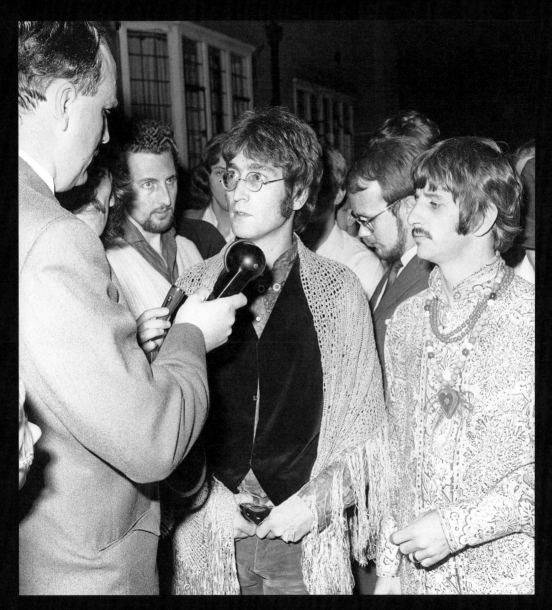

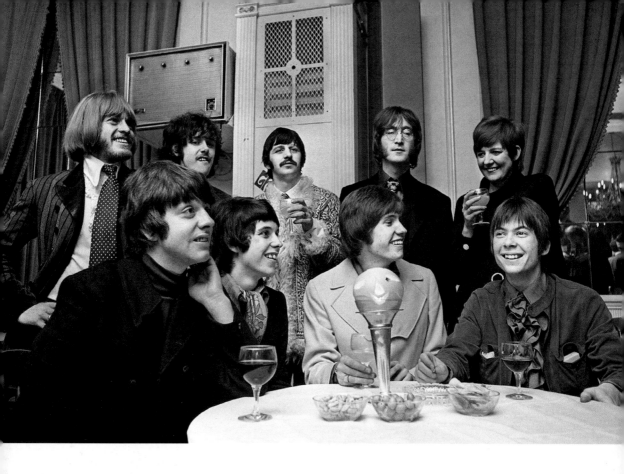

Above: At a launch party to celebrate the Apple-managed Grapefruit's debut single, *Dear Delilah*. The Scottish band however was not a success. Back row, from left to right: Rolling Stone Brian Jones, Donovan, Ringo Starr, John Lennon, Cilla Black. Front row: Grapefruit members George Alexander (born Alexander Young, 1938–1997, older brother of The Easybeats' George Young and AC/DC's Malcolm and Angus Young), Pete Swettenham, Geoff Swettenham, John Perry.

Opposite: Paul McCartney with Cynthia and John Lennon at the launch, 19 January 1968.

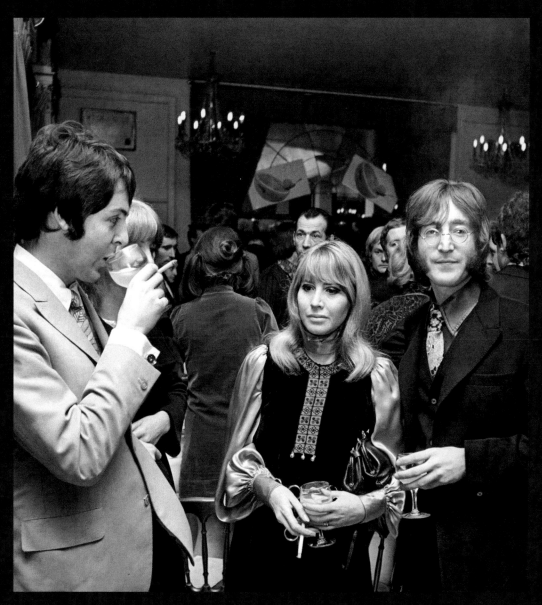

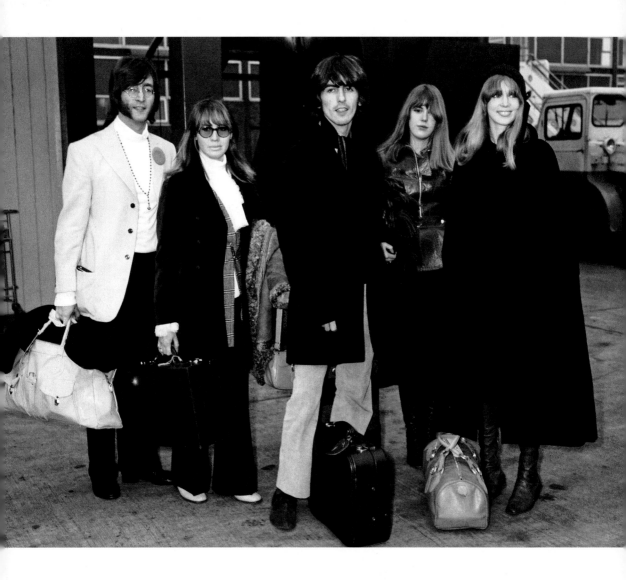

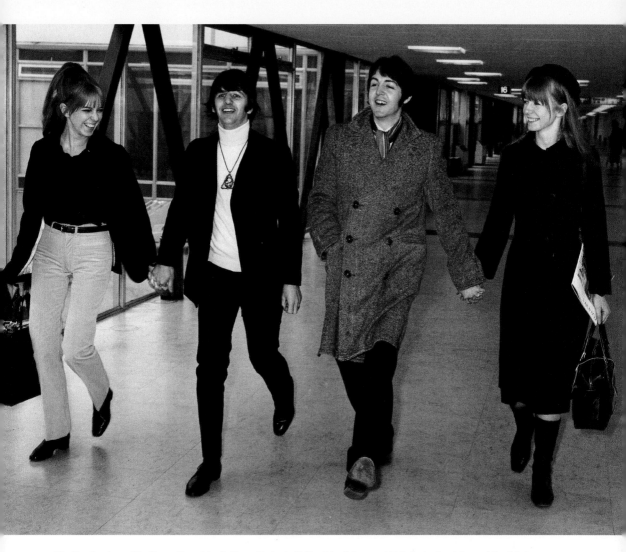

The Beatles leave Heathrow Airport for India on their mediation trip, February 1968. Opposite: John and Cynthia Lennon, George Harrison and Jenny Boyd, the younger sister of Patti Harrison (right). Above: Maureen and Ringo Starr, Paul McCartney and his girlfriend Jane Asher.

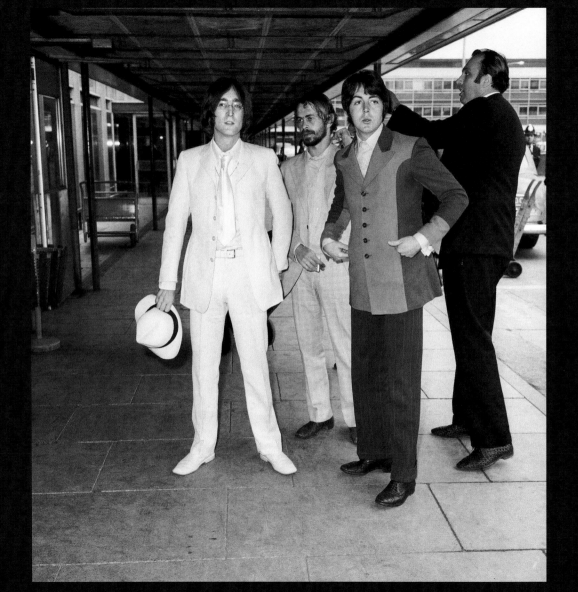

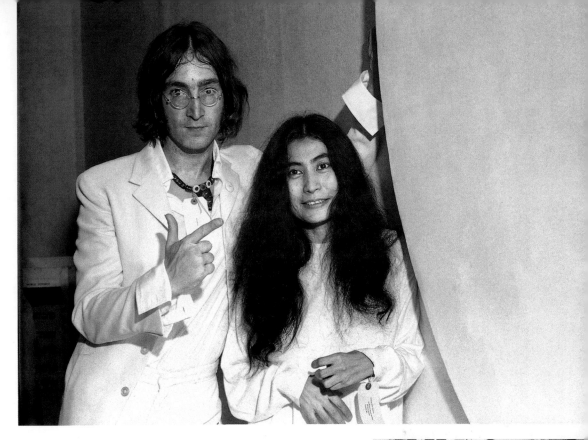

Above: John Lennon with his new partner Yoko Ono at their joint art exhibition *You Are Here*, 1 July 1968. They married 8 days after the McCartneys.

Opposite: John Lennon, associate Alexis Mardas (aka Magic Alex), Paul McCartney and Les Anthony (John's driver) at Heathrow Airport, 11 May 1968. John and Paul were bound for New York to launch The Beatles' company Apple.

Right: John Lennon and Yoko Ono are surrounded by police officers as they leave Marylebone Magistrates' Court after they were remanded on bail after being charged with drug-related offences, 19 October 1968. The charge would come back to haunt Lennon; not only did Ono miscarry soon after, but the charge was used in the early 1970s by the US government as a reason to cancel Lennon's resident's visa.

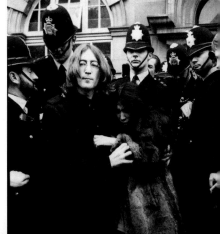

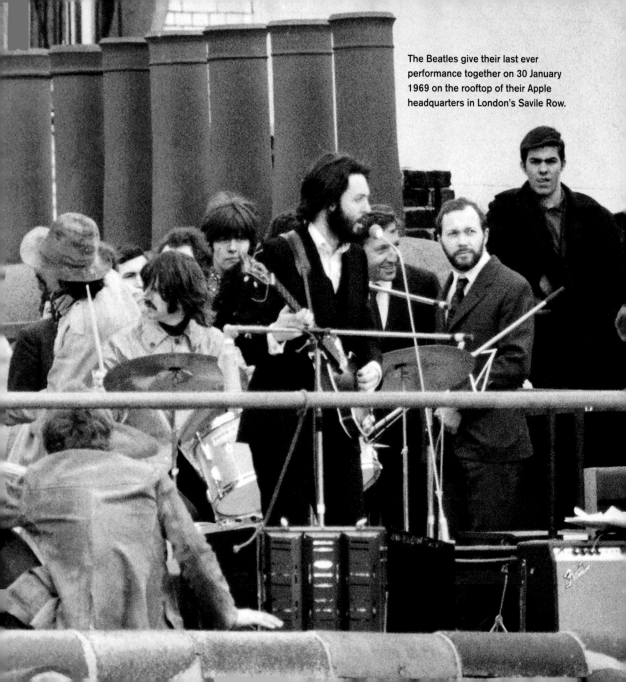

The Beatles give their last ever performance together on 30 January 1969 on the rooftop of their Apple headquarters in London's Savile Row.

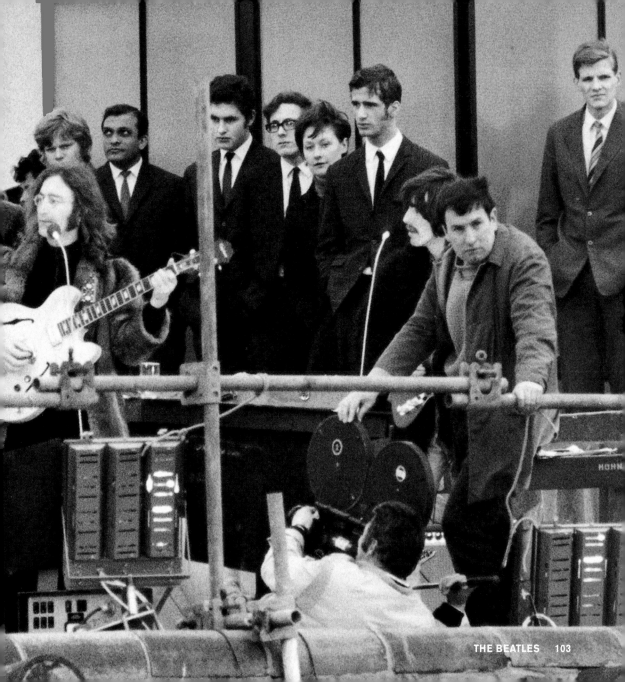

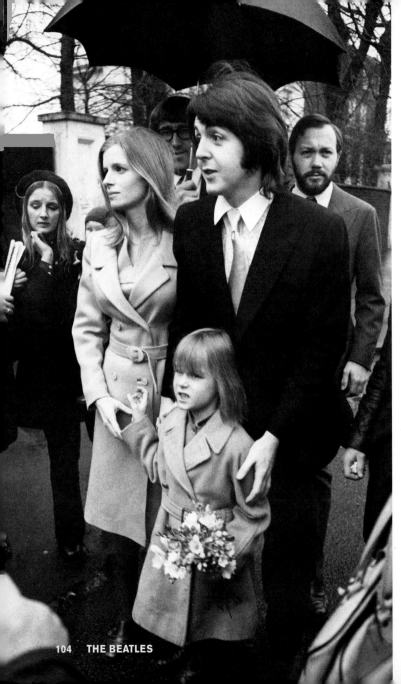

Left: Paul marries Linda Eastman at Marylebone Register Office, London, 12th March 1969. Linda's 6-year-old daughter Heather, from her previous marriage, carries a posy of flowers. The McCartneys remained married until Linda's death from cancer in 1998.

Opposite: John Lennon in bed with Yoko Ono on their honeymoon at the Hilton Hotel, Amsterdam. A week after Paul McCartney tied the knot, John and Yoko were married in Gibraltar on 20 March 1969. The Lennons decided to use the worldwide press interest to draw attention to the war in Vietnam and stay 'in bed for peace'.

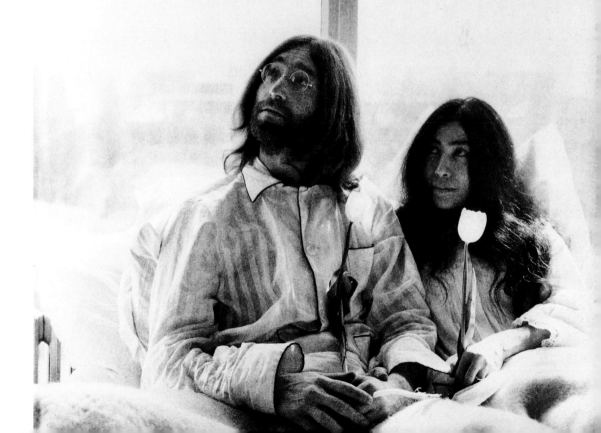

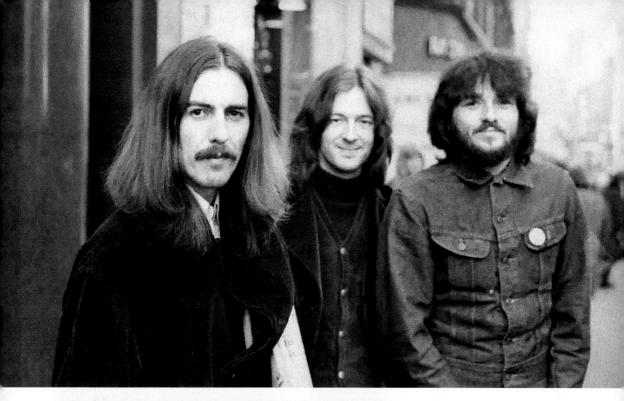

Above: George leaves the Midland Hotel, Birmingham, on his way to perform at the Town Hall with Eric Clapton and Delaney Bramlett (of American band Delaney and Bonnie), 3 December, 1969.

Left: Peter Sellers with Ringo Starr at the premiere of the musical film *Oh! What a Lovely War*, 10 March 1969. The pair had recently filmed *The Magic Christian* together. By the end of the decade, all four Beatles were involved in solo ventures and projects, hastening the band's demise in 1970.

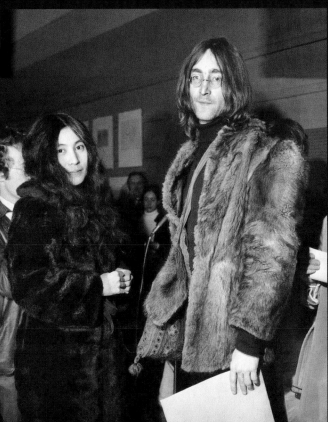

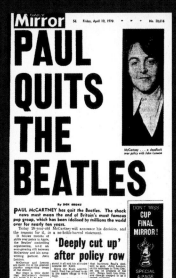

Top: John Lennon and Yoko Ono, in Piccadilly 1969. The pair had become increasingly enthralled in their own projects, further isolating Lennon from the rest of the group. Lennon was the first to announce to The Beatles that he was leaving the group, but Paul's decision got all the press.

Right: The headline that Beatles' fans around the world did not want to see. After protracted problems involving the appointment of American manager Allen Klein (pictured right) by John, George and Ringo to handle their affairs, Paul announced he had quit the band in April 1970. *Let it Be*, the band's 'posthumous' album, was released the following month.

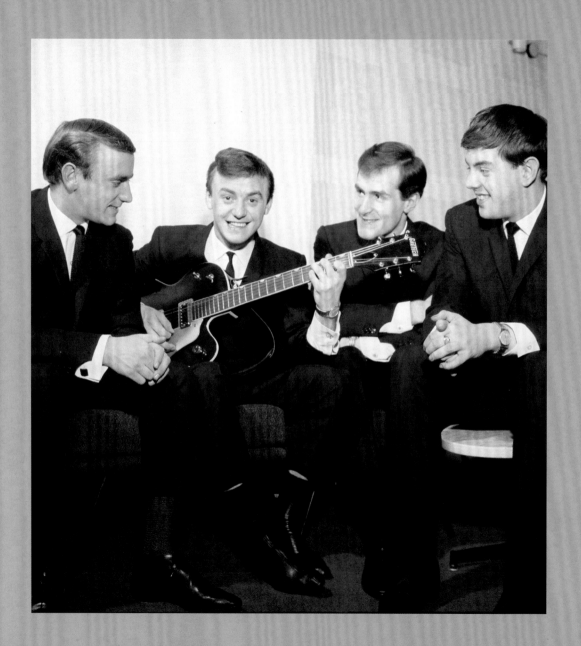

CHAPTER 2

Gerry & the Pacemakers

If 1964 belonged to The Beatles, then the previous year belonged to Gerry & the Pacemakers. This Liverpool band was the first to top the UK charts with each of their first three singles, a feat that The Beatles couldn't match. With charismatic Gerry Marsden at the helm, the Pacemakers pre-dated their more famous musical counterparts as a touring band, having been formed in 1959. Marsden (born 1942) recruited his brother Fred (1940–2006) on drums, Les Chadwick (born 1943) on bass and Arthur 'Mac' McMahon on piano. The latter was replaced by Les Maguire (born 1941) in 1961.

Gerry & the Pacemakers followed The Beatles to Hamburg and, in June 1962, were the second band signed by manager Brian Epstein. While Epstein focused on The Beatles,

it took the record label EMI another six months to commit to recording the Pacemakers. George Martin signed them to Columbia, a sister label to Parlophone, with Marsden and

GERRY
AND
THE
PACEMAKERS

The Pacemakers picking up the Mitch Murray song *How Do You Do It?* after The Beatles recorded it but refused to release it. The song went to #1 in the UK charts in March 1963, and the band followed with another

Murray composition, *I Like It*, which also reached the top of the UK charts in May of that year.

For their third release, Gerry Marsden chose a pop version of the show tune *You'll Never Walk Alone* from the musical *Carousel*. The song went into the charts in October 1963 just as the Liverpool football club started its winning run in the English premier league. The Liverpool fans adopted the song, which became the band's third straight #1, keeping it in the charts for 14 weeks.

Almost symbolically, given The Beatles' enormous impact on the music scene, Gerry & The Pacemaker's January 1964 release, *I'm the One*, was denied the top spot on the UK chart by The Beatles *I Want to Hold Your Hand*. Their next single, *Don't Let the Sun Catch*

Opposite: Gerry & the Pacemakers record the television show *Thank Your Lucky Stars* at the ABC Studios in Birmingham, 5 January 1964. Pictured left to right: Fred Marsden, Gerry Marsden, Les Maguire and Les Chadwick.

You Crying, which was written by all four band members, was a Top 10 hit internationally (UK#6 and US#4). The band toured the US as their first two singles hit the Top 20 there, but their finest moment came in December 1964 with the release of Marsden's *Ferry Cross The Mersey.* This evocative song was a Top 10 hit (UK#8 and US#6) in early 1965, and even spawned a film of the same name in which Marsden and the band starred, but the Pacemakers quickly lost chart momentum as pop music tastes started to change. *I'll Be There* was a Top 20 hit (albeit also in the US) but subsequent recordings did not chart well.

Despite Gerry Marsden's obvious charms, The Pacemakers lacked The Beatles' harmonies and musical inventiveness. After their debut album reached #2 in October 1963, The Pacemakers didn't release another 'long play' until February 1965. *Ferry Cross The Mersey,* the album, made the Top 20 in the

UK#1	How Do You Do It?	US#9
UK#1	I Like It	US#17
UK#1	You'll Never Walk Alone	
UK#2	I'm The One	US#82
UK#6	Don't Let the Sun Catch You Crying	US#4
UK#8	Ferry Cross The Mersey	US#6

US and UK. Unable to make an impact on a changing music scene, Marsden disbanded the group in 1967 for a career in television and stage. Gerry & the Pacemakers reformed in the 1970s and 1980s, touring the world with various line-ups.

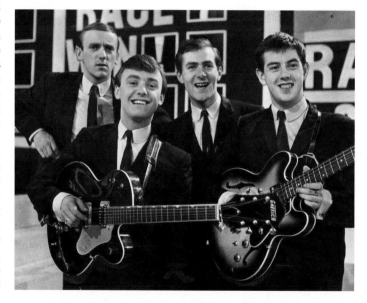

Above: Contemporaries of Liverpool's most famous group The Beatles, Gerry & the Pacemakers became the first band in pop history to have their first three recordings all go to #1 in the UK charts – *How Do You Do It?* (March 1963), *I Like It* (May 1963) and their cover of the show-tune *You'll Never Walk Alone* (October 1963).

Opposite: The indefatigable Gerry Marsden, frontman of The Pacemakers was born on 24 September 1942. He proved to be a talented singer, songwriter and guitarist with his band The Pacemakers. His song *Ferry Cross the Mersey,* which pays homage to Liverpool's River Mersey, was later made into a film featuring the band and has become as synonymous with the northern city as Lennon-McCartney's *Strawberry Fields Forever* and *Penny Lane.*

Gerry Marsden at the NME awards concert in 1964.
Marsden had a unique way of holding his guitar. The reason
he held his guitar so high was simple ... to see his fingers.

Opposite: Gerry & the Pacemakers, January 1964. Although
a success in their own right, the band could not capitalise
on their extraordinary debut year and eventually broke up in
October 1966.

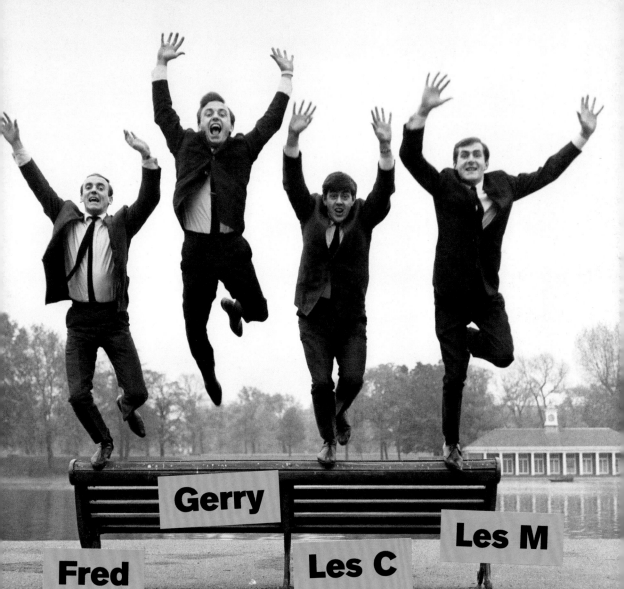

Fred

Gerry

Les C

Les M

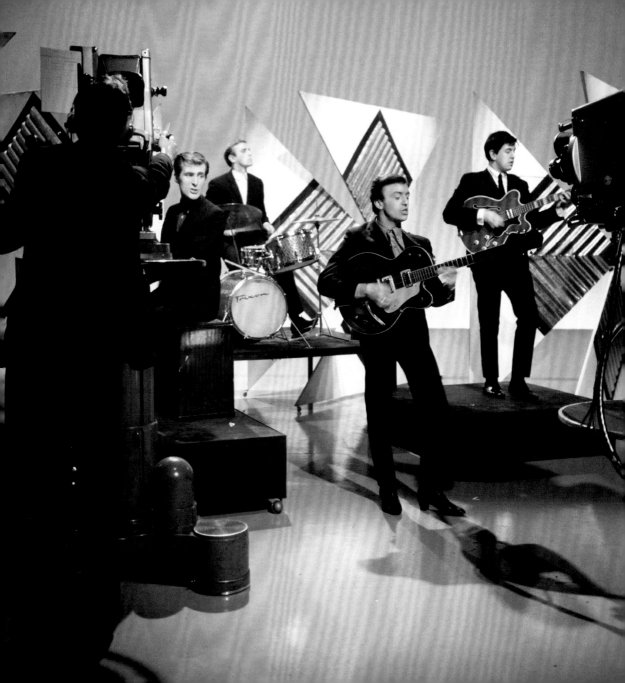

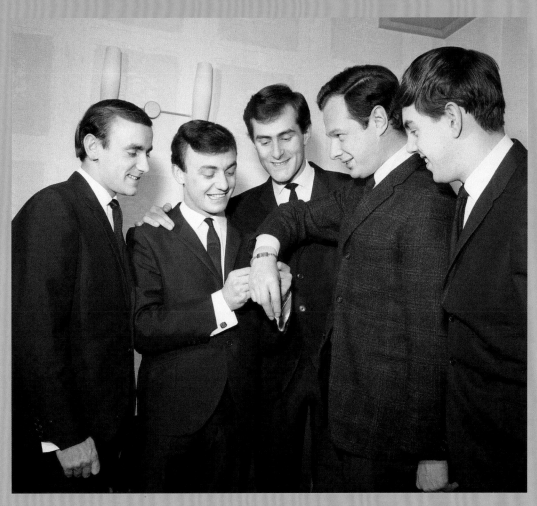

Opposite: Gerry & the Pacemakers record the television show *Thank Your Lucky Stars* in Birmingham, 29 March 1964.

Above: On their way to Ipswich to appear in a pantomime, stopped at Alpha television studios in Birmingham to record ABC TV's *Thank Your Lucky Stars* where they were joined by their manager Brian Epstein, January 1964. The band became an integral part of manager Epstein's stable.

Gerry Marsden celebrates his 21st birthday in Allerton, Liverpool, with several local girls in September 1963.

Actress Julie Samuel was chosen to appear with the pop group in the film *Ferry Cross the Mersey* in June 1964. Pictured here with Gerry Marsden during filming at the Edgwarebury Country Club at Elstree, Samuel played Gerry's girlfriend in the film; the daughter of a rich shipping magnate who convinces him to enter a 'Big Beat Competition' with the usual Hollywood-style results.

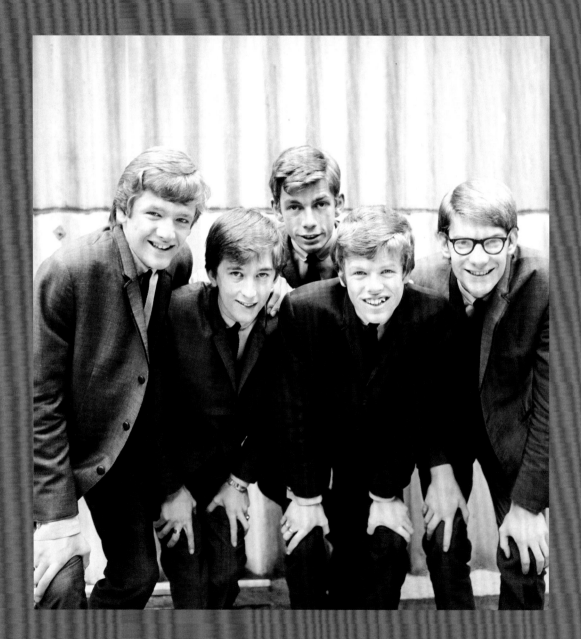

CHAPTER 3

Herman's Hermits

Originally known as Herman & The Hermits in their native Manchester, the band was a teenage rhythm and blues outfit comprising vocalist Peter Noone (born 1947), drummer Barry Whitwam (born 1946), bassist Karl Green (born 1947) and guitarists Keith Hopwood (born 1946) and Derek 'Lek' Leckenby (1943–1994). A former child actor (in the popular soap *Coronation Street*), Noone was a 15-year-old student from the Manchester School of Music and Drama when he assumed the frontman role of the band The Heartbeats with his pitch-perfect singing voice and confident stage presence.

Mere teenagers when they were discovered in Bolton in 1964 and asked to go to London to work with independent producer Mickie Most (born Michael Hayes, 1938–2003),

their name was shortened to Herman's Hermits to capitalise on Noone's cherubic good looks. Their first single, a cover of Goffin and King's *I'm into Something Good*, was released

three weeks later and introduced the band internationally after topping the UK charts in August 1964.

American audiences, post-Beatles, embraced the young band and took a series of singles

to the Top 10 over the next two years. The Hermits toured extensively and were ready-made for conservative US audiences, with Noone (widely referred to by the media as 'Herman') adored by mothers and daughters alike. The band's singles were selected and produced by Most, who relied too often on studio musicians to provide backing despite the band being more than competent live act. The band were tailored to English 'music hall' traditions that US audiences loved.

Herman's Hermits had US#1's with *Mrs. Brown, You've Got a Lovely Daughter* and *I'm Henry VIII I Am* in 1965, which were never released as singles in the UK. *Listen People* (US#3), George Formby's *Leaning On A Lamp Post* (US#9) and Ray Davies' (of The Kinks' fame) *Dandy* (US#5) followed

Opposite, left to right: Karl Green, Keith Hopwood, Barry Whitwam, Peter Noone and Derek 'Lek' Leckenby pose at the Alpha Studios in Birmingham before recording the television show *Thank Your Lucky Stars*, 1 September 1964.

Left: Peter Noone visits Mike Skotny's barber shop straight after his arrival at Manchester Airport following a world tour, 2 March 1966.

Opposite: Herman's Hermits, 1965. At back from left: Barry Whitwam (drums) and Karl Green (bass). In front from left: Derek Leckenby (guitar), Peter Noone (vocals) and Keith Hopwood (guitar).

in 1966, and the quirky *Mrs. Brown, You've Got a Lovely Daughter* in 1968, and in both of which Noone played a character named Herman.

As the 1960s took on a decidedly psychedelic tinge and the LP album became increasingly influential, Herman's Hermits were content to produce singles, tour the world and appear on television. The brilliant Graham Gouldman composition *No Milk Today* (UK#7) was a B-side in the US, but *There's*

a Kind of Hush returned the band to the Top 10 around the world in 1967. Just when it appeared that music audiences had left the band behind, 1969's *My Sentimental Friend* (UK#2) reminded us just how potent a pop force Herman's Hermits could be with the right song.

As baby boomers entered the 1970s, Peter Noone left the band for a solo career and the original band forged ahead as The Hermits before disbanding in 1971.

in 1966, although they didn't get to #1. A hurriedly released *Their Greatest Hits* album in the US – barely a year after the band started recording – sold a million copies.

As a leader, Noone excelled on TV, and the band was non-controversial. Herman's Hermits appeared in feature films – the forgettable *Hold On!*

UK#1	**I'm into Something Good**	**US#13**
	Can't You Hear My Heartbeat	**US#2**
UK#3	**Silhouettes**	**US#5**
	Mrs. Brown, You've Got a Lovely Daughter	**US#1**
UK#7	**Wonderful World**	**US#4**
	I'm Henry VIII, I Am	**US#1**
UK#15	**Just a Little Bit Better**	**US#7**
UK#6	**A Must To Avoid**	**US#8**
	Listen People	**US#3**
	Leaning On The Lamp Post	**US#9**
	Dandy	**US#5**
UK#7	**No Milk Today**	**US#35**
UK#7	**There's a Kind of Hush**	**US#4**

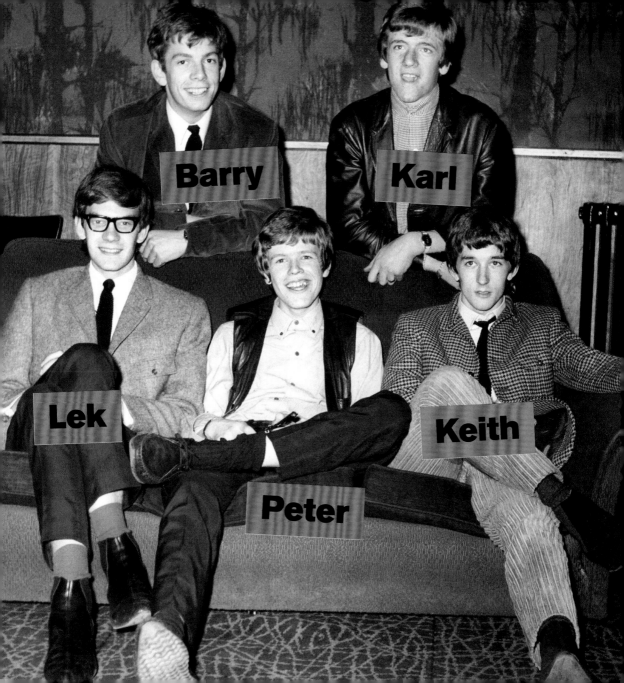

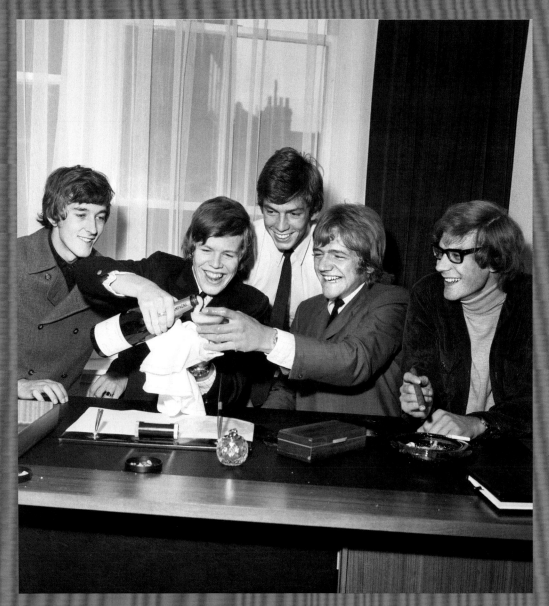

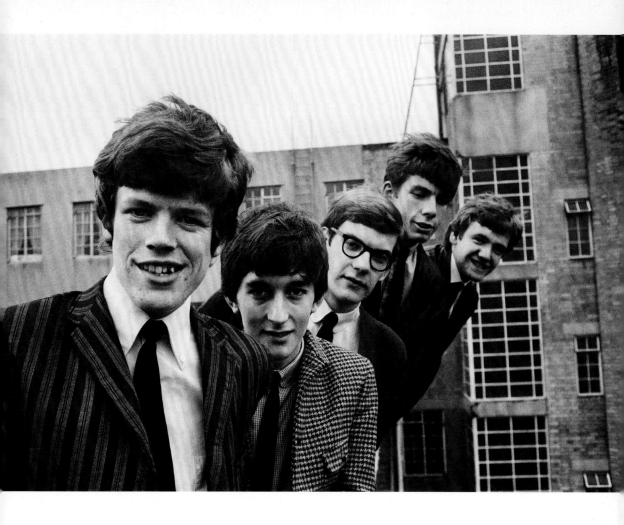

Opposite: Herman's Hermits celebrate after the group were signed to a huge film and disc deal with Metro Goldwyn Meyer, 15 March 1965.

Above: On the roof at Ivor Court in Gloucester Place, London, 24 August 1964. Left to right: Peter Noone, Keith Hopwood, Derek 'Lek' Leckenby, Barry Whitwam and Karl Green.

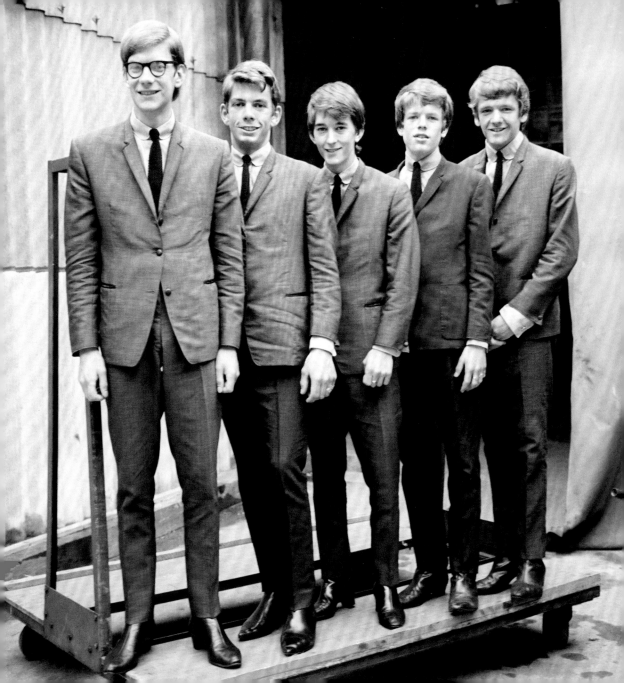

Left: Peter Noone, born on 5 November 1947, was only 16 years old when Herman's Hermits first topped the UK charts in August 1964. When the band broke in the US, many fans referred to him as Herman … a situation not helped when he played a character with that name in their first US film, *Hold On!*

Opposite: Herman's Hermits broke into the US charts in August 1964 with their UK Number 1 hit *I'm into Something Good.* The single stalled outside the Top 10 (#13) but the band later followed up with nine consecutive Top 10 hits over the next two years.

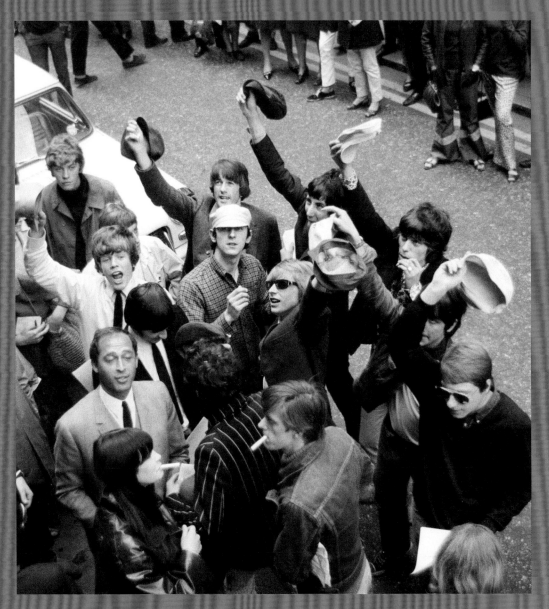

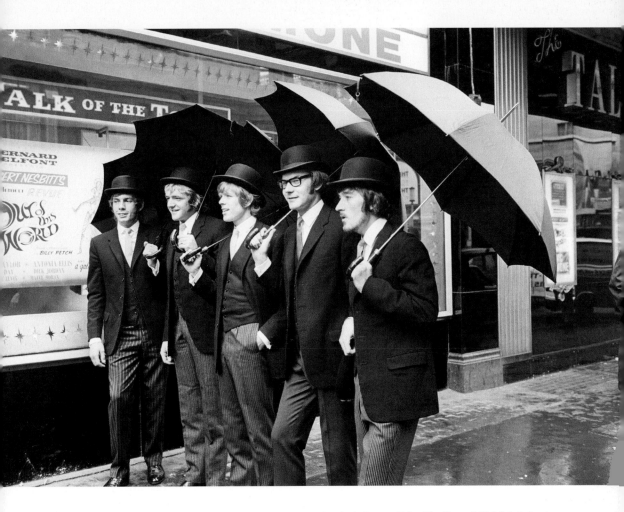

Above: Herman's Hermits were the first pop group to appear at London's famous Talk of the Town nightclub in Leicester Square. The band was enjoying an 'Indian summer' in their pop careers with *My Sentimental Friend* a Top 10 hit in the UK, Australia and New Zealand. Here the group are pictured outside dressed for rehearsals, 18 September 1969.

Opposite: Pop stars meet in Carnaby Street, London, to become founder members of an anti-bowler hat group to be known as 'the bowler hat brigade' on 1 September 1965. Peter Noone was there along with The Animals, The Kinks, The Rolling Stones, The Walker Brothers, The Merseybeats and The Who.

CHAPTER 4

The Animals

The Animals were a hard-and-fast rhythm and blues band, regarded as 'the blackest' of the white blues band that came out of England in the British blues' era in the early 1960s. The band was formed in Newcastle-upon-Tyne in 1959 by Alan Price (born 1942), a largely self-taught electric organist. Including Bryan 'Chas' Chandler (1938–1996) on bass, Hilton Valentine (born 1943) on guitar, drummer John Steel (born 1941) and Eric Burdon (born 1941) on vocals. They were originally called the Alan Price Rhythm & Blues Combo, but were christened The Animals because of their aggressively energetic stage performances and the fervent reaction of local fans.

After a residency at the Club A Go Go in Newcastle, the band moved to London in January 1964 and earned a recording contract with MGM. Produced by Mickie Most, their second single was a cover of Bob Dylan's 1962 *House of the Rising Sun*, but with 'toned down' lyrics. Interestingly, this version of the song, distinguished

by Price's pumping organ and Burdon's gravelly, emotional vocals, was credited to Alan Price for his arrangement of the traditional Negro folk song. The song became a global hit for the band in 1964, selling more than 4 million copies.

The Animas toured the UK with Chuck Berry in 1964, then travelled to the US, where they bristled when introduced there as a pop or rock 'n' roll group. They were 'R&B', through and through, and young pop audiences did not take too kindly to them and young pop audiences quickly found other British bands to idolise and promote into the charts.

Alan Price left the band in 1965 to form his own group (Price's fear of flying also contributed to his decision) and drummer John Steel followed the year after. The band suffered from not being able to write its own material, while internal friction robbed the band of the chance to develop, unlike their great rivals The Rolling Stones. Trapped in their R&B origins, they never fully embraced the 'pop' scene. Where the Stones pushed 'pop' to new boundaries,

Opposite left to right: Hilton Valentine, John Steel, Alan Price, Chas Chandler and Eric Burdon on tour in September 1964.

The Animals pushed each other too far.

Although the band had success with a series of singles including *I'm Crying* (UK#8), *Don't Let Me Be Misunderstood* (UK#3, US#15), *Bring It On Home To Me* (UK#7), *We Gotta Get Out Of This Place* (UK#2, US#13), *It's My Life* (UK#7) and *Don't Bring Me Down* (UK#6, US#12) ... none of the band's three albums charted in the US Top 100. In 1967 Burdon disbanded the group and recorded *See See Rider* (US#10) with a new line-up as Eric Burdon and The Animals. This band fared better in the US, where

UK	Song	US
UK#1	House of the Rising Sun	US#1
UK#8	I'm Crying	US#19
UK#3	Don't Let Me Be Misunderstood	US#15
UK#7	Bring It On Home to Me	US#32
UK#2	We Gotta Get out of This Place	US#13
UK#7	It's My Life	US#23
UK#6	Don't Bring Me Down	US#12
	See See Rider	US#10
UK#7	San Franciscan Nights	US#9

they were heavily influenced by the psychedelic movement, and scored a Top 10 hit with *San Franciscan Nights* in 1968, while *Monterey* and *Sky Pilot* also charted internationally.

Eric Burdon and The Animals disbanded at the end of 1968 after an aborted Japanese tour, with Burdon pursuing an acting career before fronting American funk band War in the early 1970s. The original Animals reformed in the late 1970s and 1980s, but their time as a 'pop' music force had come and passed.

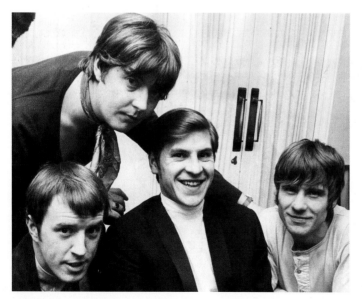

Left: The reformed original Animals in their dressing room at Newcastle City Hall, 22 December 1968, sans Eric Burdon. From left: John Steel, Chas Chandler, Alan Price and Hilton Valentine.

Opposite: The Animals celebrate their song *House of the Rising Sun* reaching #1 in the UK charts, 4 July 1964. From left: Alan Price (organ and keyboards), Chas Chandler (bass), Eric Burdon (vocals), Hilton Valentine (guitar) and John Steel (drums).

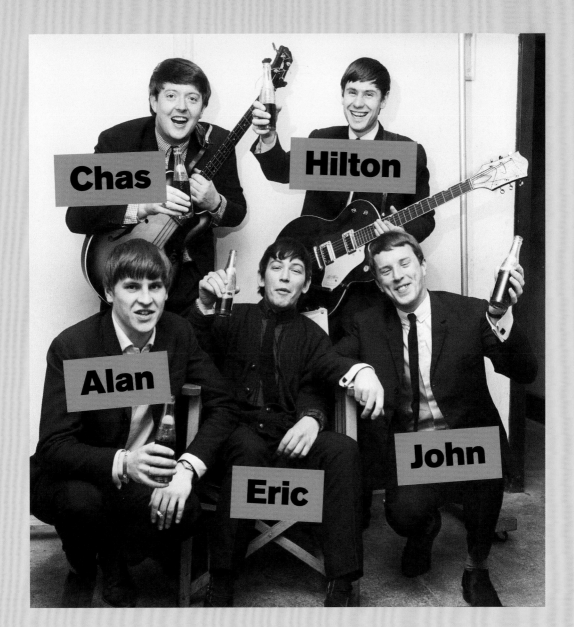

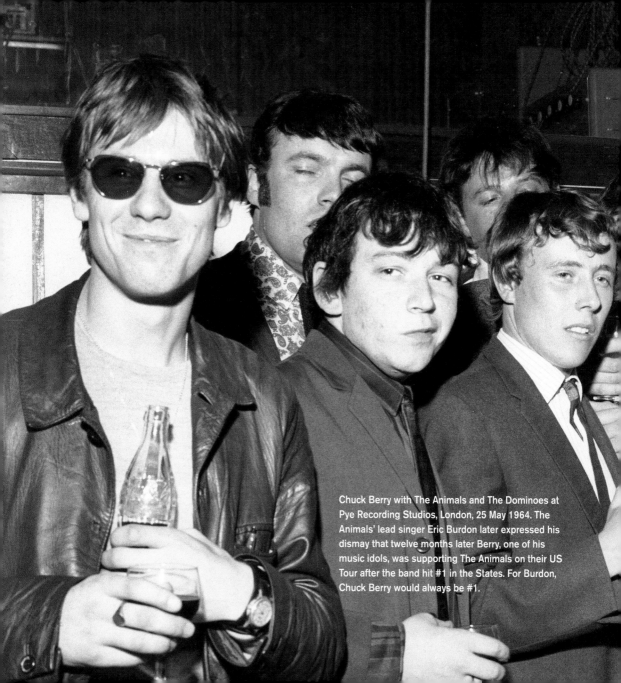

Chuck Berry with The Animals and The Dominoes at Pye Recording Studios, London, 25 May 1964. The Animals' lead singer Eric Burdon later expressed his dismay that twelve months later Berry, one of his music idols, was supporting The Animals on their US Tour after the band hit #1 in the States. For Burdon, Chuck Berry would always be #1.

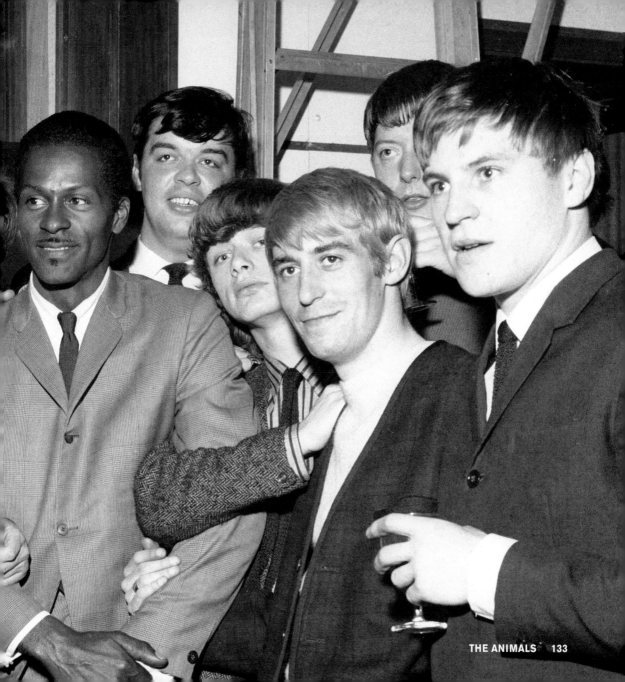

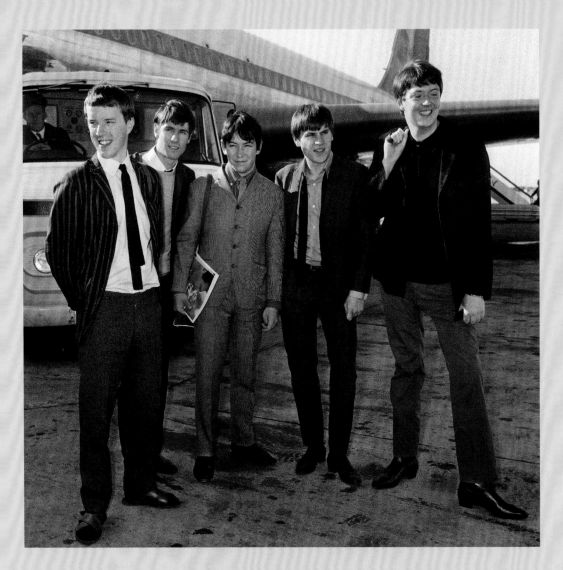

The Animals leave Heathrow Airport for their tour of Tel Aviv, 22 September 1964, on the back of their UK and US#1 *House of the Rising Sun.* Left to right: John Steel, Hilton Valentine, Eric Burdon, Alan Price and Chas Chandler.

Eric Burdon, at Newcastle City Hall, September 1970, toured with different band members (Barry Jenkins, Vic Briggs, John Weider, Danny McCulloch, Andy Summers and Zoot Money) as Eric Burdon and the Animals before fronting American funk band War (1969–70).

Opposite: Alan Price left The Animals to form the Alan Price Set in 1965. Price later formed a musical partnership with Georgie Fame, pursued a career as an actor, and wrote the music (and appeared in) Lindsay Anderson's cult movie *O Lucky Man!* (1973).

Above: The Animals reformed in the 1970s and 1980s. From left to right: Eric Burdon, Chas Chandler, John Steel, Hilton Valentine and Alan Price. Together they released two reunion albums, the aptly named *Before We Were So Rudely Interrupted* (1977) and *Ark* (1983).

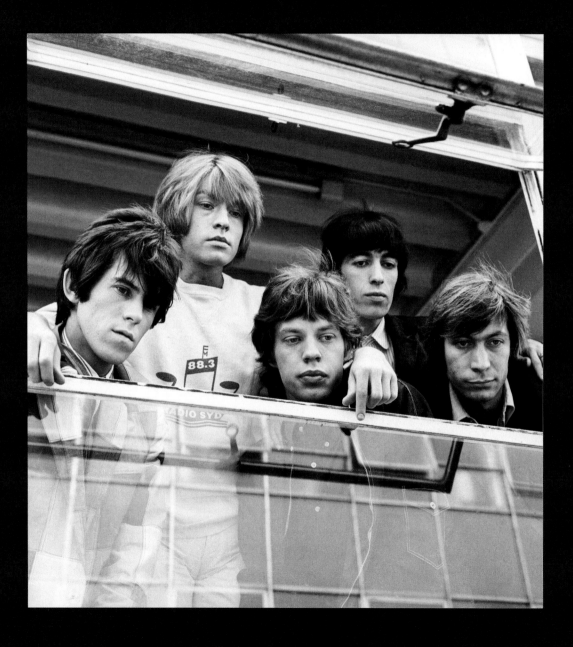

CHAPTER 5

The Rolling Stones

The Rolling Stones started out as a grinding, rhythm and blues band in Richmond, West London. Formed by two groups of friends – Brian Jones and Ian Stewart (who later became the band's road manager) and former school mates Mick Jagger and Keith Richards – they took their name from a song by American blues musician Muddy Waters. The Stones' first gig was at London's The Marquee Club in July 1962. Bassist Bill Wyman and drummer Charlie Watts came on board some six months later.

Teenager Andrew Loog Oldham (born 1944), who worked in The Beatles' manager Brian Epstein's office, was conscripted by the band to act as manager and secured them a recording deal with record label Decca. The Beatles had captured the teenybopper market so the Stones cast their net instead toward the rebellious element. Whereas The Beatles had been promoted as 'loveable mop tops', The Rolling Stones

were the complete opposite – the anti-establishment music group that parents feared.

The Stones had a minor UK hit with the Lennon-McCartney composition *I Wanna Be Your Man* (UK#12) in 1963 before scoring with a cover of Buddy Holly's *Not Fade Away* (UK#3). The Stones embraced rock 'n' roll and the 'pop' music medium and quickly became The Beatles' main rivals in America. As Jagger and Richards developed their songwriting, the band achieved six #1 hits in the UK and US over the next two years.

Non-conformist, scruffy and sullen, the Stones always elicited a strong reaction from their audience and the media. In the early 1960s, fans rioted at their concerts in Holland, Paris and Blackpool, UK, while the mainstream US media openly despised them. When they appeared on *The Ed Sullivan Show*, the band was forced to change their hit *Let's Spend the Night Together* to *Let's Spend Some Time Together*. On their 1965 US

Opposite: The Rolling Stones looking out a window at female fans after being in make up before going on Granada TV's *Scene* on 23 August 1965. The antithesis of The Beatles, the Stones were a rough, tough and ready rhythm-and-blues line-up. Left to right: Keith Richards, Brian Jones, Mick Jagger, Bill Wyman and Charlie Watts.

tour, 14 New York hotels refused to accommodate them.

The Stones' early records may have lacked the harmonies, musicianship and production of some of their contemporaries, but their songs, outside the pop music mainstream, were honest. Could Lennon and McCartney have written *(I Can't Get No) Satisfaction*? Which band would have dared record a song entitled *Sympathy for the Devil* other than the Stones? As Jagger postured and pranced on stage, the band was described as 'decadent' and 'debauched'. Their public personas finally caught up with them at the Altamont Speedway Free Festival in Southern California in December 1969 when a fight broke out and a fan was beaten to death by members of the Hells

UK		US
UK#3	Not Fade Away	US#48
UK#1	It's All Over Now	US#26
	Time Is on My Side	US#6
UK#1	Little Red Rooster	
UK#1	The Last Time	US#9
UK#1	(I Can't Get No) Satisfaction	US#1
UK#1	Get Off of My Cloud	US#1
	As Tears Go By	US#6
UK#2	19th Nervous Breakdown	US#2
UK#1	Paint It Black	US#1
	Mother's Little Helper	US#8
UK#5	Have You Seen Your Mother, Baby, Standing in the Shadow?	US#9
UK#3	Let's Spend the Night Together	US#55
UK#3	Ruby Tuesday	US#1
UK#1	Jumpin' Jack Flash	US#3
UK#1	Honky Tonk Women	US#1

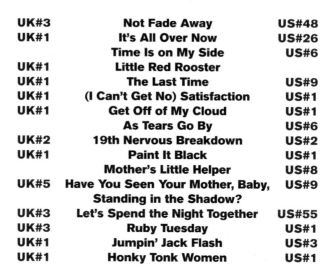

Angels who were employed as 'security'.

Prior to this event, in 1967, Mick Jagger and Keith Richards were given jail sentences for drug possession before being released after a public and judicial backlash on the severity of their sentences. The Stones appeared to be losing their way until the *Beggar's Banquet*

album, released in 1968, set the stage for the band's resurgence. The departure of an increasingly unreliable Brian Jones – several weeks before he was found dead in his swimming pool, age 27 – and the inclusion of young guitarist Mick Taylor (born 1949) set the band on a course for superstardom in the 1970s.

Left: Allen Klein (left) and Andrew Loog Oldham meet in London's Hilton Hotel to discuss Klein's involvement in the management of The Rolling Stones, 24 August 1965. Klein later bought out Loog Oldham and managed the group in his own right, beginning a troubled era for the band when he signed over the publishing rights of their entire 1960s catalogue to his own ABKCO Music & Records. Opposite: The Rolling Stones backstage in Manchester where they were recording *Top of The Pops* on 29 January 1964.

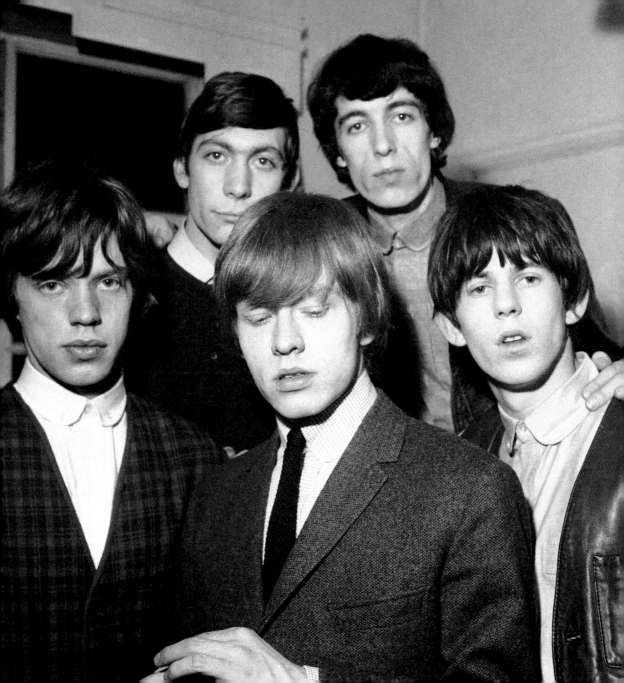

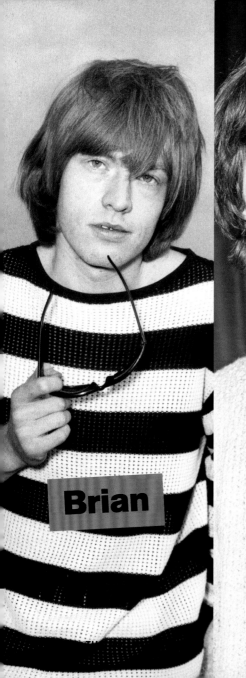

Brian

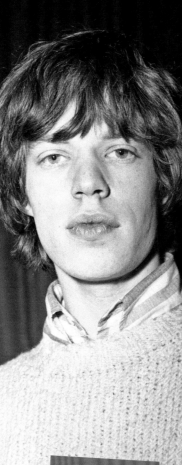

Mick

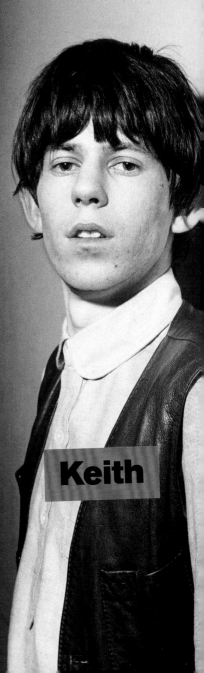

Keith

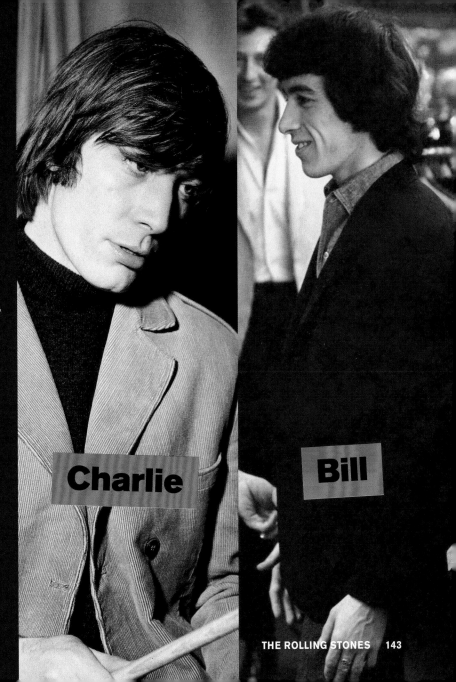

Brian Jones (1942–1969), co-founder of The Rolling Stones, was musically talented but rebellious. Expelled from school as a teenager and fathering children from a number of casual relationships, he moved to London in the early 1960s and formed a rhythm-and-blues band.

Mick Jagger (born 1943), articulate, intelligent, outspoken ... the ultimate frontman.

Keith Richards (born 1943), a school-friend of Mick Jagger whose interest in music was fostered by his jazz-loving grandfather. Richards and Jagger were performing in a R&B band when they joined Brian Jones' group in 1962.

Charlie Watts (born 1941) was a veteran of jazz and blues bands in the late 1950s and early 1960s and was the last to join the Stones in January 1963.

Bill Wyman (born 1936). Some years older than the rest of the Stones, his age was kept a secret for many years.

Charlie

Bill

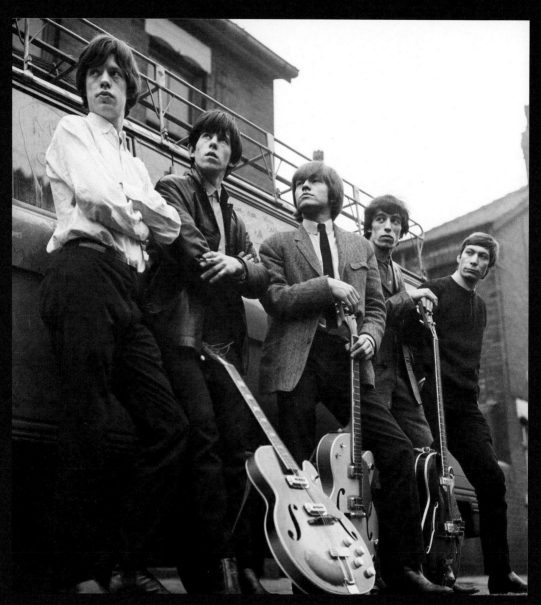

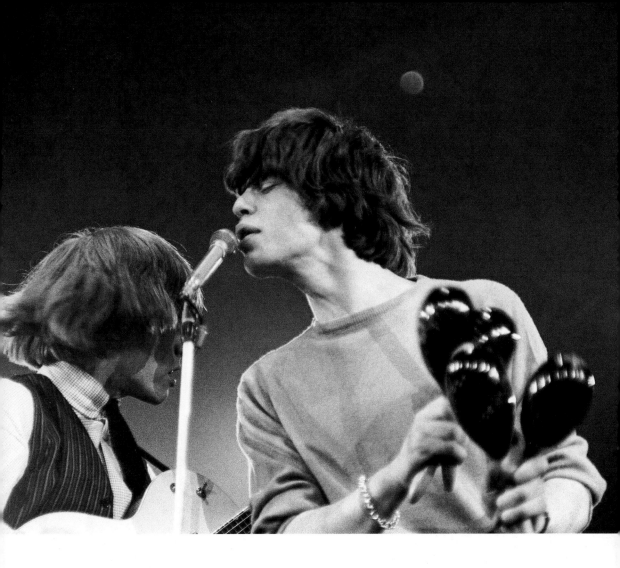

Opposite: The Rolling Stones in 1964. Mick Jagger, Keith Richards and Charlie Watts could not have dreamt that more than fifty years later, the band would be still touring.

Above: Mick Jagger and Brian Jones perform at the New Musical Express Poll Winners 'All Star' Concert at Wembley, London, 26 April 1964. Jagger is playing that most underrated of rock and roll instruments … the maracas!

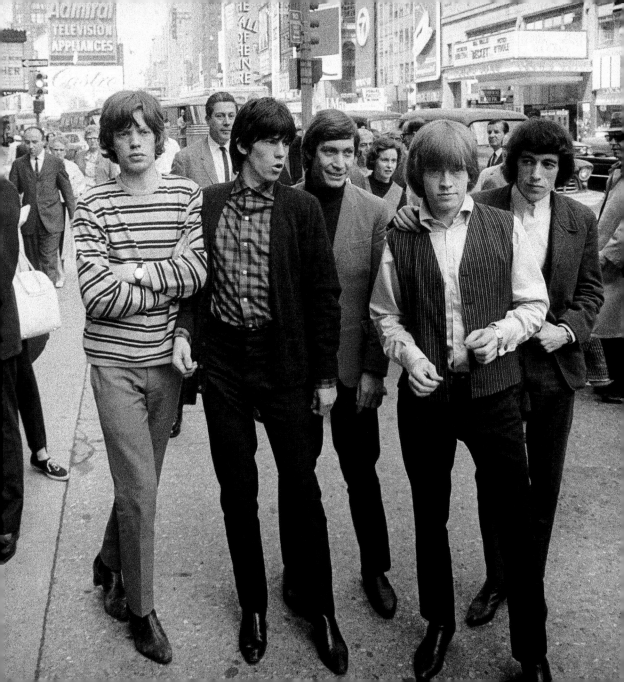

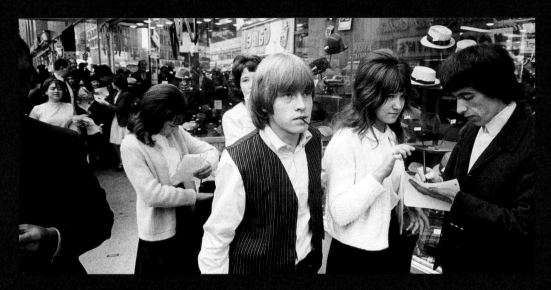

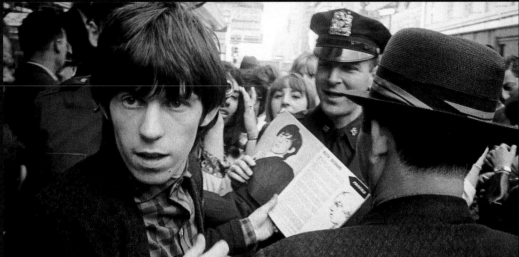

Opposite: The Rolling Stones on Broadway, New York, 2 June 1964. From left: Mick, Keith, Charlie, Brian and Bill.

Above: Brian Jones and Bill Wyman (top) and Keith Richards (below) signing autographs in New York, 1964.

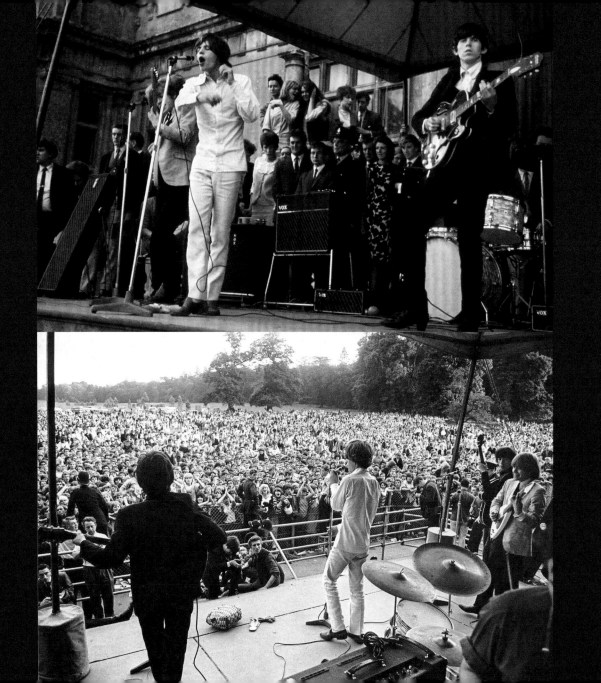

Above: The Rolling Stones at The Tower Ballroom, New Brighton, Wallasey, 10 August 1964. Note the scarcity of on-stage equipment (especially lighting), the antiquated venue and the bouncers at the front of the stage dressed in tuxedos. Opposite: On stage at Longleat House, Wiltshire, 2 August 1964.

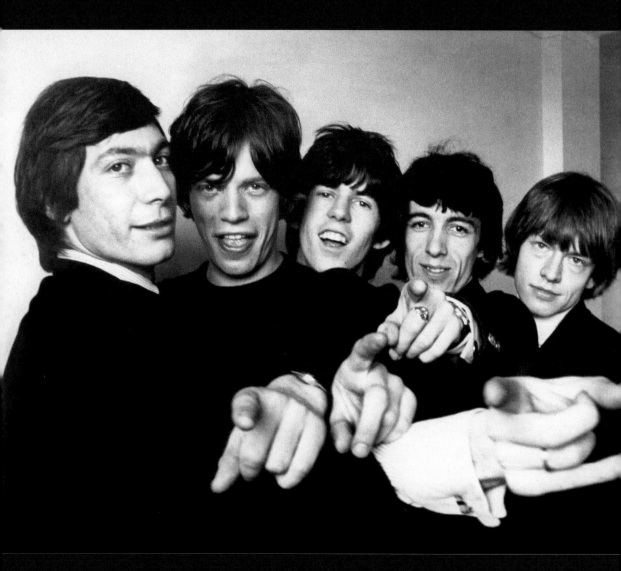

The Rolling Stones, April 1964. Charlie Watts, Mick Jagger, Keith Richards, Bill Wyman and Brian Jones.

Opposite: The Rolling Stones leave for a month-long tour of North America, 23 June 1966.

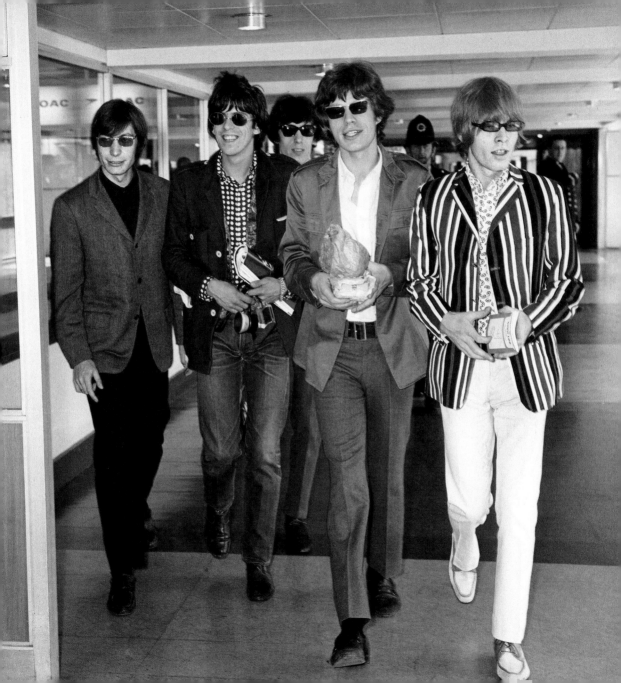

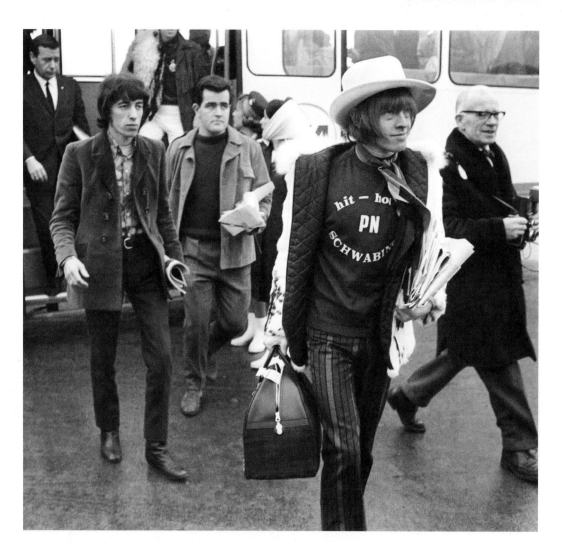

Above: The Rolling Stones depart for North America where they appeared on *The Ed Sullivan Show*, January 1967. In the centre of the picture, between Bill Wyman and Brian Jones is the 'sixth Stone' Ian Stewart, the band's part-time pianist, road manager and confidante.

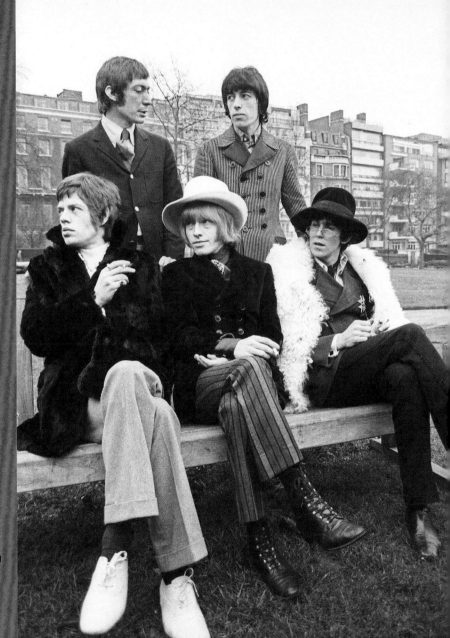

Right: The Rolling Stones in
Green Park, London, wearing
the fashions of the day,
11 January 1967.

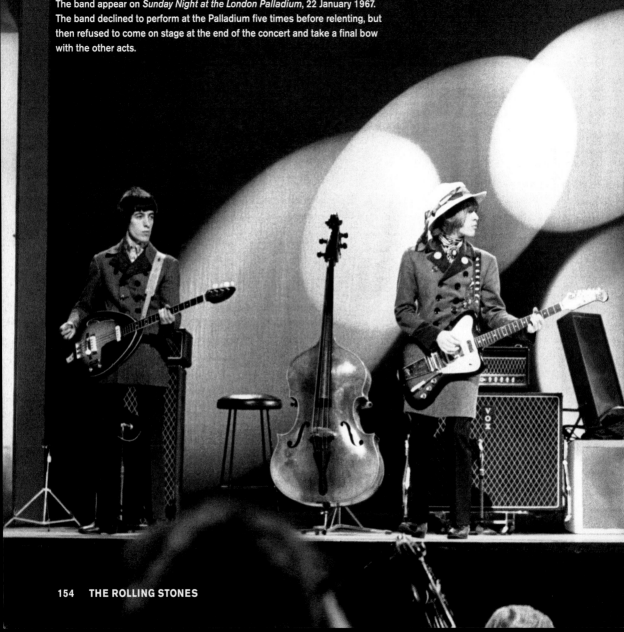

The band appear on *Sunday Night at the London Palladium*, 22 January 1967. The band declined to perform at the Palladium five times before relenting, but then refused to come on stage at the end of the concert and take a final bow with the other acts.

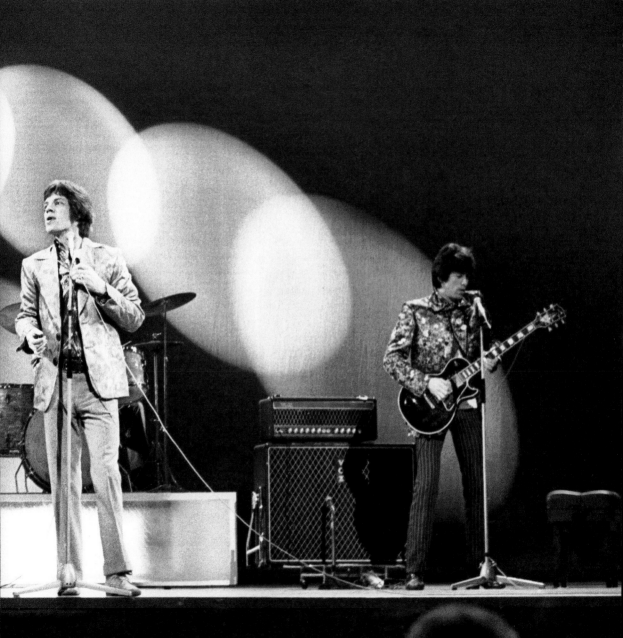

Left: Mick Jagger on his way from Chichester Magistrates Court to Lewes prison after being found guilty of drugs charges, 28 June 1967.

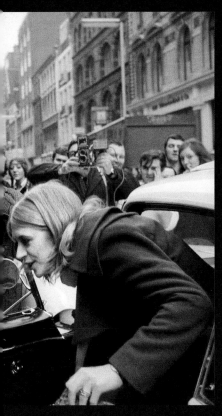

Above: Mick Jagger and Marianne
Faithfull at Marlborough Street
Magistrates Court, London, after being
charged with possessing cannabis
resin, 26 January 1970. Jagger was
found guilty and fined £200. Faithfull
was acquitted.

Right: Keith Richards and Mick Jagger,
2 July 1967, having been released on
bail a couple of days previously.

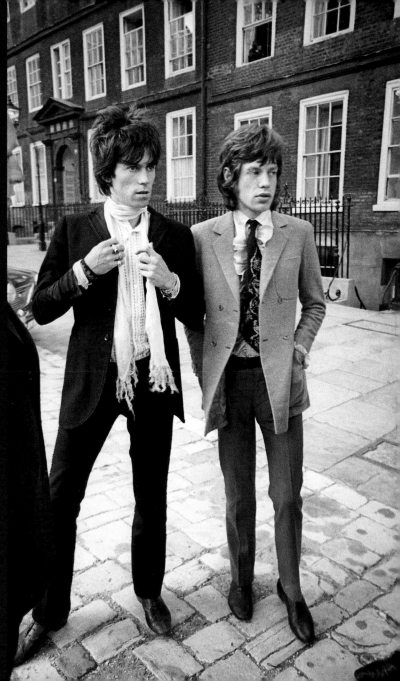

Left: Brian Jones with girlfriend Anita Pallenberg at Los Angeles airport in December 1965. Anita had joined up with The Rolling Stones, who were on tour in North America. Pallenberg later formed a relationship with Keith Richards.

Below: Charlie Watts, wife Shirley and their three year-old daughter Serafina leave Heathrow for their home in Nice, 1972. This was during the band's period of living as tax exiles in France.

Right: Folk singer Joan Baez meets Mick Jagger in Glasgow on 6 October 1965, when the Stones were playing two shows there.

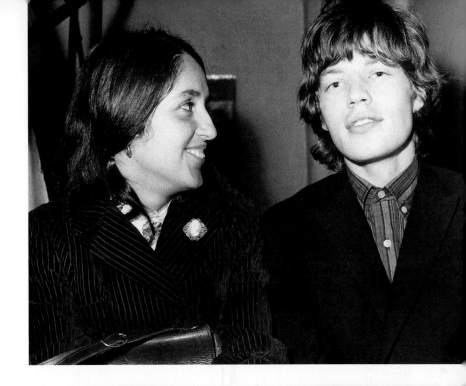

Right: Four years later: Keith Richards is pictured at Heathrow Airport with Anita Pallenberg and their baby son Marlon. Richards returning to London after the group's disastrous free concert in Southern California on 6 December 1969.

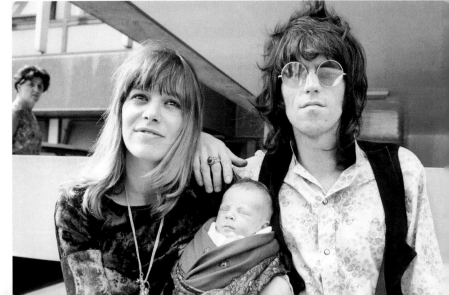

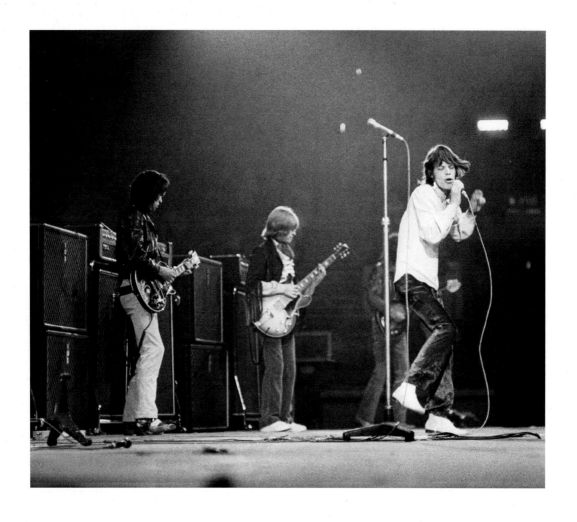

Above: The Rolling Stones perform at the NME Poll Winners Concert, on 12 May 1968.

Opposite: Backstage at the NME Poll Winners Concert. One can only wonder what drummer Charlie Watts (front) is doing with that guitar.

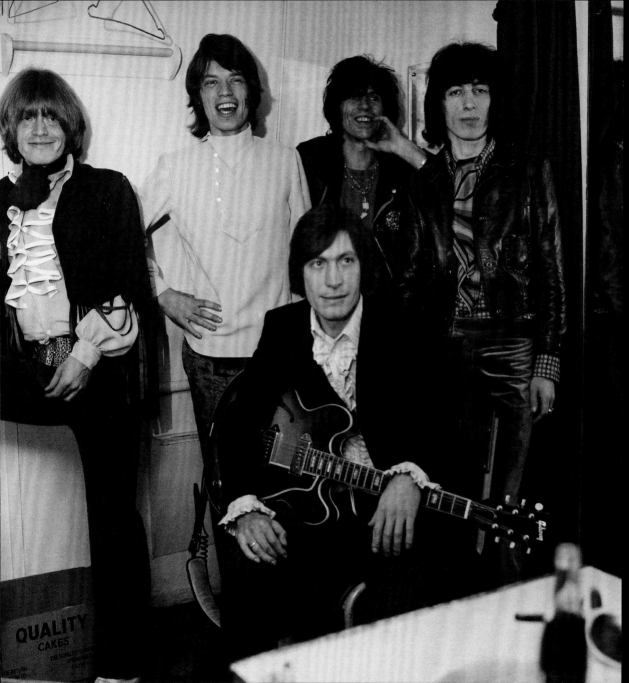

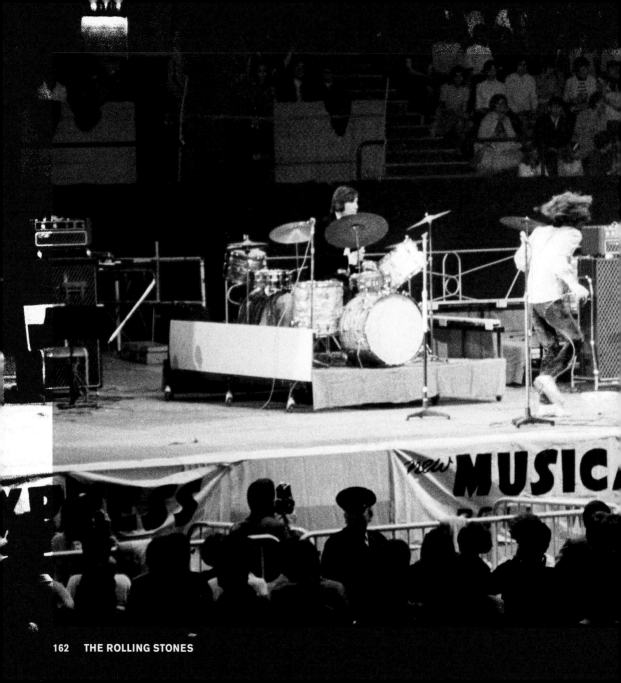

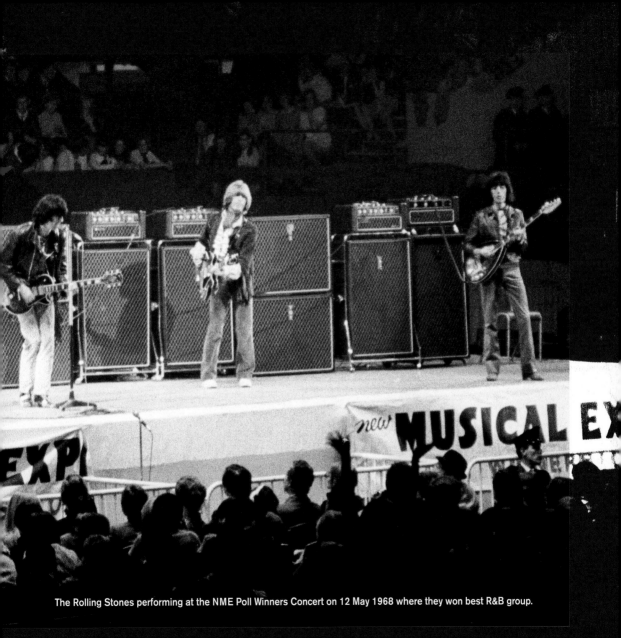

The Rolling Stones performing at the NME Poll Winners Concert on 12 May 1968 where they won best R&B group.

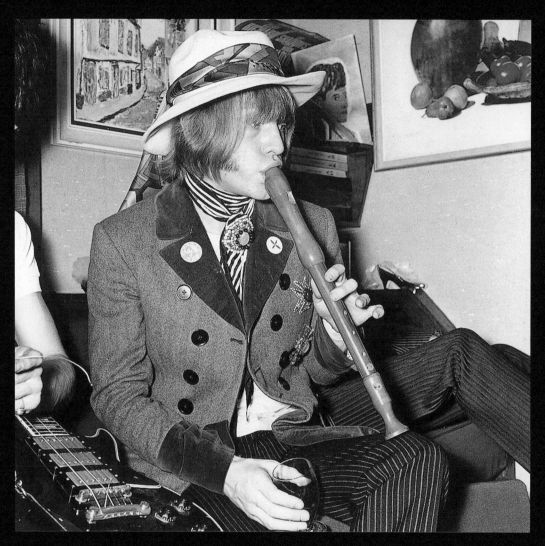

Brian Jones ready to record a backing for the track *We Love You*, 19 May 1967. Jones' penchant for playing unusual instruments (Jones played saxophone on The Beatles' *You Know My Name*) eventuality alienated the rest of the group, who preferred the rawness of electric guitars.

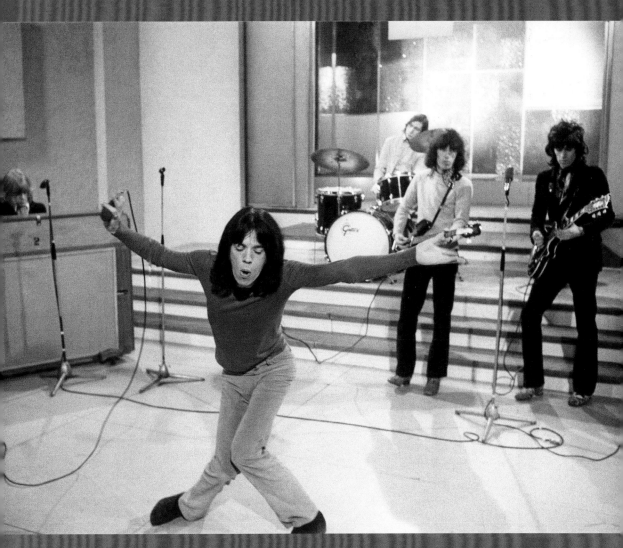

The Rolling Stones during rehearsals at the Wembley Park Studios for the band's appearance on David Frost's programme *Frost on Saturday*, 29 November 1968. Jagger's hair is dyed for his role in the Nicolas Roeg film *Performance*.

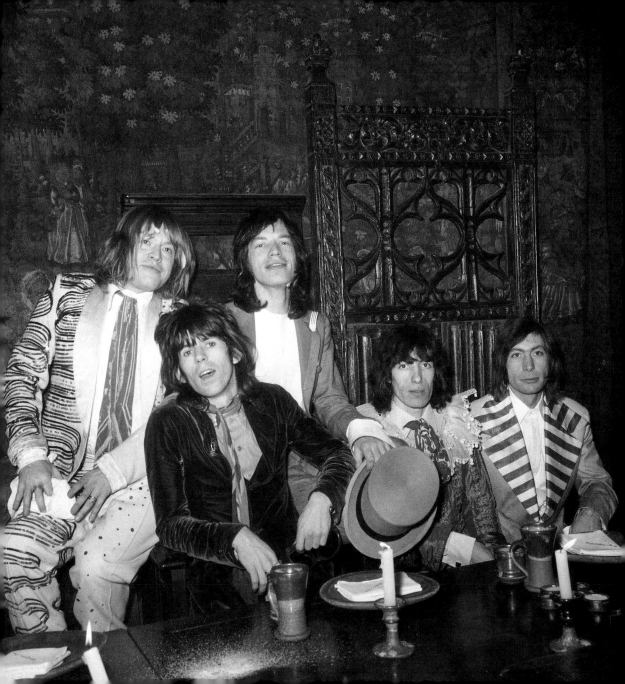

The Rolling Stones launch their *Beggars Banquet* album at the Elizabethan room at The Gore Hotel, London, on 5 December 1968 ... with predictable results.

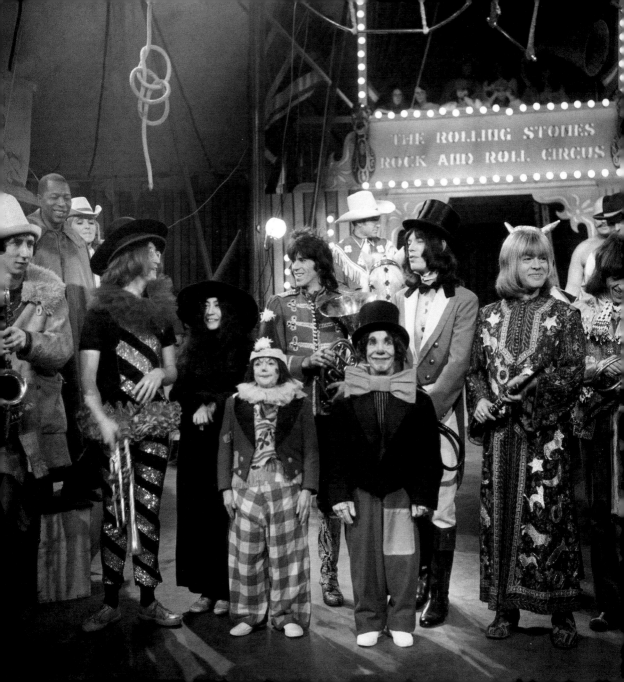

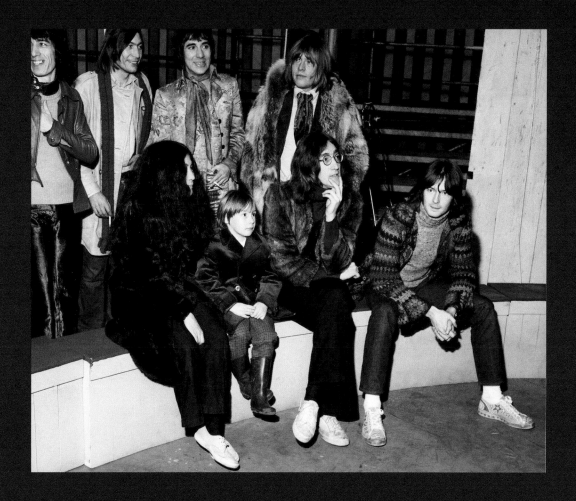

Above: Backstage at the *Rock and Roll Circus* event. At the back are Bill Wyman, Charlie Watts, Keith Moon of The Who, and Brian Jones. In front are Yoko Ono, Julian Lennon, John Lennon and Eric Clapton.

Opposite: *The Rolling Stones Rock and Roll Circus* television special was filmed on 11 December 1968. The Stones, however, were unhappy with their performance and did not release the film until 1996. From left: Pete Townshend of The Who, John Lennon and Yoko Ono, Keith Richards, Mick Jagger, Brian Jones and Bill Wyman among a cast of characters.

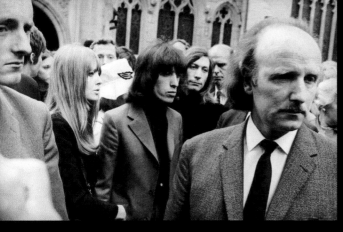

Left: Mourners at Brian Jones' funeral in Cheltenham, 10 July 1969. Frank Thorogood, Brian Jones' builder, who found his body in the pool, is in the extreme right foreground, with Bill Wyman (centre), and Charlie Watts on his left.

Left middle: The coffin of Brian Jones is carried inside Cheltenham Parish church during his funeral service.

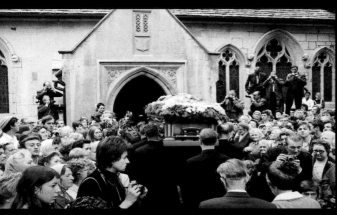

Above: Brian Jones, pictured shortly before he was found drowned in his swimming pool at his Cotchford Farm home on 3 July 1969. Left: Brian Jones' grave … the tragic end of a troubled talent.

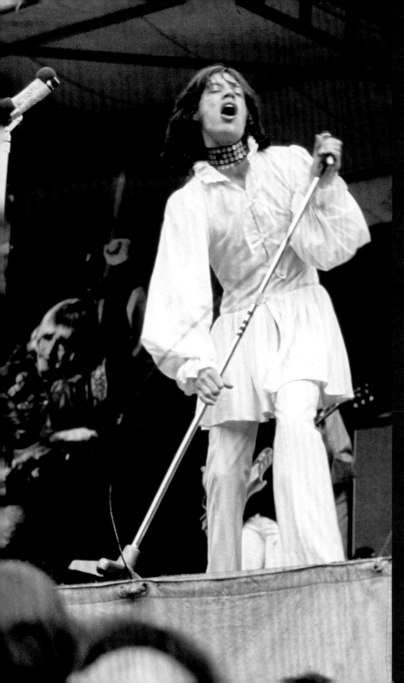

Left: Mick Jagger in concert at Hyde Park, with the image of Brian Jones behind him.

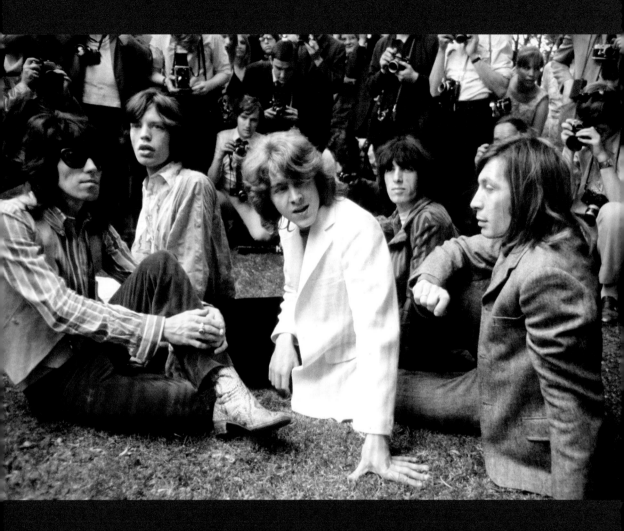

Above: The Stones introducing Mick Taylor (centre), who took Brian Jones' place in the band, to the press in Hyde Park, 13 June 1969. The band announced they would hold a free concert in Hyde Park the following month, which turned into a requiem for Jones.
Opposite: Mick Jagger and Keith Richards on stage at Hyde Park.

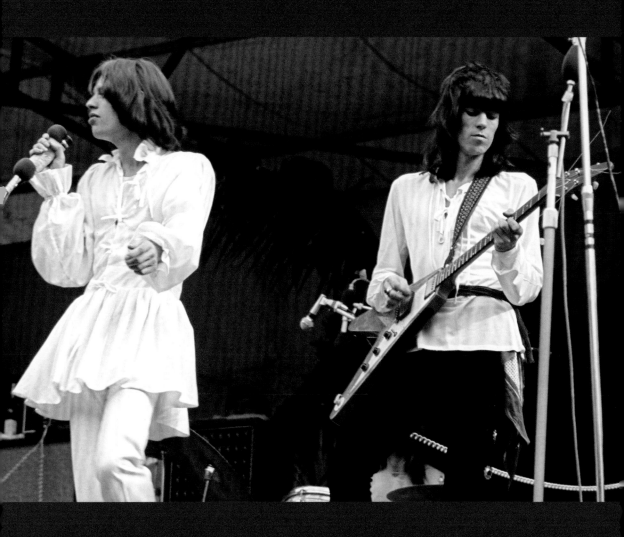

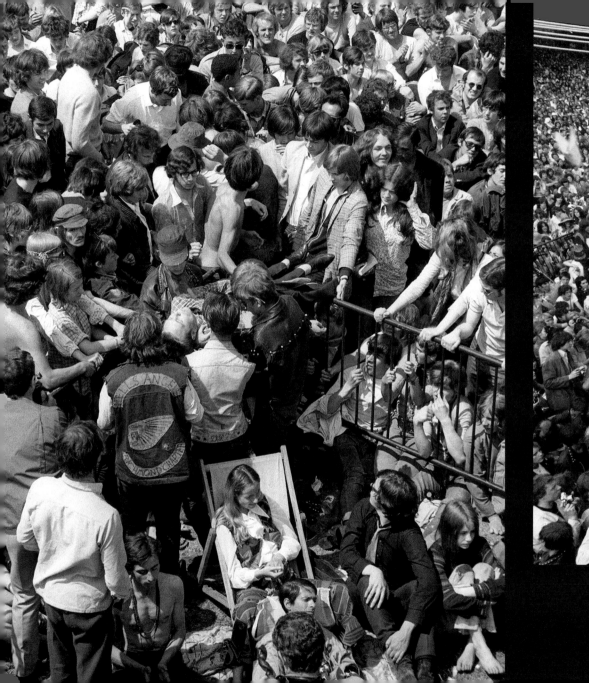

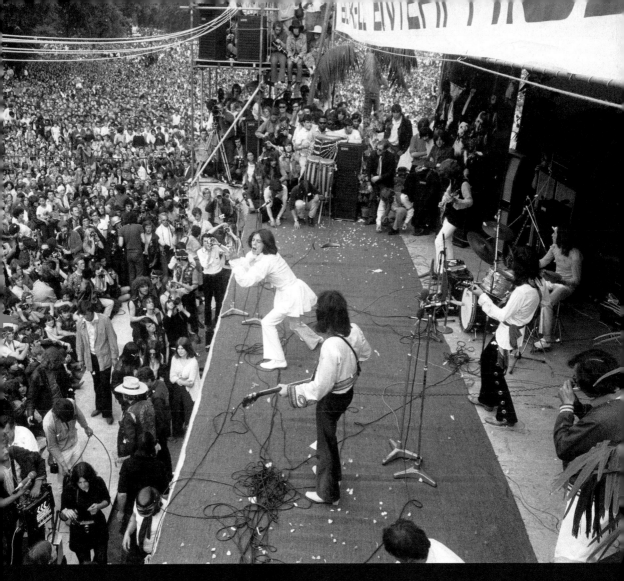

Above: The Rolling Stones' free concert in Hyde Park, 5 July 1969.

Opposite: Members of the Hells Angels help pass a collapsed fan forward to the first aid attendants during the Stones' concert in Hyde Park. They would not be so helpful at Altamont in December that year.

Above: The Rolling Stones at The Alamo, San Antonio, Texas, 1975, with newest member of the band, former Jeff Beck Group's bassist and Faces' guitarist Ronnie Wood (born 1947, second from right).

Right: Bill Wyman, July 1969. The unassuming bassist enjoyed solo success in the 1970s with the album *Monkey Grip* and in the 1980s with the hit *(Si, Si) Je Suis un Rock Star*. Wyman stayed with the band until January 1993, when he announced his retirement at age 56. The Stones chose not to replace Wyman, but have used the services of bass player Darryl Jones for the past 20 years.

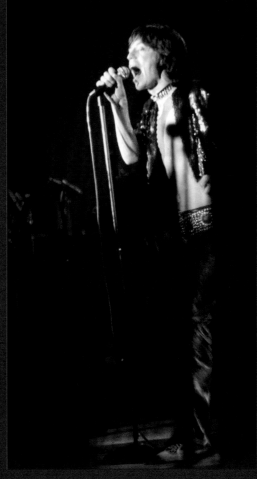

Above: Keith Richards during his drug trial in 1967. Richards, who battled drug busts, relationship changes and a distancing in his relationship with Jagger over the ensuing decades now holds a revered position as rock's elder statesman.

Above: Mick Jagger, performing on stage at Leeds University, 13 March 1971. More than forty-five years later, Jagger is still treading the boards … trim, athletic and past 70!

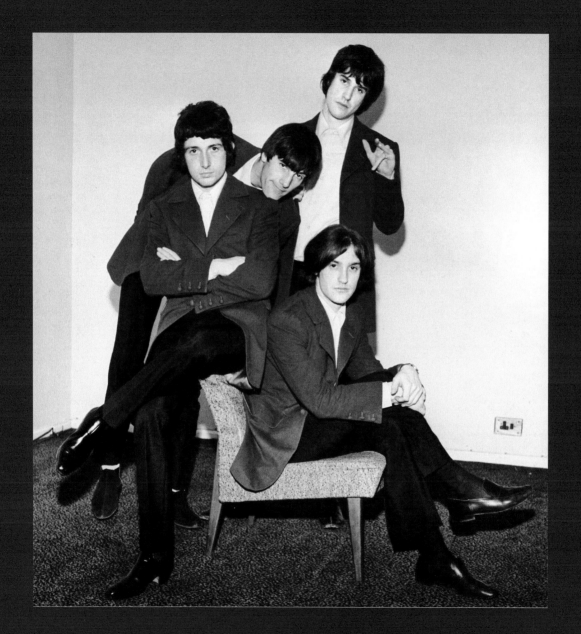

CHAPTER 6

The Kinks

The Kinks (under various names) were formed in Muswell Hill, London, in 1961 by art student Ray Davies (born 1944), his brother Dave (born 1947), bassist Peter Quaife (1943–2010) and Mick Avory (born 1944) on drums. Originally a rhythm and blues band, the band was distinguished by their 'kinky' clothes – dark pink hunting jackets, Regency frills and lace with black stockings – from which they took their name. Never a band to take themselves too seriously, musically The Kinks were a ragged bunch, uneven at times, but they were certainly original.

The Ray Davies-penned *You Really Got Me* was years ahead of its time. Dave Davies distorted his guitar sound by slashing his amp with a razor, providing inspiration for hundreds of rock guitarists. The song was a UK#1, and #7 in the US, built

around two chords and a thumping beat that gradually built in excitement. The sheer power of the song appeared ready to fall apart at any moment ... just like the band. The brothers Davies

maintained an uneasy truce in their formative years, and later during a concert in Cardiff in 1965, Dave Davies and Mick Avory came to blows, and the long-term viability of the band was brought into question by

competing management companies who oversaw the band's fortunes.

You Really Got Me was the first of a dozen Top 10 hits for the band, with *All Day and All of the Night* (UK#2, US#6) and *Tired of Waiting for You* (UK#1, US#6) setting the trend. The Kinks struggled with their own self-destructive impulses as they toured Australia, New Zealand and the US in 1965. The band was blacklisted for four years in the US, however, for not paying music union fees. (Ray Davies famously punched a union official backstage before their television appearance on a Dick Clark special for NBC). They did not tour America again until 1969 after being banned by the American Federation of Musicians for 'unprofessional conduct'.

Lead singer Ray Davies was

The Kinks scored a UK#1 with *You Really Got Me* in September 1964, launching them into the US where it was a Top 10 hit. Peter Quaife, Mick Avory, Dave Davies and Ray Davies.

UK		US
UK#1	You Really Got Me	US#7
UK#2	All Day and All of the Night	US#7
UK#1	Tired of Waiting for You	US#6
UK#9	Set Me Free	US#23
UK#8	Till the End of the Day	US#50
UK#4	Dedicated Follower of Fashion	US#36
UK#1	Sunny Afternoon	US#14
UK#2	Waterloo Sunset	
UK#3	Death of a Clown	
UK#3	Autumn Almanac	
UK#2	Lola	US#9

The Kinks appeared out of step with the psychedelic 1960s and the hits dried up in 1968–69. But then the band's albums were never fully promoted by their record company ... *The Kinks Are The Village Green Preservation Society* harked back to a gentler time in England as society became increasingly bureaucratic and mechanised. *Arthur (Or The Decline and Fall of the British Empire)* was Davies' attempt at a concept album – a year before The Who's *Tommy* – but neither album charted highly.

The Kinks bounced back in 1970 with arguably their greatest success. *Lola* was a song about a one-night stand with a transvestite.

Peter Quaife was replaced by John Dalton on bass, and organist John Gosling was added to the band as they belatedly set out to conquer North America for a second time in the 1970s.

Left: The Kinks on tour in Northern England, 1964. This was the reality of rock 'n' roll for many bands at the time ... a quick meal on a camp stove on the way to another gig. Note the graffiti on the touring van.
Opposite: The original Kinks line-up, from left: Peter Quaife, Mick Avory, Dave Davies and Ray Davies.

the key to The Kinks' success. Socially perceptive, and humorously poetic, Davies wrote hauntingly melancholy, almost whimsical songs such as *Sunny Afternoon* (UK#1 in 1966) and *Waterloo Sunset* (UK#2 in 1967). 1965's *Dedicated Follower of Fashion* (UK#5) was a sharp satire on what was happening in London in the mid 1960s. No other band tackled such sacred cows with such humour, but the Americans just didn't get it.

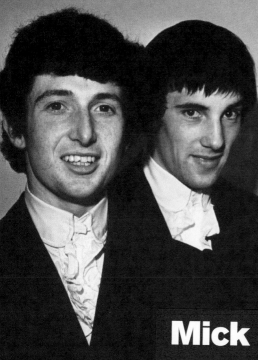

Peter

Mick

Dave

Ray

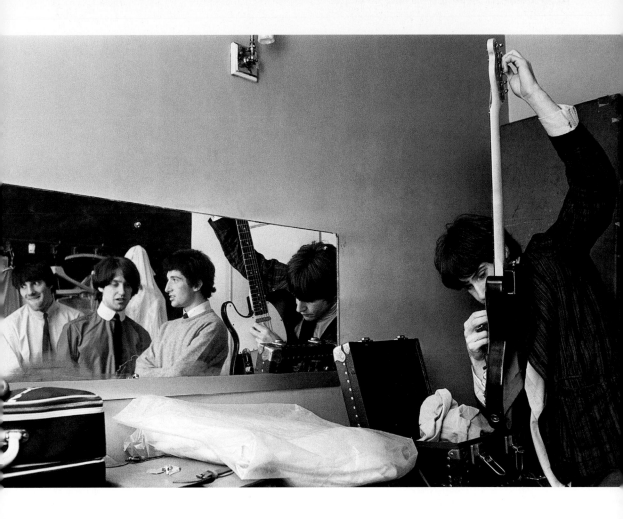

Opposite top: Ray Davies, Mick Avory and Dave Davies in their dressing room before a concert at The Neeld Hall, Chippenham, 7 September 1964.

Opposite bottom: Ray Davies and Dave Davies rehearse in their dressing room before their concert in Wiltshire. Ray was aged 20 then; Dave, just 17, 18 September 1964.

Above: Ray Davies, lead singer and chief songwriter of The Kinks, tunes up in the band's dressing room while other members (from left) Mick Avory, Dave Davies and Pete Quaife look on.

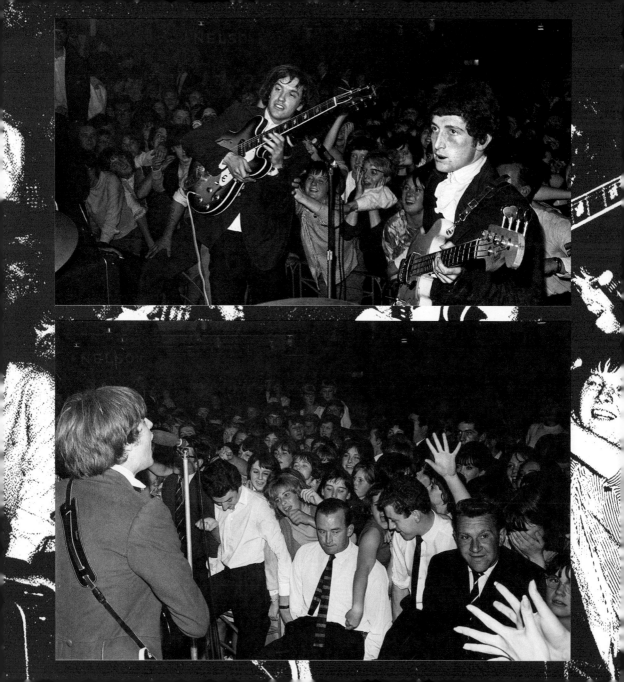

Opposite top: Dave Davies (lead guitar) and Pete Quaife (bass) on stage.

Opposite bottom: Ray Davies on stage. In front of him bouncers attempt to hold back the young female audience.

Above: Ray Davies on stage, as adoring female fans reach out, The Neeld Hall, Chippenham, September 1964.

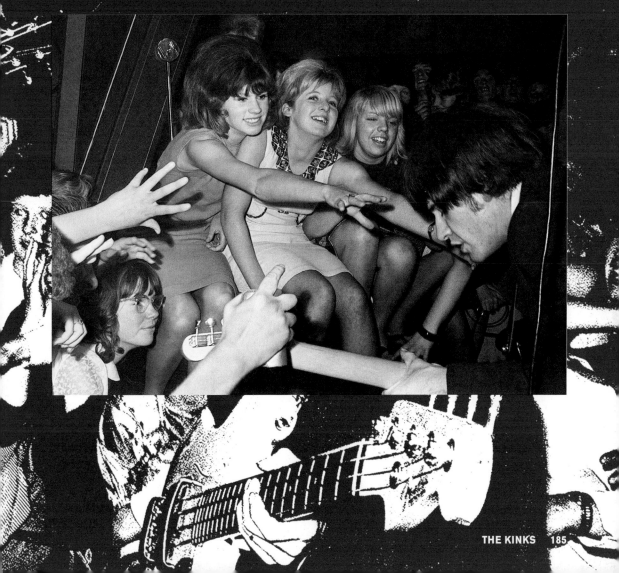

Opposite: The Kinks relax in their
dressing room after their concert at
Chippenham. The band's tour of North

America that year did not go smoothly,
and The Kinks were unofficially
banned from touring there until 1969.

Above: The Kinks enjoy a pint of beer
with a pub landlord, September 1964.

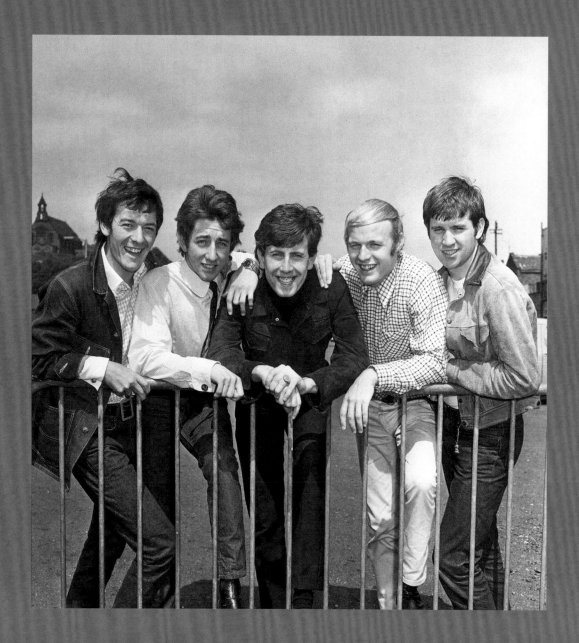

CHAPTER 7

The Hollies

The Hollies burst out of Manchester in the early 1960s after Salford school friends Alan Clarke (born 1942) and Graham Nash (born 1942) had started a skiffle band and performed Everly Brothers' songs at local clubs and church halls. The pair, who had perfected their harmonies over many years, later teamed up with local band The Fourtones for live performances. They changed their name to The Hollies in September 1962, not so much in honour of their early idol Buddy Holly as for the popular Christmas garland. The following January, the band was discovered performing at The Cavern by Parlophone producer Ron Richards, who had already worked with The Beatles.

Several of the original Fourtones members bowed out of the group at this point and were replaced by Bobby Elliott (born 1941) on drums, and teenager Tony Hicks (born 1945) on lead guitar. Hicks not only brought a harder edge to the band, but his ability to harmonise with

Clarke and Nash took the band to another level vocally. Eric Haydock (born 1942) was the band's original bass player from 1962–66, but was later replaced by Bernie Calvert (born 1942).

The Hollies' line up had been together for only a month when they were invited to London to record a demo in 1963. The Hollies released three singles before they achieved a UK Top 10 hit with a cover of Maurice Williams' *Stay*. Another cover, Doris Troy's *Just One Look*, went to #2 in the spring of 1964 and started a run of 12 Top 10 hits for the band over the next three years. *I'm Alive* fared best at home (a UK#1 in 1965), and although the band flexed its songwriting prowess (*It's a Carousel* and *Carrie Anne*), it was the Graham Gouldman-penned *Bus Stop* that helped the band break into the US in 1966.

The decision to release Nash's wonderfully original *King Midas in Reverse* as a single in 1967 broke The Hollies' string of hits and saw the band return to safer musical territory. When the band recorded

Opposite: In June 1965: from left, Allan Clarke, Tony Hicks, Graham Nash, Bobby Elliott and Eric Haydock.

Jennifer Eccles in 1968 and planned to record a whole album of Bob Dylan songs, Nash quit the group and moved to the US to work with David Crosby (ex-The Byrds) and Stephen Stills (ex-Buffalo Springfield). The Hollies replaced Nash with former The Escorts' guitarist Terry Sylvester (born 1947), and though the band may have lost some of its vocal magic, the hits kept coming with Alan Clarke's peerless vocals to the fore.

The Hollies closed out the sixties with *Sorry Suzanne* (UK#3) and the classic *He Ain't Heavy, He's My Brother* (UK#2 and US#7). Just when it appeared the band's international success had peaked, *Long Cool Woman in a Black Dress*, co-written by Clarke, was a

US#2 in 1972. Clarke briefly left the band because of voice problems (his place taken by Swedish singer Mikael Rickfors) but he returned for The Hollies' last chart hurrah, 1974's *The Air that I Breathe* (UK#2 and US#6). Although Clarke retired in 1999, the band continues to tour with original members Tony Hicks and Bobby Elliott.

UK#8	Stay	
UK#2	Just One Look	US#98
UK#4	Here I Go Again	US#107
UK#7	We're Through	
UK#9	Yes I Will	
UK#1	I'm Alive	US#103
UK#4	Look Through Any Window	US#32
UK#2	I Can't Let Go	US#42
UK#5	Bus Stop	US#5
UK#2	Stop Stop Stop	US#7
UK#4	On a Carousel	US#11
UK#3	Carrie Anne	US#9
UK#7	Jennifer Eccles	US#40
UK#3	Sorry Suzanne	US#56
UK#3	He Ain't Heavy, He's My Brother	US#7

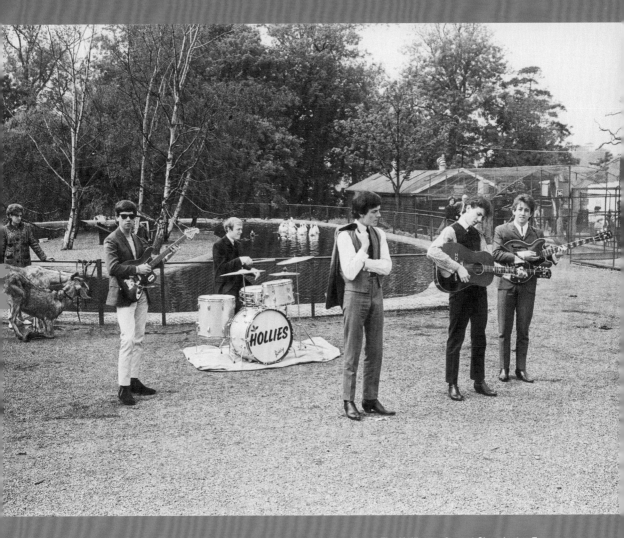

Opposite: The Hollies at the wedding of lead singer Allan Clarke to Jennifer Bowstead, 24 March 1964. The distinctive voice of The Hollies, Clarke declined the 'rock and roll lifestyle' to marry his sweetheart at the relatively young age of 22.

Above: The Hollies perform at Chessington Zoo, 26 May 1964. In the early 1960s, bands would do anything, perform anywhere, and pose for any photograph for a chance to promote their records.

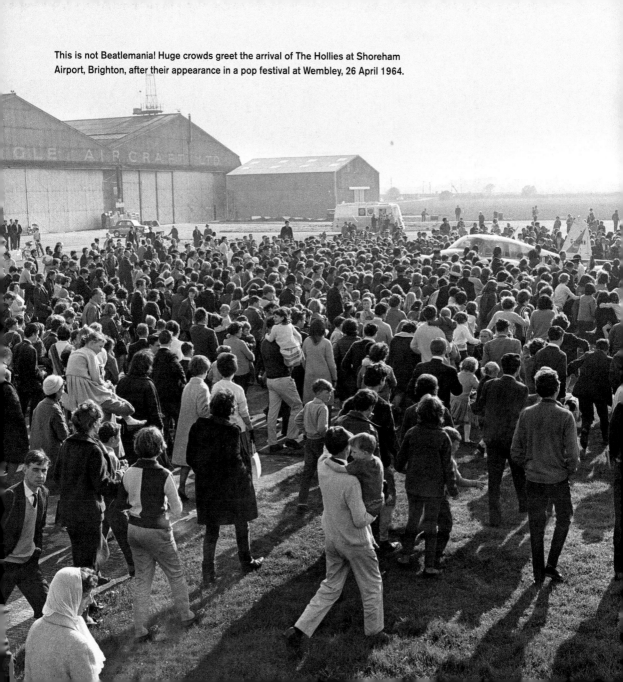

This is not Beatlemania! Huge crowds greet the arrival of The Hollies at Shoreham Airport, Brighton, after their appearance in a pop festival at Wembley, 26 April 1964.

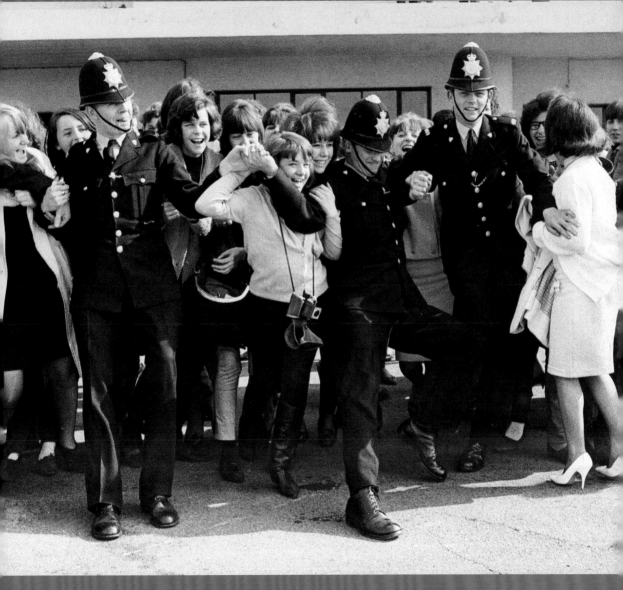

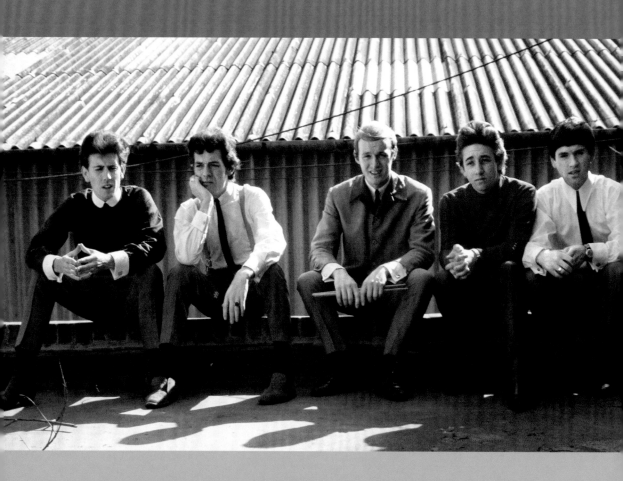

Above: The Hollies pictured with stand-in drummer Tony Mansfield during rehearsals for the television show *Doddy's Music Box* at the ABC studios, 9 March 1967. Drummer Bobby Elliott was ill for most of that year and Mansfield, formerly of The Dakotas, deputised for concerts, tours and TV appearances.

Opposite, left to right: Graham Nash, Allan Clarke, Bobby Elliott, Tony Hicks and Eric Haydock, pose at the Alpha Studios in Birmingham before recording the television show *Thank Your Lucky Stars*, 17 May 1964.

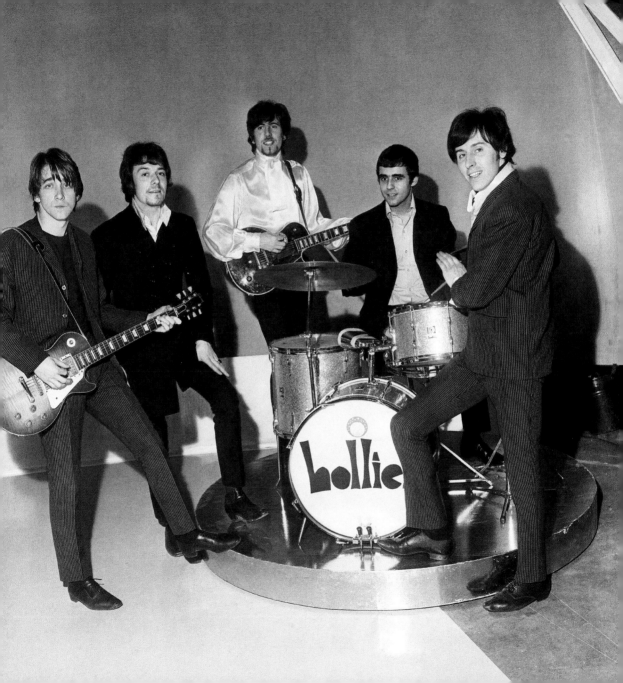

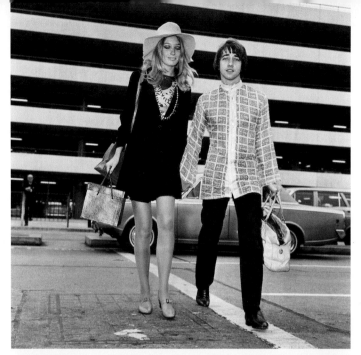

Left: Tony Hicks and his model girlfriend Jane Lumb at Heathrow Airport as she heads off to New York, 16 September 1967. Hicks famously turned his back on an apprenticeship as an electrician to join The Hollies, but only after the band guaranteed him his apprentice wage of £17 a week.

Left: Folk singer Joni Mitchell arrives at Heathrow Airport for a concert at the Festival Hall with her boyfriend Graham Nash, on 9 December 1969. Nash left the Hollies earlier that year to work with ex-Byrds guitarist David Crosby and former Buffalo Springfield duo Stephen Stills and Neil Young in North America.

Opposite: The Hollies perform on the BBC television chart show *Top of the Pops*, in May 1969, following the departure of bassist Eric Haydock and singer/guitarist Graham Nash. The band was supporting their hit *Sorry Suzanne* at the time. From left: Bernie Calvert, Terry Sylvester, Allan Clarke, Tony Hicks and Bobby Elliott.

CHAPTER 8

The Who

The Who were formed in Acton, West London, in 1963 by Roger Daltrey, and school friends guitarist Pete Townshend and bass guitarist John Entwistle who had played in

early rhythm and blues band The Detours. Doug Sandom (born 1930) was the band's original drummer but, tellingly perhaps, was sacked by Townshend for being 'too old'. Wem-bley teenager Keith Moon took over the drumming duties in 1964 when he demolished the drum kit of a stand-in drummer after daring the band to 'give him a go'.

Performing as The High Numbers for several months before settling on the more enigmatic The Who, the band displayed an aggressive playing style – to the point of smashing equipment worth thousands of pounds while on stage, and which they didn't own, as well as adopting the fashion and attitudes of young 'Mods' in trying to find an identity in an increasingly congested pop scene. All four member of the band tried their hand at song writing but in Pete Townshend, The Who had a quirkily original genius and a masterful musician. After Top 10 success with UK singles *I Can't Explain* (#8) and *Anyway, Anyhow, Anywhere* (#10), Townshend summed up the angst of a new generation in 3 minutes 18 seconds with *My Generation*, which was a UK#2.

The raw power of the band with their faux Beach Boys-style harmonies didn't immediately translate into international success, however.

Opposite: In 1965, members of The Who rock group sent their managers to purchase a guard dog from Battersea Dogs Home to guard their van and equipment. Left to right: Pete Townshend, Keith Moon, John Entwistle and Roger Daltrey. While they were there, the van and instruments valued at £5000 were stolen.

UK#8	I Can't Explain	US#93
UK#10	Anyway, Anyhow, Anywhere	
UK#2	My Generation	US#74
UK#5	Substitute	
UK#2	I'm a Boy	
UK#3	Happy Jack	US#24
UK#4	Pictures of Lily	US#51
UK#10	I Can See for Miles	US#9
UK#4	Pinball Wizard	US#19
	See Me, Feel Me	US#12

Substitute (UK#5), *I'm a Boy* (UK#3), *Happy Jack* (UK#3) and *Pictures of Lily* (UK#4) were not your usual pop songs but touched on deeper, darker and even more humourous themes of love and sex. It was clear, however, that songwriter Townshend was searching for the inspiration to produce something truly great.

The problem for The Who was that the band contained four lead players, each on their respective instruments, all vying for attention; they argued, fought and publicly derided each other but they came together as a musical force on stage. Managed by Kit Lambert and Chris Stamp, the band was able to keep their original line up intact for more than a decade until the death of the increasingly eccentric Keith Moon in 1978.

The Who cracked the US charts in 1967 with *I Can See for Miles* (UK#10, US#9) which gave the band traction internationally. Their knock-out performance at the Monterey Music Festival in June 1967 consolidated the band's status in the US. It was not until the release of the double album *Tommy* in 1969, however, that the 23-year old Townshend was able to deliver a fully-realised narrative about a deaf, dumb and blind boy who is seen as a messiah to the masses after becoming a pinball wizard. The music was brilliant and as a 'rock opera', the album could be performed live around the world.

Tommy reached #4 in the US (UK#2) and spent 47 weeks in the Top 40. The Who toured the world – most memorably at the Woodstock Festival – and for a time *Tommy*'s success threatened to dwarf the band. The release of the *Live at Leeds* album in 1970 and *Who's Next* the following year saw The Who enter a new decade considered as the greatest rock and roll band in the world.

Opposite: The Who desperately needed a hit in 1968 and embraced every media opportunity to remain in the public eye. In May, they took this photo with Yellow Printer, the world's fastest greyhound and trainer John Bassett. Roger Daltrey, apparently, was not available for the photoshoot.

Above: Roger Daltrey works on a new song in his London flat, September 1966. In those early days none of The Who's members got along or socialised with each other outside of performing with the group.

At the Colston Hall,
Bristol, 1964.

Pete

Keith

Roger

John

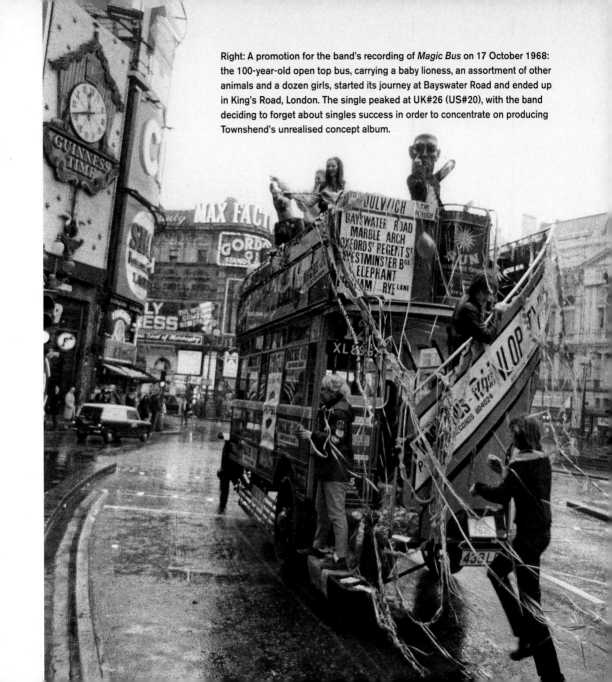

Right: A promotion for the band's recording of *Magic Bus* on 17 October 1968: the 100-year-old open top bus, carrying a baby lioness, an assortment of other animals and a dozen girls, started its journey at Bayswater Road and ended up in King's Road, London. The single peaked at UK#26 (US#20), with the band deciding to forget about singles success in order to concentrate on producing Townshend's unrealised concept album.

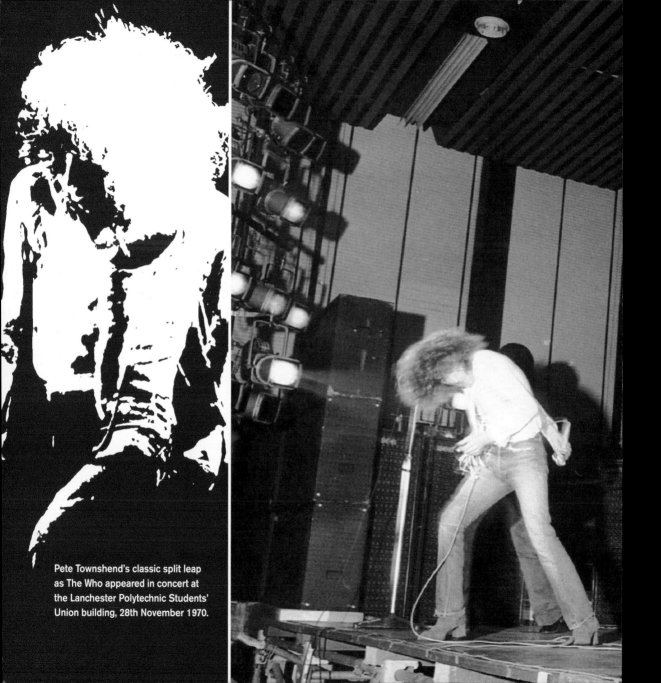

Pete Townshend's classic split leap as The Who appeared in concert at the Lanchester Polytechnic Students' Union building, 28th November 1970.

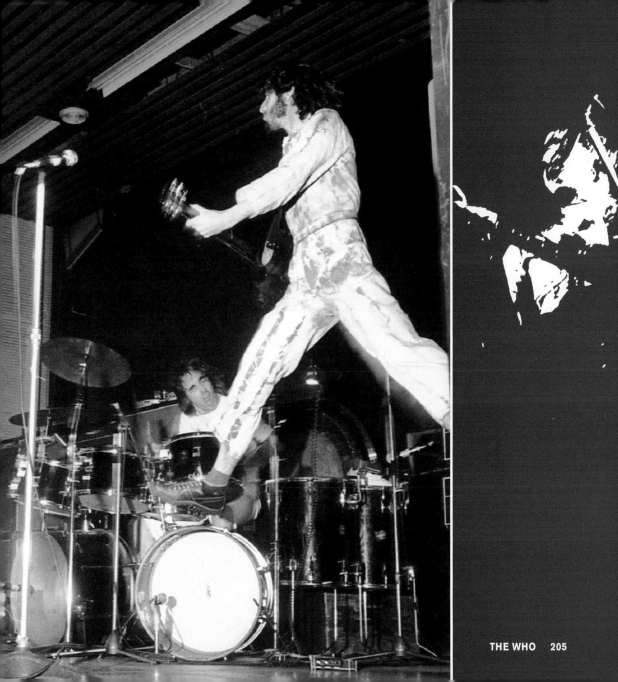

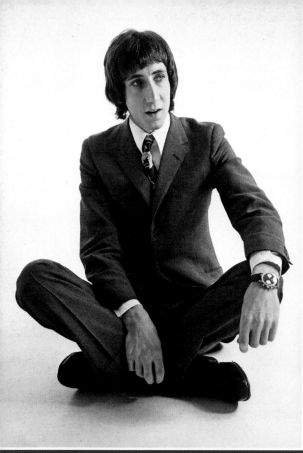

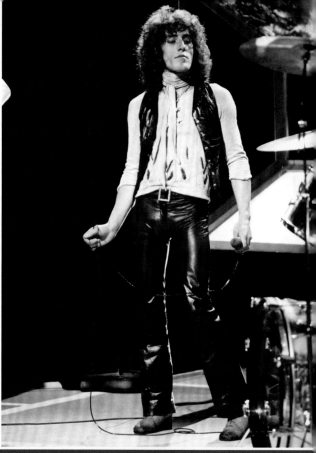

Above left: Pete Townshend (born 1945), guitarist and chief songwriter, in an uncharacteristic pose, 14 December 1967. The 22-year old meant business. His aim? To make The Who a global force in popular music.

Above right: Roger Daltrey (born 1944), lead singer of The Who performing songs from the band's *Tommy* album on *Top of the Pops*, May 1969. Pete Townshend credits Daltrey for giving *Tommy* a voice, and in return finding his identity as The Who's undisputed frontman.

Opposite top: John Entwistle (1944–2002) is widely regarded as the greatest bass guitarist in rock music. Entwistle played the bass guitar like a lead instrument, earning the nickname Thunderfingers. He was also a mean French horn player.

Opposite bottom: Keith Moon (1947–1978), the court jester of rock and roll. No hotel was safe when The Who, and 'Moon the Loon', was on tour. When it came to playing the drums, however, very few rock drummers came close to his talent and energy.

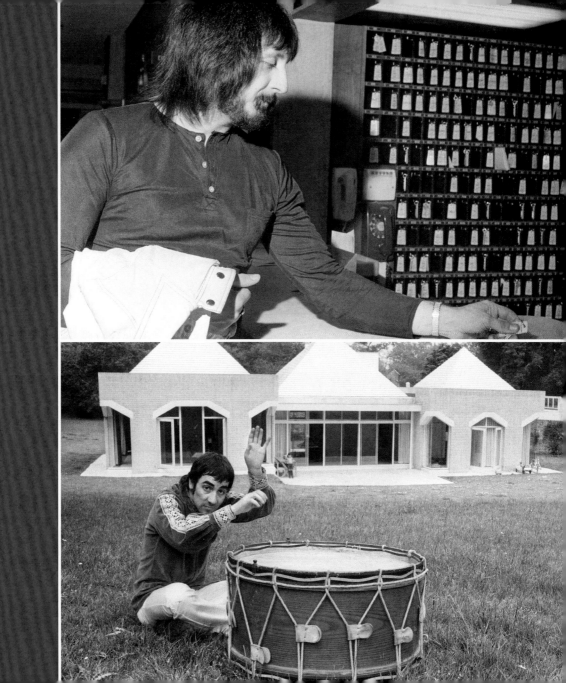

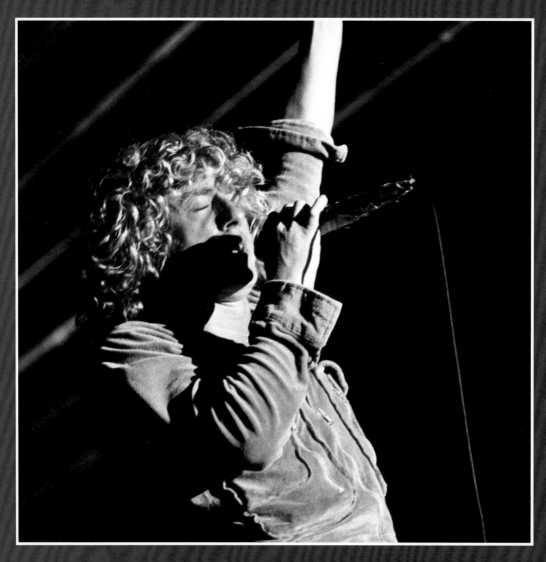

The Who in concert, with Roger Daltrey on stage in his early 1970s' 'rock god' persona. Fifty years after the band started, Daltrey still possesses one of the finest and most distinctive voices in rock and roll.

Pete Townshend, September 1969. Also pictured is Townshend's inspiration for both *Tommy* and its brilliant 1971 follow up *Who's Next*, Indian spiritual master and self-proclaimed Avatar Meher Baba (1894–1969).

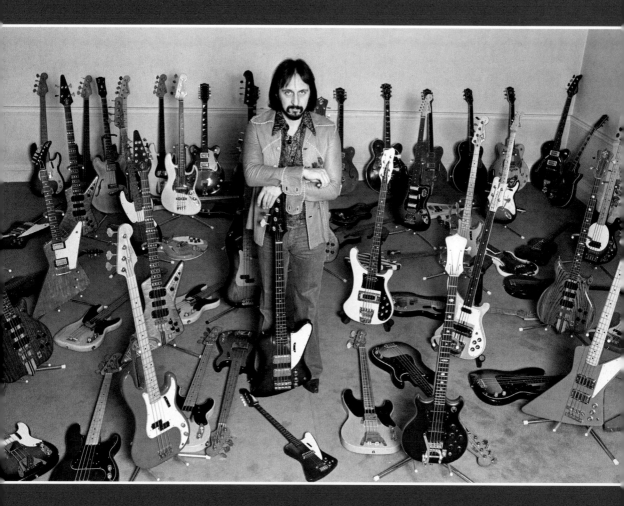

Above: John Entwistle surrounded by his many guitars at his Victorian mansion in the Cotswolds, in the early 1970s. Following Entwistle's death while on tour in the US, in 2002, aged just 57, his estate sold 178 guitars at a Sotheby's auction.

Opposite: The increasingly erratic Keith Moon with girlfriend Annette Walter-Lax at the La Val Bonne Club in London. 17th March 1978.

Above: The Who backstage before a concert in the UK, June 1976. The band was stuck in a rut in the mid 1970s, both on record and on tour, and something had to give …
Opposite: Roger Daltrey seen here during rehearsals for the BBC television programme *Top of the Pops* in 1973. Daltrey pursued a successful solo career in the UK during the mid-1970s as all four members contemplated the band's future.

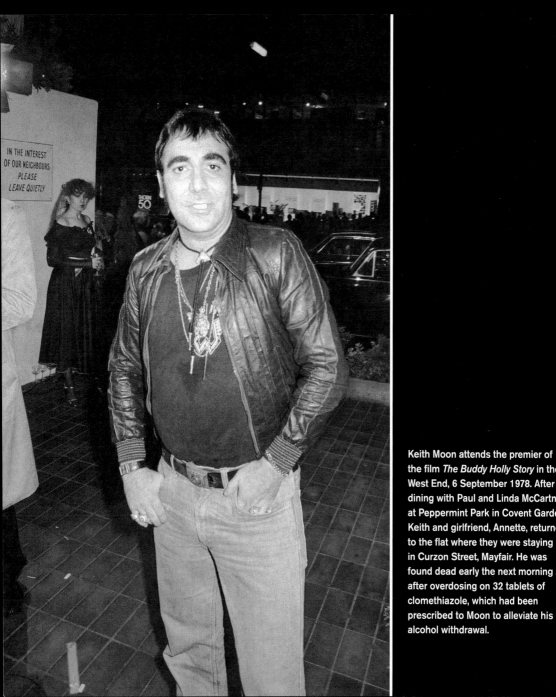

Keith Moon attends the premier of the film *The Buddy Holly Story* in the West End, 6 September 1978. After dining with Paul and Linda McCartney at Peppermint Park in Covent Garden, Keith and girlfriend, Annette, returned to the flat where they were staying in Curzon Street, Mayfair. He was found dead early the next morning after overdosing on 32 tablets of clomethiazole, which had been prescribed to Moon to alleviate his alcohol withdrawal.

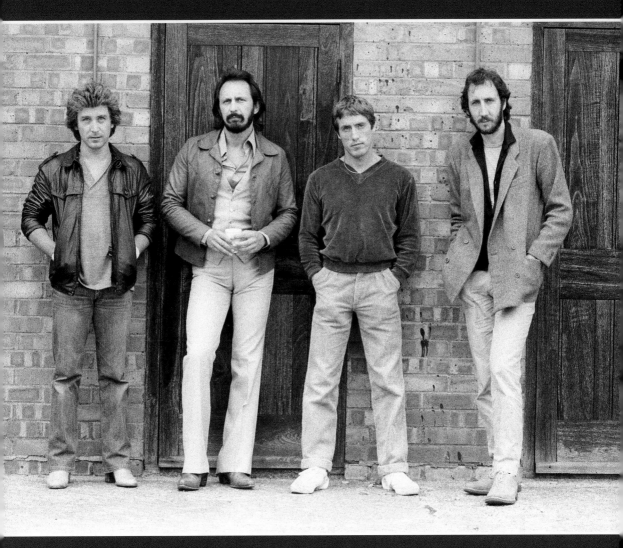

The Who pictured with new drummer Kenney Jones (left), 12 August 1979, who joined the band after Keith Moon's death the previous year. The band continued on for several years with relative success, but some of the chaotic magic of The Who was lost forever following Moon's passing.

CHAPTER 9

They Also Served

Cliff Richard

WITH THE SHADOWS

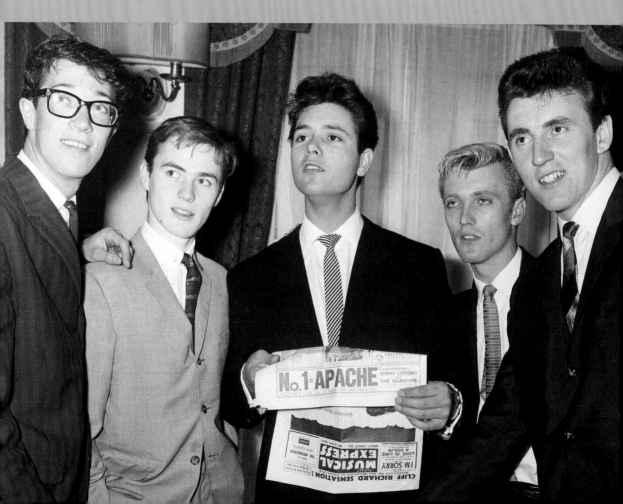

Cliff Richard with The Shadows

Cliff Richard (born Harry Webb, 1940) was Britain's answer to Elvis in the late 1950s – brooding good looks, a series of Top 10 hits and even a film career (*The Young Ones*, 1961, and *Summer Holiday*, 1962) – but success in America was not a formality for this likeable performer. Richard's backing group was originally known as The Drifters but after meeting musicians Hank Marvin (guitar), Bruce Welsh (guitar), Jet Harris (1939–2011, bass) and Tony Meehan (1943–2005, drums), he replaced his band and changed their name to The Shadows. Their hit *Living Doll* in 1959 peaked at #30 in the US and the group's Greyhound Tour of America in 1960 could not improve

its fortune stateside. The Shadows had instrumental hits with *Apache* (1959), the first of a dozen Top 10 hits in the UK, Australasia and in Europe, before Cliff decided to go solo in 1966. It was not until 1976's *Devil Woman*, however, that he had a Top 10 hit in the US (#6), despite having sold over 21 million singles in the UK alone.

He finally reached #1 again with in 1979 *We Don't Talk Anymore*.

UK#1	**Apache**
UK#1	**Kon-Tiki**
UK#1	**Wonderful Land**
UK#1	**Dance On!**
UK#1	**Foot Tapper**
UK#1	**Living Doll**
UK#1	**Travellin' Light**
UK#1	**Please Don't Tease**
UK#1	**I Love You**
UK#1	**The Young Ones**
UK#1	**The Next Time**
UK#1	**Summer Holiday**
UK#1	**The Minute You're Gone**
UK#1	**Congratulations**

Above: Cliff Richard and The Shadows celebrate their tenth anniversary with EMI in 1969. Together and separately, the team had over a dozen #1 hits in the UK during that period, as well as more than 50 Top 10 releases. Opposite: Hank B Marvin, Tony Meehan, Cliff Richard, Jet Harris and Bruce Welsh celebrate The Shadow's *Apache* reaching #1 on 18 August 1960.

BILLY J. KRAMER

with The Dakotas

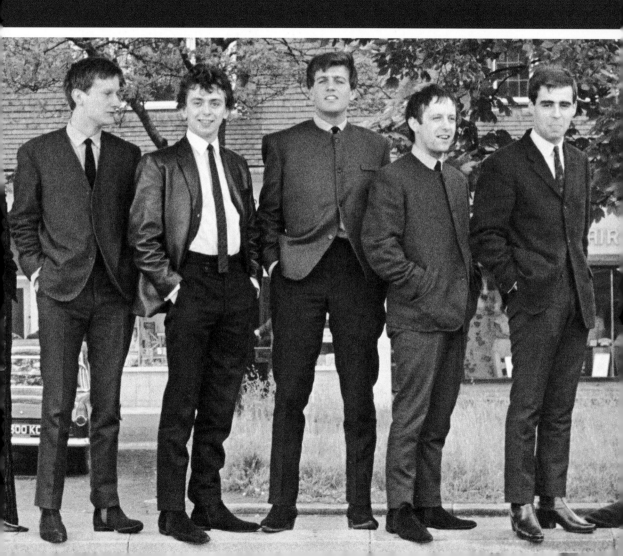

Billy J. Kramer with The Dakotas

Billy J. Kramer (born William Ashton, 1943) grew up in Bootle, Liverpool, and upon leaving school took up an engineering scholarship with British Railways. Dabbling with rhythm guitar in local pop groups, Kramer switched to vocals and was signed by Beatles' manager Brian Epstein in 1963.

Epstein teamed Kramer with Manchester group The Dakotas, and their first UK#1 was the Lennon-McCartney composition *Bad to Me* in August 1963. Kramer followed with a cover of The Beatles' *Do You Want to Know a Secret?* (UK#2), but success in the US was stymied by the release of The Beatles' own version of that record, sung by George Harrison and reached #2 on the US charts.

Stepping out from The Beatles' shadow, Kramer topped the UK charts with *Little Children* in March

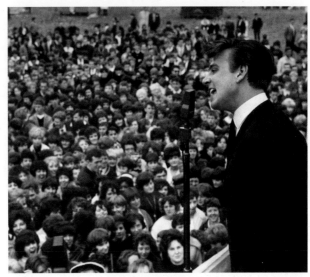

UK#1	**Bad to Me**	US#9
UK#2	**Do You Want to Know a Secret?**	
UK#1	**Little Children**	US#7

1964. The release of the single in the US, backed with *Bad to Me* saw both songs achieve the rare feat of being Top 10 hits there (#7 and #9, respectively). Kramer had a minor hit with the Burt Bacharach-Hal David song *Planes and Boats and Trains* in 1965 (UK#12), but by the time he went solo in the mid 1960s the Merseybeat phenomenon had ended.

Above: Billy J. Kramer and some of the crowd at the *Daily Herald* Beat Festival, August 1963.
Opposite: Robin McDonald, Mike Maxfield, Billy J. Kramer, Ray Jones and Tony Bookbinder.

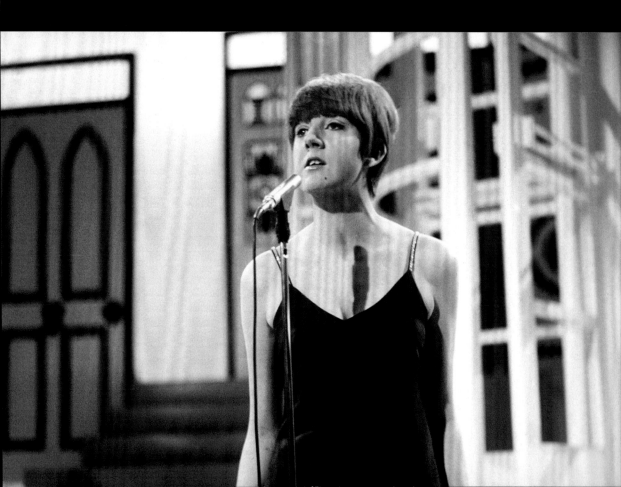

Cilla Black

Cilla Black, (born Priscilla White, 1943–2015) often sang at The Cavern with then unknown groups The Beatles and Gerry & the Pacemakers. Spotted by Brian Epstein in September 1963 when she appeared with the boys at Southport's Odeon, he quickly signed her to a contract and changed her name to Cilla Black (because she sounded like a black singer). Cilla possessed a 'girl next door' quality, toothy grin and all, but her strong voice was other-worldly.

Her first recording in 1963 was the Lennon-McCartney composition *Love of the Loved*, and she had a hit in February 1964 with *Anyone Who Had a Heart*, a cover of the Dionne Warwick song written by Burt Bacharach and Hal David. She followed up with *You're My World*, (which was originally an Italian song, *Il Mio Mondo*), but US success proved elusive. Although she had a series of Top 10 hits in her native UK (in February 1965 Black's cover version of *You've Lost That Lovin' Feelin'* reached #2 in the UK charts in the same week the Righteous Brothers' original version went to #1 there), Black pursued a brief film career before becoming a much loved star on UK television.

UK#1	**Anyone Who Had a Heart**	
UK#1	**You're My World**	**US#26**
UK#2	**You've Lost That Lovin' Feelin'**	

Opposite and above: Cilla Black – from The Cavern in Liverpool to international stardom in the 1960s.

THE DAVE CLARK 5

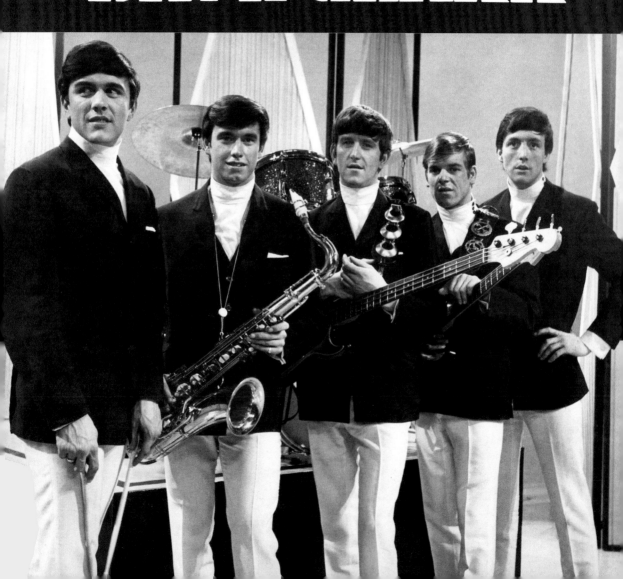

The Dave Clark Five

The Dave Clark Five were formed by the group's eponymous drummer (born 1942, in Tottenham) in the late 1950s. Clark taught himself to play the drums, formed a skiffle band and appointed himself both manager and producer.

The band refined their act by playing three nights a week at the Tottenham Ballroom in North London, but the members were only semi-professional before their breakthrough hit in January 1964. The success of *Glad All Over* (UK#1, US#6), written by Clark and lead singer Mike Smith, saw the band follow The Beatles to America, and for a brief time. 'The Tottenham sound' – pounding drums, driving vocals and even a saxophone – was heralded as the next big thing in pop. It wasn't, but on the back of relentless touring The Dave

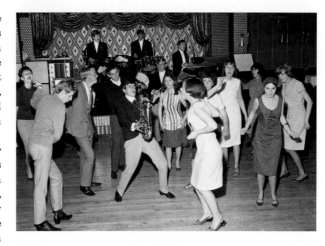

| **UK#1** | **Glad All Over** | **US#6** |
| **UK#5** | **Catch Us If You Can** | **US#4** |

Clark Five finished 1965 with a US#1 with *Over and Over*.

The Dave Clark Five was decidedly old-fashioned, with dark blue jackets and white trousers, but the US embraced the band's showmanship (they released 14 singles in the US in a two-year period). *Catch Us If You Can* (UK#5, US#4), which was also the title of the group's well-received film by John Boorman, may have been the band's high-point, but they continued to produce Top 10 hits in the UK for the remainder of the decade.

Above: Young Mods dance to The Dave Clark Five at Basildon, Essex, September 1963.
Opposite: The Dave Clark Five on *Top of the Pops* in 1964. From left: Dave Clark (drums), Denis Payton (saxophone), Rick Huxley (bass), Lenny Davidson (guitar) and Mike Smith (vocals).

Helen Shapiro

Helen Shapiro (born in London, 1946) was a teenage sensation in the early 1960s and became the youngest person to have a #1 hit in the UK. The youngster was signed by Columbia (EMI) A&R man John Schroeder; her deep, mature voice belying her young age (and her gender). At age 14 Helen had a Top 10 hit in the UK with *Don't Treat Me Like A Child* and followed this with back-to-back #1's – *You Don't Know* and *Walkin' Back to Happiness*, with all three songs written by Schroeder and Michael Hawker. The Beatles supported Shapiro on her 1963 national tour, but plans for her to record the Lennon-McCartney song *Misery* never eventuated. Her version of *It's My Party*, which was recorded in the US, was replaced in the UK by the song *Not Responsible*, which was only a modest hit. Shapiro spent

the remainder of the decade in cabaret and club work, playing the role of Nancy in Lionel Bart's *Oliver!* on the West End after starring in the Richard Lester film, *It's Trad, Dad!* (1962)

Helen Shapiro appeared on *The Ed Sullivan Show* in 1961 and recorded an album *Helen in Nashville*, but success in America did not eventuate. When this photograph was taken in June 1964, her promising recording career was already on the wane – at age 18!

UK#1 You Don't Know
UK#1 Walkin' Back to Happiness

The Honeycombs

Formed in North London in 1963 by guitarist Martin Murray after he put an advertisement in a local paper; the ad attracted guitarist/pianist Alan Ward who, in turn, recommended brother and sister team, John and Ann 'Honey' Lantree, the latter a drummer. Singer Denis D'Ell soon followed, and the novelty of having a female drummer produced their name, The Honeycombs.

Managed by songwriting team Alan Blaikley and Ken Howard, it was their composition *Have I the Right?* that was selected by independent producer Joe Meek (of *Telstar* fame) to record and present to Pye for release. *Have I the Right?* was a UK#1 in August 1964 and went to #5 in the US. It was fitting that a driving drum beat on the

chorus distinguished The Honeycomb's hit. Murray left the group at the end of the year and was replaced by Peter Pye, but the band could not repeat their original chart success. Pye, D'Ell and Ward departed in 1966, the year before the band called it a day.

UK#1 **Have I the Right?** **US#5**

In September 1965, The Honeycombs responded to the Minister of Health's appeal for blood donors. From left to right: Alan Ward, John Lantree, Peter Pye and Denis D'Ell comfort group member Honey Lantree.

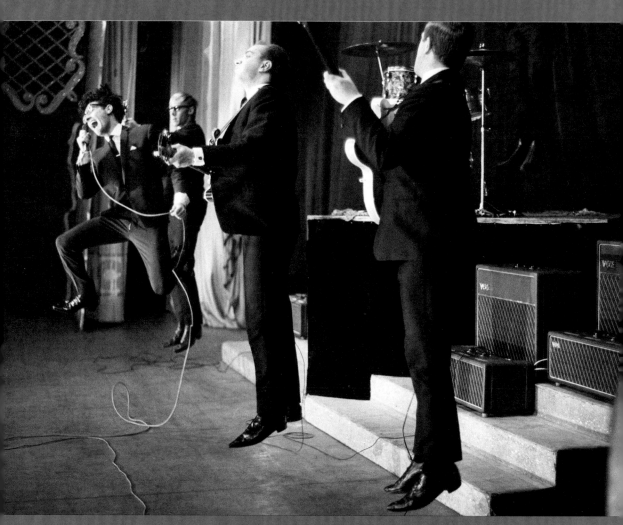

Freddie and the Dreamers

Manchester's Freddie Garrity (1936–2006) was more showman or actor than pop singer (he was also considerably older than most who found success in the early 1960s) but his winning personality and love of a 'gimmick' contributed much to the success of the Dreamers. Crazy dances, a zany backing group that was easily the least photogenic of the era's pop groups (and had great fun playing on that fact) and several film roles (*Every Day's A Holiday*, 1965) also added to their appeal, but they never had a #1 in the UK. *If You Gotta Make A Fool of Somebody*, released in 1963, was the first of four Top 10 hits for Freddie and the Dreamers, and just as the group's appeal was waning, *I'm Telling You Now* cracked the US charts in 1965 – two years after its UK release

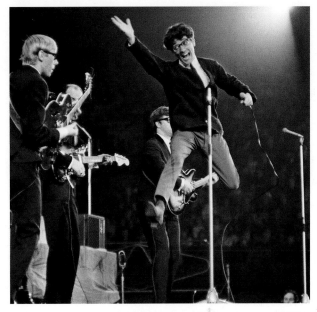

UK#2 **I'm Telling You Now** **US#1**

– after Freddie and the Dreamers performed the song on the American variety show *Hullabaloo*. The Beatles-starved American public made the song a surprise #1 that March. The band's success stalled in the mid 1960s, however, and consigned to nightclubs and children's TV, they broke up in 1967.

Opposite: Freddie and the Dreamers jump in unison at the Britannia Theatre, Great Yarmouth, Norfolk, 8 September 1963.
Above: Freddie Garrity leaps in front of the Dreamers at a concert in April 1964.

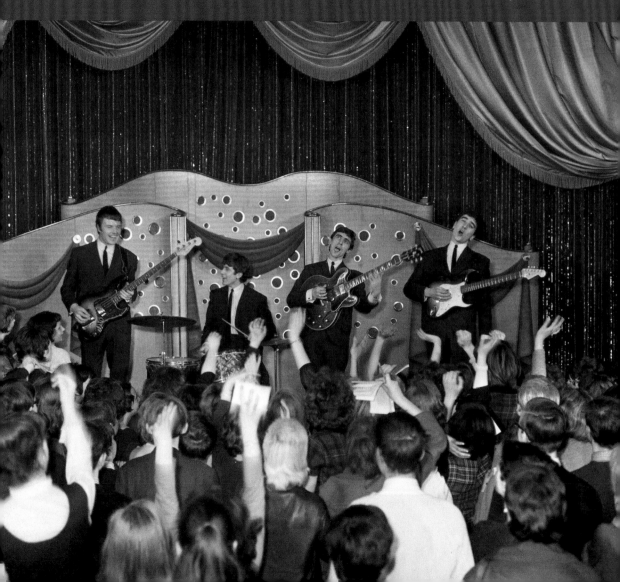

the **swinging** blue jeans

The Swinging Blue Jeans

The Swinging Blue Jeans were another Merseybeat band managed by Brian Epstein. Veterans of the Hamburg club scene, like their Liverpool contemporaries The Beatles and Gerry & the Pacemakers, the band went through a number of line-up changes as they evolved from The Bluegenes skiffle group to hard-and-fast rock and roller. Originally a quintet – Ray Ennis (vocals, guitar), Ralph Ellis (guitar), Les Braid (bass), Paul Moss (banjo) and Norm Kuhlke (drums) – Moss left the group before their cover of *Hippy, Hippy Shake* for EMI imprint HMV in December 1963. The song was a UK#1 and reached a respectable #21 in the US in early 1964. The biggest US hit of their career had been a standard of British beat groups since Chan Romero's recording in 1959 (The Beatles even covered it in their *Live at the BBC* recordings). The Swinging Blue Jeans charted with *Good Golly Miss Molly* and *You're No Good* in 1964 before being resigned to the northern England club circuit through a lack of new material.

UK#1 **Hippy, Hippy Shake** **US#21**

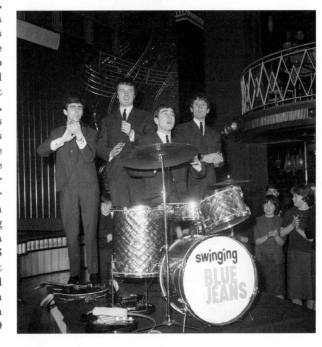

Above and opposite: The Swinging Blue Jeans at the Empire, Leicester Square, in January 1964.
From left: Les Braid, Norman Kuhlke, Ralph Ellis and Ray Ennis.

Millie

Millicent 'Millie' Small (born in Jamaica, 1946) came to London in 1963 to pursue her music career after enjoying success in Kingston. Chris Blackwell, who was her manager and legal guardian in the UK (Millie was only 17), had established his own record company – Island Records – and steered Millie toward bluebeat (ska) arrangement (by Jamaican guitarist Ernest Ranglin) of the 1956 song *My Boy Lollipop*. Jack Baverstock released the song on Fontana Records in 1964 (Blackwell was still setting up his label) and it was a #2 hit in both the UK and the US, but topped the charts in Australia and sold more than 3 million copies worldwide.

A favourite with fans, with her bubbly personality and distinctive voice, but the queen of the bluebeat's career floundered after her cover of *See You Later Alligator* the following year.

UK#2 **My Boy Lollipop** **US#2**

Brian Poole and the Tremeloes

Brian Poole and the Tremeloes carved their name into pop history when they were signed by Decca on New Year's Day, 1962, ahead of Liverpool band The Beatles. Decca opted for Brian Poole (born 1941) and his band apparently because they lived closer to London (Dagenham). For a while, Poole and the Tremeloes (the name was misspelt at an early gig) did everything right ... they recorded *Twist and Shout* in 1963, had a UK#1 with the Berry Gordy cover *Do You Love Me?* (which was also covered by The Dave Clark Five, and

The Hollies), and even made a film (*A Touch of Blarney*, 1964). The band had two more Top 10 hits in the UK (*Candy Man* and *Someone, Someone*) before he left for a solo career in 1966.

With the Tremeloes sharing vocals, drummer Dave Munden (born 1943), lead guitarist Ricky West (born Richard Westwood, 1943), Alan Blakely (1942–1996) on piano and organ and Len 'Chip' Hawkes

(born 1946) replacing Alan Howard on bass, the band moved to Columbia and cracked the US charts with the Cat Stevens' composition *Here Comes My Baby* in 1967 (UK#4 and US#13). Their version of a 1963 Four Seasons B-side *Silence is Golden* was a worthy UK#1 in the summer of 1967 and the band followed up with a successful US tour.

The Tremeloes charted in the UK Top 10 until 1970.

UK#1	**Do You Love Me?**	
UK#2	**Someone, Someone**	
UK#4	**Here Comes My Baby**	**US#13**
UK#1	**Silence is Golden**	**US#11**

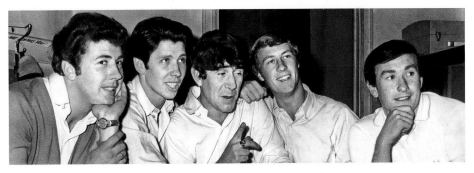

From left to right: Dave Munden, Ricky West, Alan Blakely, Alan Howard and Brian Poole in 1964.

The Searchers

The Searchers were formed in Liverpool in 1959 by Mike Pender (born 1942) and John McNally (born 1941) and took their name from the classic 1956 John Wayne film. After original singer Ron Woodbridge and his replacement Jon Sandon left the group, The Searchers settled down as a four-piece with the addition of drummer Chris Curtis (1941–2005) and Tony Jackson (1938–2003) on bass.

One of the few Liverpool bands that Brian Epstein missed, the band had a UK#1 with *Sweets for My Sweet* in 1963 and followed up with the Tony Hatch-penned *Sugar and Spice* (UK#2).

It was their cover of *Needles and Pins* that introduced them to America in early 1964 (US#13).

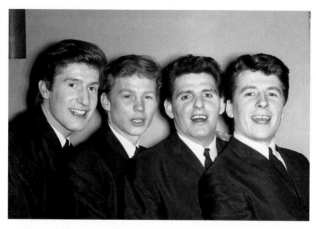

The Searchers, from left: Chris Curtis, John McNally, Tony Jackson and Mike Pender, 30 January 1964.

The song was written by Sonny Bono (soon of Sonny and Cher fame) and future Neil Young producer Jack Nitzsche. And that was the rub; the success of this fine band was dependent on finding the right material. Their cover of the Orions' *Don't Throw Your Love Away* was a UK#1 in May 1964, and although Del Shannon gave the band their biggest US success with *Love Potion No.9* in 1964 (US#3), it was not released as a single in the UK. The Searchers attempted to change with the times, but this underrated but influential band didn't have the original songs to survive the end of the British beat boom.

UK#1	Sweets for My Sweet	
UK#2	Sugar and Spice	
UK#1	Needles and Pins	US#13
UK#1	Don't Throw Your Love Away	US#16
	Love Potion No.9	US#3

Peter and Gordon

Peter Asher (born 1944) and Gordon Waller (1945–2009) met at a London boarding school in 1959 and began their musical journey as a guitar-playing duo in the early 1960s. Discovered by EMI while performing in London's Pickwick Club, the pair was offered a recording contract in late 1963. At the time, Peter's teenage sister Jane was going out with a young Liverpool musician named Paul McCartney, who was actually living at the Asher family home in Marylebone. McCartney suggested Peter and Gordon record the Lennon-McCartney cast-off *World Without Love* instead of their self-penned *If I Were You*, which was relegated to the B-side, and the single was a huge hit. In the wake of The Beatles' American success in early 1964, it certainly didn't hurt that their song was written by

UK#1 **World Without Love** **US#1**

Lennon-McCartney (mostly McCartney) but Peter and Gordon's soft harmonies sent it to #1 in the UK and US. A tour of America followed for the pair, with requisite television appear-ances, and although they never achieved another similar success, their songs – several of which were penned by Lennon-McCart-ney – were regularly in the Top 10.

Peter and Gordon in their dressing room at the Empire, Oldham, 28 April 1964. Peter Asher (left) later became a record producer for The Beatles' Apple records, while Gordon Waller became a successful businessman.

DUSTY SPRINGFIELD

Dusty Springfield

Dusty Springfield (born Mary O'Brien, 1939–1999) made her reputation as a singer as a member of The Springfields folk trio, along with her brother Tom, in the early 1960s. Voted Britain's top vocal group in 1961–62, they had a US hit with *Silver Bells and Golden Needles* (#23, the highest position of any British group to date) before Dusty went solo at the end of 1963 in order to follow her pop/soul sensibilities. Her first record, *I Only Want to Be with You* was a #3 hit in the UK (US#12), and the series of Top 10 hits that followed marked her as the best female singer of her generation.

In December 1964, she returned from her South African tour after refusing to play to segregated audiences. Her 1965 hit *You* *Don't Have to Say You Love Me* was her only #1 in the UK (US#4) and it seems incongruous today that she never achieved a US#1. *Son of a Preacher Man* (1968) was perhaps her last hurrah of the 1960s, but she achieved iconic status well before her premature death from breast cancer, aged just 59.

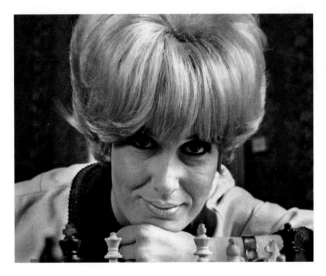

UK#4	I Only Want to Be with You	US#12
UK#1	You Don't Have to Say You Love Me	US#4
UK#9	Son of a Preacher Man	US#10

Opposite: Dusty Springfield is made up before her appearance on *Thank Your Lucky Stars*, 1964.
Above: Dusty ponders the future despite a #1 hit, April 1966. Springfield was on top of the charts with *You Don't Have to Say You Love Me* but went 'on strike' promoting the record because of a dispute with her American recording company.

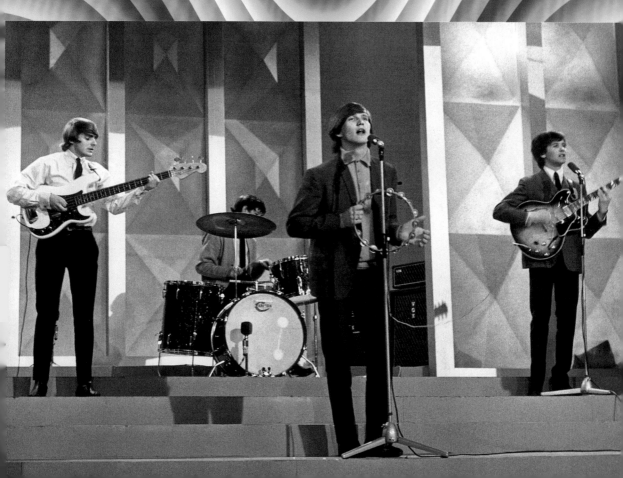

Wayne Fontana and the Mindbenders

Wayne Fontana (born Glyn Ellis in Manchester, 1945) formed The Mindbenders in 1963 for an audition at the Oasis Club for manager Jack Baverstock of Fontana Records. Ellis actually changed his stage name in honour of Elvis's drummer D.J. Fontana and the record company's name was a happy coincidence. The band comprised Bob Lang (bass), who was a member of Fontana's previous group The Jets; Eric 'Ric' Rothwell (drums) and future 10CC frontman Eric Stewart on guitar. Baverstock was impressed with the four-piece and signed them to his label, but it wasn't until their fifth single – a cover of *Um, Um, Um, Um, Um, Um,* in 1964 – that they broke into the UK charts.

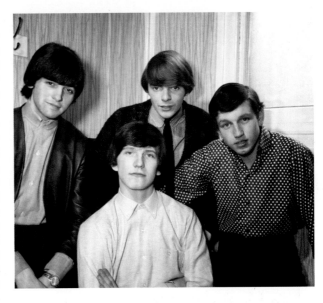

Their next outing, *Game of Love*, went to #2 in the UK and #1 in the US in April 1965, ultimately becoming a million seller.

Fontana left the group to go solo the following year (*Pamela, Pamela* was a UK#11 in 1966), while The Mindbenders had a UK#2 and US#2 hit with *Groovy Kind of Love*.

| UK#2 | Game of Love | US#1 |
| UK#2 | Groovy Kind of Love | US#2 |

Opposite: Wayne Fontana and The Mindbenders singing *Long Time Comin'* at the Brighton Pop Festival, 25 May 1965.

Above: Wayne Fontana (seated) with Eric Stewart, Bob Lang and Ric Rothwell before recording the show *Thank Your Lucky Stars* on 3 May 1964.

The Zombies

The founding members of The Zombies were schoolmates at St Albans School, Hertfordshire, where Rod Argent, Hugh Grundy and Paul Atkinson formed the band in the early 1960s. With the addition of Chris White and Colin Blunstone, the band quickly graduated from school dances and local clubs to winning the *London Evening News* beat group competition. The Zombies were in danger of breaking up as members pursued university and professional careers when they won the £250 prize. Ken Jones and Joe Roncoroni of Marquis Enterprises had the bands' parents sign publishing and management contracts and arranged for an audition with Dick Rowe at Decca. Argent submitted *She's Not There* and the song was a minor hit in the UK (#12), but rode the wave of the

British pop invasion all the way to a US#2 in August 1964. The band had another Top 10 hit that year with *Tell Her No* (US#6) but had effectively broken up when they charted again with the wonderfully evocative *Time of the Season* (US#3) in 1968. Rod Argent later formed his own self-named

band in the 1970s and had a worldwide hit with *Hold Your Head Up* in 1972.

The Zombies' pictured after *She's Not There* reached #1 in the North American chart in December 1964. From left: Rod Argent, aged 19 (piano, organ, clarinet and harmonica); Hugh Grundy, 19 (drums); Paul Atkinson, 18 (lead guitar) Chris White, 21 (bass) and Colin Blunstone, 19 (vocals-guitar).

UK#12	She's Not There	US#2
UK#42	Tell Her No	US#6
	Time of the Season	US#3

Georgie Fame

Georgie Fame was born Clive Powell in Leigh, Greater Manchester, in 1943. Already a veteran of local jazz clubs and (like Ringo Starr) Butlin's Holiday Camp in Wales, the teenager moved to London in the early 1960s, changed his name at the bequest of promoter Larry Parnes and became the leader of The Blue Flames.

Fame switched to the organ and Georgie Fame and The Blue Flames began a highly successful residency at London's Flamingo Club and The Scene club on Great Windmill Street.

The jazz-influenced *Yeh Yeh* was a #1 hit in January 1965 (US#21) and Fame enjoyed another UK#1 with *Getaway* in 1966. After going solo In 1967, Fame's recording of the Peter Callander-Mitch Miller song *Bonnie and Clyde* (on the back of the success of the popular Warren Beatty film of the same name) was #1

at home, and a Top 10 hit in the US (US#7). Fame later joined former Animals' organist Alan Price on tour in the 1970s, and formed the Rhythm Kings with former Rolling Stone Bill Wyman in the 1990s.

UK#1	**Yeh Yeh**	**US#21**
UK#1	**Getaway**	**US#70**
UK#1	**Bonnie and Clyde**	**US#7**

Jackie Trent and Tony Hatch

Jackie Trent (born Yvonne Burgess, 1940–2015) and Tony Hatch (born 1939), pictured here shortly after their marriage in March 1967. The pair had already enjoyed a UK#1 together when Trent recorded their composition *Where Are You Now (My Love)* in May 1965. Hatch was responsible for Petula Clark's run of hits and later collaborated with his wife on Clark's 1967 hits.

Trent and Hatch had a #1 hit in Australia with their recording of their composition *The Two of Us* in 1969, and lived there for many years before their marriage ended in 1995. The pair also wrote the theme to the long-running Australian series *Neighbours*.

UK#1
Where Are You Now (My Love)

Donovan

Donovan Leitch (born in 1946 in Glasgow, Scotland) was busking around London in 1965 with an eclectic group of musicians (including a kazoo player) when he met manager Peter Eden. Television appearances and a recording contract with Pye quickly followed, with his single *Catch the Wind* a UK#4 hit in 1965. The song's success, and the release of *Universal Soldier* at the beginning of the Vietnam War, took Donovan to America in the Summer of '65.

His highest chart success was *Sunshine Superman* (UK#2 and US#1) in September 1966, while *Mellow Yellow*, *Hurdy Gurdy Man*, and 1969's *Atlantis* were all Top 10 in the US. A confidante of The Beatles (Donovan went to India with the group to meditate in February 1968), you can also spy Donavon climbing through a window (!) in the Bob Dylan documentary *Don't Look Back* (1965). A masterful guitar player, his gentle but distinctive songs made his name – shortened to just his Christian name – internationally.

UK		US
UK#2	**Sunshine Superman**	US#1
UK#8	**Mellow Yellow**	US#14
UK#4	**Hurdy Gurdy Man**	US#5
UK#23	**Atlantis**	US#7

Manfred Mann

Originally known as Manfred Mann and the Manfreds, the band was formed by South African-born Manfred Mann (real name Manfred Lubowitz, born 1940), a graduate of New York's Julliard School of Music and the Vienna State Academy. Mann played jazz at a Butlin's Holiday Camp as a pianist/organist, where he met drummer Mike Hugg (born 1942).

Performing as the Mann-Hugg Blues Brothers with a succession of rhythm and blues incarnations, the band changed their name and found a voice in Oxford-educated Paul Jones (born 1942). Their fifth single *Do Wah Diddy Diddy* by the American songwriting team Jeff Barry and Ellie Greenwich, was a global hit (UK#1 and US#1) in late 1964. The hits kept coming for Manfred Mann during the 1960s, even after the replacement of bassist Mike Vickers with Beatles' sideman Klaus Voorman (born 1938) and the departure of Paul Jones for a solo career in 1966, with the band scoring UK#1s with cover versions of The Deep's *Pretty Flamingo* (1966) and Bob Dylan's *The Mighty Quinn* (1967). With Mike d'Abo (born 1944) on vocals, the band remained a pop force in the UK and internationally before disbanding in 1969.

UK#1	**Do Wah Diddy Diddy**	**US#1**
UK#1	**Pretty Flamingo**	**US#29**
UK#1	**The Mighty Quinn**	**US#10**

From left: Mike Hugg, Mike Vickers, Paul Jones, Manfred Mann and Tom McGuinness, in 1964.

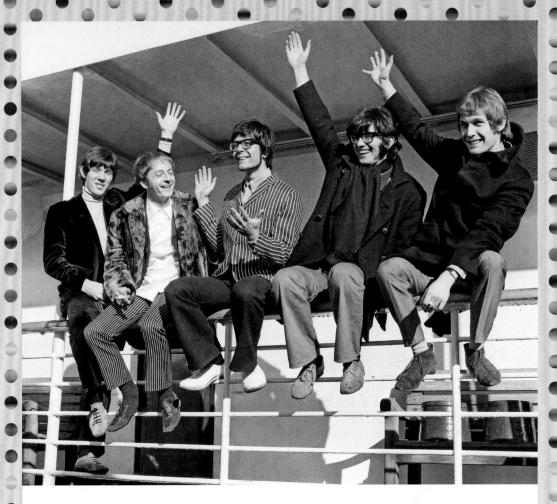

The band Manfred Mann aboard the ship *Chusan* before sailing from Southampton. The group entertained passengers and performed concerts at various ports. Left to right: Klaus Voorman (long-time Beatles friend and associate), Mike Hugg, Manfred Mann, Tom McGuinness and Mike d'Abo, 5 November 1966. Manfred Mann would make a stunning comeback in the mid 1970s with a new line-up called Manfred Mann's Earth Band (covering Bruce Springsteen's song *Blinded by the Light* in 1976).

SANDIE SHAW

Sandie Shaw

Sandie Shaw (born Sandra Goodrich in Essex, 1947) was introduced to singer Adam Faith (1940–2003) backstage at The Commodore, Hammersmith, in 1964. Faith, who had a number of Top 10 hits in the UK after 1959 asked Shaw to sing for him and was so impressed with the 16-year old he introduced her to his manager Eve Taylor. Signed to Pye, Shaw struck gold with her second record, the Burt Bacharach-Hal David composition *(There's) Always Something There to Remind Me*. The song went to #1 in the UK and she repeated her success with *Long Live Love* the following year.

A fashion icon whose recording career appeared to have peaked by 1967, her greatest success came that year when she won the

Eurovision Song Contest with the UK entry *Puppet on a String*. The song became Shaw's third UK#1 – a record for a British female singer at the time – and finally brought her international success.

UK#1 **(There's) Always Something There to Remind Me**

UK#1 **Long Live Love**

UK#1 **Puppet on a String**

Opposite: Sandie Shaw and Adam Faith leave Heathrow, London, 1967. Shaw regarded Faith as her mentor, but he had to use all of his persuasive powers to get her to enter the Eurovision Song contest.

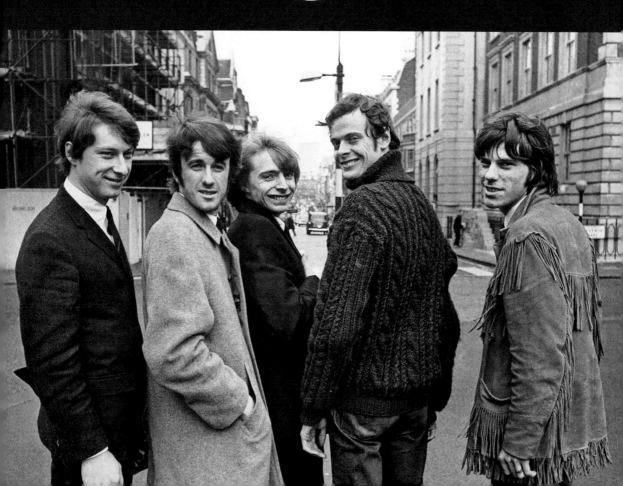

The Yardbirds

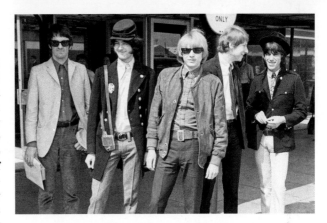

Keith Relf (vocals) and Paul Samwell-Smith (bass) were joined by Chris Dreja (guitar), Anthony Topham (guitar) and Jim McCarty (drums) in their band The Yardbirds. The band chose their name in honour of blues' legend Charlie 'Yardbird' Parker. In 1963, they took residency of Surrey's Crawdaddy Club, recently vacated by The Rolling Stones. The prodigious Eric Clapton replaced Topham on guitar, but when the band decided to release the more commercial *For Your Love* (written by teenager Graham Gouldman) in 1965, Clapton left the group in protest. The song, with Clapton on guitar and Brian Augur on harpsichord, went to #3 in the UK and #6 in the US.

The band toured extensively during 1965–66, and with Jeff Beck taking Clapton's place on lead guitar enjoyed Top 10 hits with *Heart Full of Soul* (1965) and *Shapes of Things* (1966). When Samwell-Smith left the group, session musician Jimmy Page joined the band, but Beck's sacking soon after brought The Yardbirds to a state of flux.

In July 1968, Relf and McCarty decided to pursue a new musical direction and Dreja changed career to become a photographer. As the last man standing, Jimmy Page re-branded the band in his own image – bluesier, with a rock and roll edge and much, much louder – but, for legal reasons, he required a new name. Page chose Led Zeppelin.

UK#3	**For Your Love**	US#6
UK#2	**Heart Full of Soul**	US#9
UK#3	**Shapes of Things**	US#11

Above: At London airport as they start a month long tour of the United States. From left: Jim McCarty, Jimmy Page, Keith Relf, Chris Dreja and Jeff Beck. 4th August 1966. Opposite: The Yardbirds in New York, 24 February 1966. From left: Chris Dreja, Jim McCarty, Keith Relf, Paul Samwell-Smith and Jeff Beck. Beck joined the group when Eric Clapton left the band earlier that year.

Lulu

Born Marie McDonald McLaughlin Lawrie in Glasgow, in 1948, Lulu signed with Decca at age 15 and first charted with a cover of The Isley Brothers' *Shout* (UK#7) as Lulu and the Luvvers in 1964.

The petite singer gained a worldwide following with her rendition of *To Sir With Love* (backed by The Mindbenders), the theme song to the film starring Sidney Poitier in which she and the band also appeared. The success of the movie propelled the Mickie Most-produced song to #1 in the US in October 1967, but incredibly, the song did not even chart in the UK where is was released as the B-side to *Let's Pretend*. Lulu's greatest success as home during the decade was the 1969 Eurovision Song Contest winner *Boom Bang-A-Bang*, which rose to #2 that year.

To Sir With Love US#1

Lulu, 1965. Her signature song, *To Sir With Love* was the highest selling US single of 1967

Petula Clark

Former child star Petula Clark (born 1932) was in her early 30s, her acting career seemingly already behind her, but still a music star in Europe when she achieved her first US hit in 1964. *Downtown* was written by Tony Hatch and although it reached only #2 in the UK (denied the top spot by The Beatles' *I Feel Fine*), it became the first US#1 by a British female singer since Vera Lynn in 1952. Clark later received a Grammy for this recording and followed up with two more US#1s – *My Love* (1966, also written by Tony Hatch) and *This is My Song* (1967) – among various Top 10 hits. More than any other singer, Clark personified, for international audiences, the voice of Swinging London in the 1960s, and Americans especially loved her pleasantly English persona.

UK#2	Downtown	US#1	At the Dorchester Hotel in 1965.
UK#4	My Love	US#1	From left: Cilla Black, Petula Clark
UK#1	This is My Song	US#1	and Sandie Shaw.

TOM JONES

Tom Jones

Tom Jones (born Thomas John Woodward in Wales, 1940) came to London with his band The Playboys to appear on BBC television in 1964. Jones made such an impact with his booming Welsh voice and Presley-esque body moves, that he was invited back and secured a recording deal with Decca. While the semi-professional Playboys were sent back to Wales, Jones was groomed by manager Gordon Mills as a solo star.

Mills even wrote Jones' first major hit, *It's Not Unusual*, which topped the UK charts in March 1965 and introduced him

Right: Tom Jones in Las Vegas, 1969.
Opposite: Tom Jones and Engelbert Humperdinck with their recently purchased Rolls Royce Silver Clouds in February 1969. Humperdinck had major hits with *Release Me* and *The Last Waltz* (both 1967).

to North American audiences (US#8). The son of a miner, and a married father at the age of 16, the immensely talented singer had another international hit that year with the theme song to the movie *What's New Pussycat?* (UK#10, US#3) before scoring a UK#1 with the country-and-western-themed *Green, Green Grass of Home* in December 1966.

Jones had a slew of Top 10 hits during the next decade, hosted his own television show in the UK and the US and toured Las Vegas, before being discovered by a new generation of techno-musicians who propelled him back to the top of the charts with a cover of Prince's *Kiss* (1988) and Talking Heads' *Burning Down the House* (1999).

UK#1	**It's Not Unusual**	US#8
UK#10	**What's New Pussycat?**	US#3
UK#1	**Green, Green Grass of Home**	US#11

Marianne Faithfull

Marianne Faithfull

Marianne Faithfull (born 1946) in London started her career as a teenage folk singer in coffee houses in the early 1960s, and her beauty and grace caught the attention of Stones' manager Andrew Loog Oldham.

Her first single was a cover of the Jagger-Richards-Oldham composition *As Tears Go By*, which rivalled the Stones' modest US chart success at the time when it reached #22 in 1964.

Faithfull appeared on North American television, and her next three singles also went Top 10 in the UK, but her private life soon overtook her public career. Faithfull left her marriage to live with Jagger for much of the 1960s, was famously busted for drugs at Keith Richards' house in 1967, and overdosed in Australia when Jagger was filming

Ned Kelly there in 1969. Their relationship later ended, and after battling heroin addiction, Faithfull turned to acting and later

reclaimed her music career with her deep and soulful rasp of a voice, releasing the heartfelt album *Broken English* in 1979.

UK#9	**As Tears Go By**	US#22	
UK#4	**Come and Stay With Me**	US#26	
UK#6	**This Little Bird**	US#32	

Mick Jagger of The Rolling Stones and Marianne Faithfull arrive at Covent Garden, 23 February 1967.

CHAPTER 10

Those Who Followed

The Spencer Davis Group

The Spencer Davis Group were formed in 1963 by Birmingham University student Spencer Davis (born 1939) when he conscripted guitarist Mervyn 'Muff' Winwood (born 1943) on guitar and his 13-year-old brother Steve Winwood (born 1948) on piano, and drummer Peter Yorke (born 1942). The band, which was originally called the Rhythm and Blues Quartet, changed their name to The Spencer Davis Group so their older lead singer would be forced to do most of the media interviews. Signed by Chris Blackwell to Fontana Records, the band had a UK#1 with *Keep on Running* in January 1966, and repeated the feat with another Jackie Edwards song, *Somebody Help Me*, in April that year. Both songs cracked the US Top 100, but

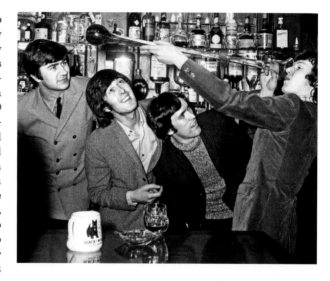

their international breakthrough was the out and out rocker, *Gimme Some Lovin'*, in 1966. Written by the group (with a riff borrowed from a Homer Banks song), *Gimme Some Lovin'* reached #2 in the UK and #7 in the US. *I'm a Man* was

a Top 10 hit on both sides of the Atlantic in 1967 (UK#9, US#10) before Steve Winwood, who was only 19 at the time, left to form Traffic, and brother Muff became a producer with Chris Blackwell's Island Records. A new line-up disbanded in 1969, before Spencer Davis regrouped in the early 1970s and continued touring into the new millennium.

Steve Winwood with The Spencer Davis Group celebrating his 18th birthday by drinking a yard of ale at the Shakespeare pub in the West End, 13 May 1966. From left: Peter York, Spencer Davis, Muff Winwood and Steve Winwood.

Small Faces

Londoners Steve Marriott (1947–1991) and Ronnie Lane (1946–1997) formed the Small Faces in 1965, adding Kenney Jones (born 1948) on drums and John Winston (born 1945), who switched from guitar to piano, to their band. Identified with Mod culture, the band had a stylish look, and shared a love of American rhythm and blues. The band won a large following from their energetic stage shows and were signed by manager Don Arden, who contracted them to Decca. In 1966, Ian McLagan (born 1945) replaced Winston on organ, and the band enjoyed success with *Sha-La-La-La-Lee* (UK#3) and *All or Nothing* (UK#1) before their career highpoint, *Itchycoo Park*, in 1967. A Top 20 hit in the US (#16) *Itchycoo Park* has become a minor classic from that summer of '67,

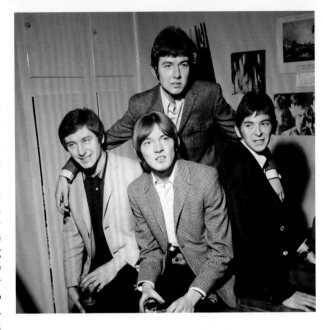

and further hits followed with the suitably psychedelic *Tin Soldier* (UK#3) and the almost over-bearingly English *Lazy Sunday* (UK#2) in 1968. Despite producing the concept album *Ogden's Nut Gone Flake* the band imploded in 1969, with Marriott leaving to form

Humble Pie after tiring of the band's pop image.
In 1970, the remaining members of the band were joined by former Jeff Beck duo Rod Stewart (vocals) and Ronnie Wood (guitar) and found enormous success in the 1970s as The Faces.

Small Faces in 1967, from left: Kenney Jones, Ronnie Lane (standing), Steve Marriott (sitting) and Ian McLagan. Marriott later died in a house fire in 1991, aged 44, while Lane, who was diagnosed with multiple sclerosis in the late 1970s, died in 1997. Kenney Jones joined The Who after the death of Keith Moon in 1978.

THE MOODY BLUES

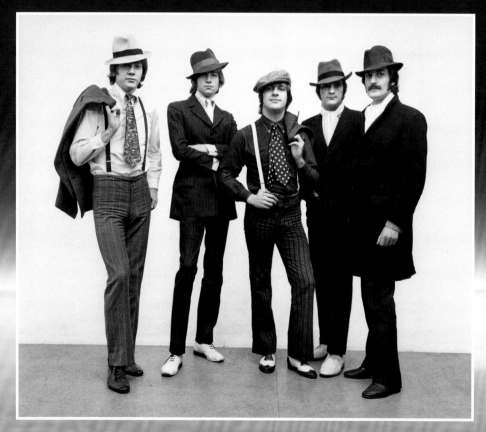

The Moody Blues

UK#1	**Go Now**	US#10
UK#9	**Nights in White Satin**	US#2
UK#2	**Question**	US#21

The Moody Blues were an eclectic group of Birmingham musicians led by Denny Laine (born Brian Hines in 1944), with Mike Pinder (born 1942), Graeme Edge (born 1944), Ray Thomas (born 1942) and Clint Warwick (born Albert Eccles, 1940–2004) conscripted from various bands in the early 1960s to play Birmingham's brand of rhythm and blues.

Signed by Decca in 1964 their second record was a cover of Bessie Banks' *Go Now*, which was a UK#1 hit in January 1965. The song was a Top 10 hit in the US the following month, but Laine and Warwick left the group the following year and Pinder's former bandmate John Lodge (born 1945) and newcomer Justin Hayward (born 1946) joined the band.

The Moody Blues 'mark II' ventured into new musical territory with the classical inspired album *Days of Future Passed* (1967), which produced their seminal recording, Hayward's *Nights in White Satin* (UK#9). The song was a surprise US#2 hit five years later as the band rode the wave of six consecutive Top 10 albums in the UK and the States. The 1970 single *Question* (UK#2) was taken from the band's best-selling album *A Question of Balance* (UK#1 and US#3) but although The Moodies still continue to tour in modified form, the band lost momentum after their 1973 hiatus.

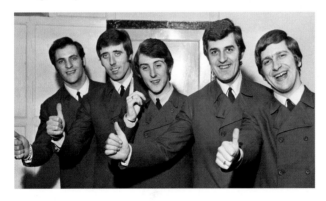

Above: The Moody Blues give a thumbs up after learning that they are #1 with their cover of *Go Now*, 18 January 1964. Left to right, Michael Pinder, Clint Warwick, Denny Laine, Ray Thomas and Graeme Edge. Opposite: The Moody Blues, 18 October 1967. From left to right. John Lodge (bass), Justin Hayward (lead guitar and vocals), Graeme Edge (drums), Mike Pinder (melophone), and Ray Thomas (flute).

The Status Quo

Francis Rossi and Alan Lancaster formed The Scorpions in 1962. In 1963 they recruited John Coghlan on drums changed the name to The Spectres. Roy Lynes joined on keyboards in 1965.

The group discovered psychedelia in 1967 and changed the name to Traffic Jam (avoiding confusion with Steve Winwood's Traffic, before settling on The Status Quo with the arrival of Rick Parfitt (1948–2016) from The Highlights. They had their first hit in the UK and the US in 1968 with *Pictures of Matchstick Men*.

By the time Lynes departed in 1970 they were known simply as Status Quo and went on to become a boogie rock band with a record 60 chart hits in the UK, yet curiously *Matchstick Men* remains their last hit in America.

From left: Francis Rossi, John Coghlan, Alan Lancaster, Roy Wynes and Rick Parfitt, September 1969.

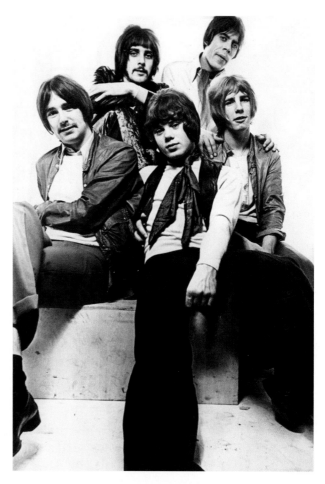

US#7 **Pictures of Matchstick Men** **UK#12**

Cat Stevens

Born Steven Demetre Georgiou (in 1948), by the late 1960s Cat Stevens was more teen idol than thought-provoking singer-songwriter as he was later known. London-born and of Greek-Cypriot and Swedish parentage, Stevens (the nickname 'Cat' came from a remark about his 'cat-like' eyes) who produced the soundtrack to the early 1970s, taught himself to play the guitar and started performing in coffee houses and pubs. Discovered by former Springfields' singer Mike Hurst, Stevens scored UK hits with *Matthew and Son* (#2) and *I'm Gonna Get Me a Gun* (#2) in 1967.

Cat Stevens cooking in February 1967.

Stevens wrote and recorded *The First Cut is the Deepest*, which became an international hit for Keith Hampshire, Rod Stewart and later, Sheryl Crow, but international recognition did not come until 1970, when a bearded and more mature performer captivated audiences around the world. Stevens retired in the late 1970s, converted to Islam and changed his name to Yusuf Islam, before a new generation discovered his talents and encouraged him to perform again.

UK		US
UK#2	Matthew and Son	US#115
UK#6	I'm Gonna Get Me a Gun	
UK#22	Moonshadow	US#30
UK#9	Morning Has Broken	US#6

THE TROGGS

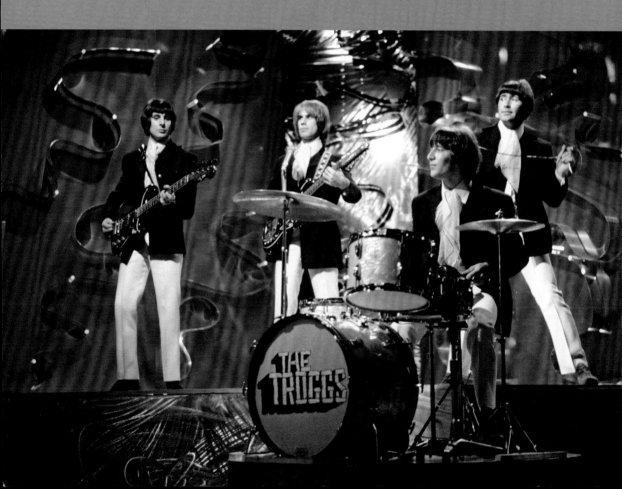

The Troggs

The Troggs (originally The Troglodytes) were formed in Hampshire, England, in 1964, by frontman and bass player Reg Presley (born Reg Ball, 1941–2013). Peter Staples (born 1944) took over on bass, leaving Presley to vocals, with guitarist Chris Britton (born 1944) and drummer Ronnie Bond (1940–1992) completing the line-up. Quickly picked up by The Kinks' manager Larry Page, the Troggs' recording of Chip Taylor's *Wild Thing* in July 1966 went to #2 in the UK and #1 in the US. The band's straightforward playing style, combined with a heavy riff and Presley's snarling nasal delivery, made *Wild Thing* a favourite with garage bands all over the world (the song was also famously covered by Jimi Hendrix).

The Troggs followed with further Top 10 hits,

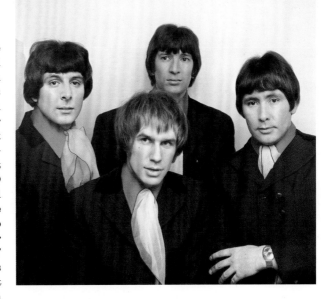

With a Girl Like You (UK#1 in August 1966), *I Can't Control Myself* (UK#2 in September 1966), *Anyway That You Want Me* (UK#8 in December 1966) and *Love is All Around* (UK#5 in November 1967), which were composed by Reg Presley. The band split in 1969 but re-formed in the 1970s and toured with various line-ups until Presley's death in 2013.

UK#2	**Wild Thing**	US#1
UK#1	**With a Girl Like You**	US#29
UK#2	**I Can't Control Myself**	US#43

Above, from left: Peter Staples and Chris Britton, Ronnie Bond (behind) and Reg Presley, April 1968.
Opposite: The Troggs appearing on the BBC television programme *Top of the Pops* in January 1968.
From left: Peter Staples, Chris Britton, Ronnie Bond and Reg Presley.

Van Morrison

Born George Ivan Morrison in Belfast, Northern Ireland, in 1945, Van Morrison played saxophone, guitar and harmonica in a variety of Northern Irish bands from the age of 12. He found success with Them in the mid 1960s, and together they recorded a series of hits for Decca – *Baby, Please Don't Go, Here Comes the Night* and the classic *Gloria*, the B-side of their first single. Touring the US to support The Doors at the nightclub Whisky a Go Go in Los Angeles, Morrison's blues-inspired singing style and 'air of subdued menace' very much influenced his namesake, Jim Morrison. Van Morrison split from Them in 1967, and his first single, the hastily recorded *Brown Eyed Girl* for an album (*Blowin' Your Mind*) he didn't even know he was recording, became his signature song. The song introduced Morrison internationally as a solo artist of immense talent and

UK#2	**Here Comes the Night**	US#24
UK#10	**Gloria / Baby, Please Don't Go**	US#71
UK#60	**Brown Eyed Girl**	US#10

remains today one of the most played songs from the 1960s. His subsequent 1968 album *Astral Weeks* merely confirmed his genius.

Van Morrison and Janet (Planet) Rigsbee, 10 October 1967. Planet was Morrison's first wife and mother to their daughter, singer-songwriter Shana Morrison.

Long John Baldry

At 6 feet 7 inches (2.01 metres) 'Long' John Baldry (1941–2005) was the Big Boss Man of the British blues scene in the early 1960s. After singing with various blues line-ups (Alexis Korner and Cyril Davies) in London clubs, Baldry formed his own band, The Hoochie Coochie Men. In 1965 the band morphed into Steampacket when Baldry brought in the unknown Rod Stewart (Baldry discovered Stewart after one of his gigs, singing at a railway station) and Julie Driscoll on vocals, with Brian Auger on organ. Baldry then formed Bluesology with the equally unknown Reg Dwight on piano (Dwight later changed his name to Elton John and rivalled Rod Stewart for superstardom in the 1970s). Baldry had a surprise UK#1 with the saccharine

Let the Heartaches Begin in 1967, and although he was popular in the America (especially Canada, where he later became a citizen) his subsequent solo career was overshadowed by that of his former bandmates. Baldry later became an actor and continued to record and perform right up to his death in 2005.

UK#1 **Let the Heartaches Begin** **US#88**

Long John Baldry celebrates going to the top of the charts with a bottle of champagne in Manchester, November 1967. *Let the Heartaches Begin* was the second successive UK#1 from the songwriting team of Tony Macaulay and John Macleod, coming straight after The Foundations' *Baby, Now that I Found You.*

Dave Dee, Dozy, Beaky, Mick and Tich

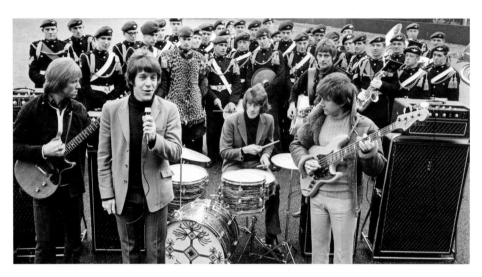

Five boys from Salisbury, Wiltshire in southwest England recorded two songs that sold more than a millions copies in the mid-1960s. Managed by successful songwriting team of Ken Howard and Alan Blaikley (The Honeycombs), this good-looking 'boy band' had a batch of Top 10 hits in the mid 1960s. *Bend It* was a UK#2 in September 1966 (#1 New Zealand and Germany) before the band went to the top of the UK charts in February 1968 with the flamenco-inspired *The Legend of Xanadu* (also NZ#1). Although the US remained oblivious to their charm, Europe and the British Commonwealth adopted the band's brand of bubble gum pop before Dave Dee (1943–2009) left the group to pursue a solo career.

UK#2	**Bend It**	**US#110**
UK#1	**The Legend of Xanadu**	**US#123**

From left: Tich (Ian Amey) on guitar, Dave Dee (David Harman) on vocals, Mick (Michael Wilson) on drums, Beaky (John Dymond) on guitar and Dozy (Trevor Ward-Davies) on bass, while the regimental band of the 1st Battalion of the Parachute Regiment watch at the barracks in Montgomery Lines, Aldershot.

The New Vaudeville Band

In their desperation to embrace everything English in the 1960s, the US took a liking to The New Vaudeville Band, which was formed by songwriter Geoff Stephens (born in London, 1934) to record his novelty song inspired by the dance bands of the 1920s, *Winchester Cathedral*, in 1966. The demo of the song was sung by John Carter (born John Shakespeare, in 1942) in mock Rudy Vallée style, with the subsequent single reaching #1 in the US (#10 in the UK) that December.

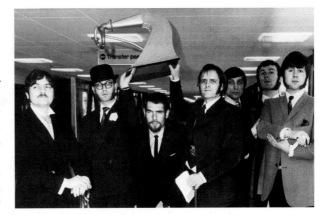

UK#1 **Winchester Cathedral** **US#10**

Above left: singer John Carter.
Above right: The New Vaudeville Band leaving for Las Vegas to perform for two weeks at the Tropicana club, 24 May 1967.

Winchester Cathedral was the best-selling English song in 1966, surpassing The Beatles. Asked to tour and promote the song on US television, Stephens tried to recruit the entire Bonzo Dog Doo-Dah Band (*I'm the Urban Spaceman*, 1969), but only Bob Kerr (born 1940) agreed.

Stephens and Carter did not tour with the band, with vocals taken on by Alan Klein (born 1942). Hugh Watts, Mick Wilsher, Neil Korner, Stan Hayward and Henry Harrison rounded out the touring group.

The band also released a popular album (*On Tour*, on Fontana Records) and a successful single follow-up, *Peek-a-Boo* (UK#7) in February 1967. *Winchester Cathedral* was later covered by more than 400 artists, including Frank Sinatra!

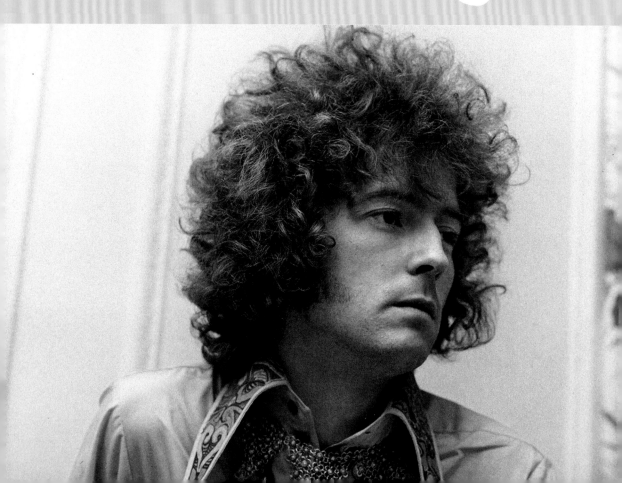

Cream

Cream

Formed in 1966, Cream was the aptly named trio of master musicians comprising Eric Clapton (born in Surrey, 1946) on guitar, Jack Bruce (born in Scotland, 1943) on bass, and power drummer Ginger Baker (born Peter Baker in London, 1939).

For all their marvellous musicianship – three talented individualists playing a hybrid jazz-blues-rock style that proved immensely popular – the band had one fatal flaw. Jack Bruce and Ginger Baker could not stand to be on the same stage together. The band spent most of their time in the States, where they toured extensively and two major hits – *Sunshine of Your Love* (#5) and *White Room* (#6) – and four Top 10 albums, culminating in 1969's *Goodbye* (UK#1 and US#2) and the obligatory *Best of ...* compilation before Cream called it quits.

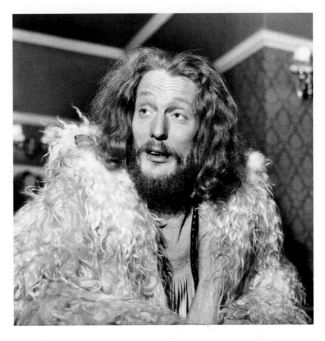

| UK#25 | **Sunshine of Your Love** | US#5 |
| UK#28 | **White Room** | US#6 |

Above: Ginger Baker, rock's 'first superstar drummer', preferred the use of two bass drums like his jazz idol Louie Bellson from the Duke Ellington Orchestra. A veteran of Blues' outfits Alexis Korner, and the Graham Bond Organisation, Baker set up a recording studio in Nigeria in the1970s.

Opposite: Eric Clapton, June 1967. After Cream, Clapton went on to form the short-lived band Blind Faith (1969) and Derek and the Dominos (1970) before overcoming heroin addiction to forge a solo career in the 1970s.

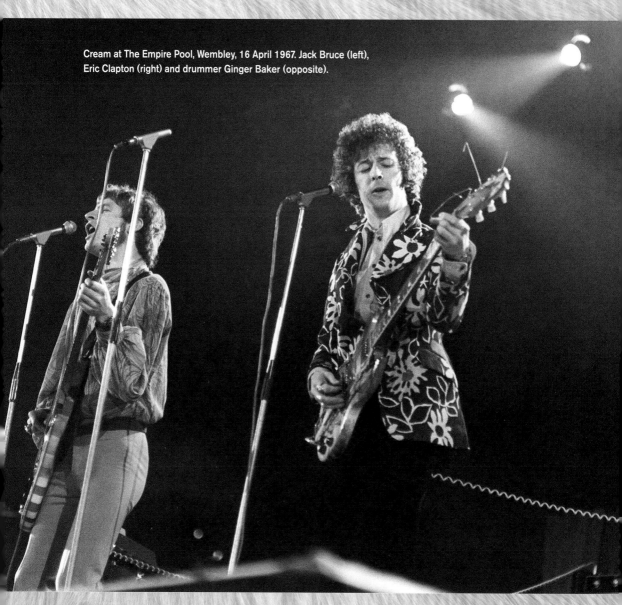

Cream at The Empire Pool, Wembley, 16 April 1967. Jack Bruce (left),
Eric Clapton (right) and drummer Ginger Baker (opposite).

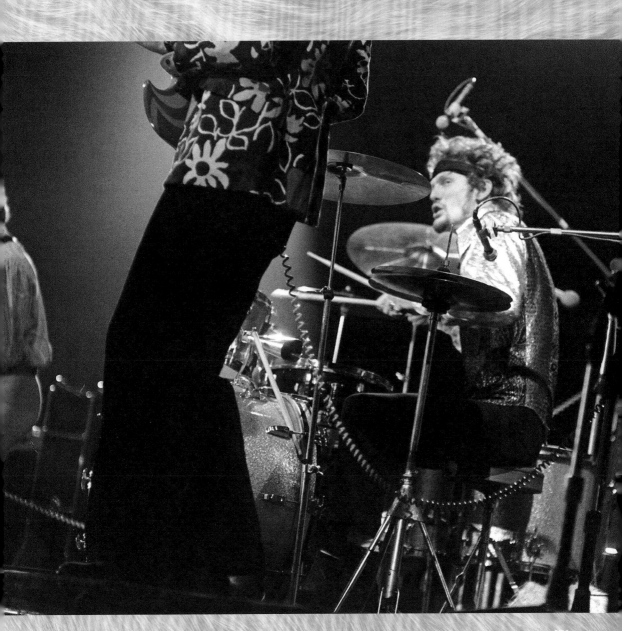

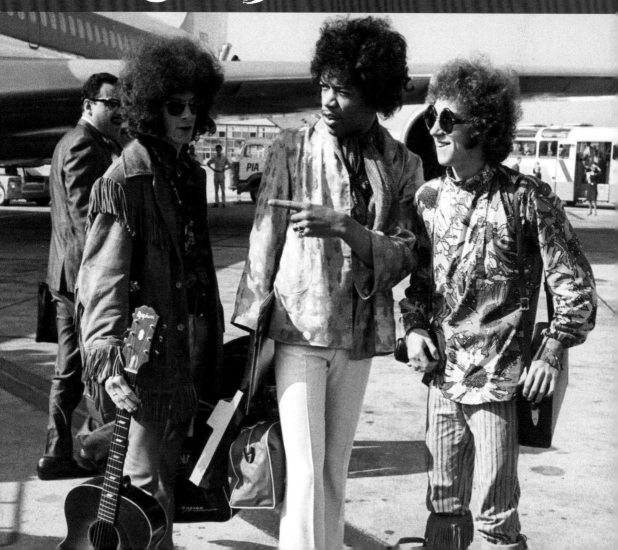

Jimi Hendrix Experience

Jimi Hendrix (born John Allen Hendrix in Seattle, USA, 1942–1970) launched his extraordinary, but short-lived, career from London with an all-British backing band, the Jimi Hendrix Experience. Hendrix was recommended to The Rolling Stones' management after a girlfriend of Keith Richards saw him performing in New York. Andrew Loog Oldham declined to sign Hendrix, but The Animals' bassist Chas Chandler, who was branching out into management, had seen Hendrix performing as Jimmi James and the Blue Fames in New York and was keen for the guitarist to record the Billy Roberts song *Hey Joe*. Chandler put together bass

guitarist Noel Redding (1945–2003) and ex-Blues Flame drummer Mitch Mitchell (1946–2008) to back Hendrix, who stunned the English pop scene with his live performances. *Hey Joe*, *Purple Haze* and *The Wind Cries Mary* were Top 10 hits in the UK as was the London-recorded album *Are You Experienced* (1967). Undoubtedly, Hendrix's brilliant performance at the Monterey Pop Festival in June 1967 (performing The Troggs' *Wild Thing*) made his reputation in his homeland, and his cover of Bob Dylan's *All Along the Watchtower* and follow-up album *Electric Ladyland* went to #1 there in 1968. By the time Hendrix played Woodstock in August

1969, Redding had gone and Hendrix's output was increasingly erratic because of his drug use. His death in September 1970 after an accidental overdose robbed popular music of one of its undoubted masters.

UK#6	Hey Joe	
UK#3	Purple Haze	US#65
UK#6	The Wind Cries Mary	US#65
UK#5	All Along the Watchtower	US#20

Opposite: Arriving at Heathrow Airport, London. The group were held at customs after Mitch Mitchell had a tear gas gun confiscated, August 1967. From left: Noel Redding, Jimi Hendrix and Mitch Mitchell.

Pink Floyd

Pink Floyd were formed toward the end of 1965 by six students at London's Regent Street Polytechnic School of Architecture. Originally performing as Sigma 6, The Tea Set and The Agricultural Abdabs, three members – Nick Mason (born 1945), Roger Waters (born 1944) and Richard Wright (1945–2012) – were joined by art student Roger 'Syd' Barrett (1946–2006) on vocals who suggested a name change to The Pink Floyd Blues Band (in honour of US bluesmen Pink Anderson and Floyd Council). Eventually known as simply Pink Floyd, the quartet gravitated toward art house rock and multi-media stage experimentation and became the darlings of the psychedelic era in the mid 1960s.

Signing with Columbia in 1967, Pink Floyd had two hit singles wit *Arnold Layne* (UK#2) and *See Emily Play* (UK#6) and their album *Piper at the Gates of Dawn* was a Top 10 hit in 1967. Syd Barrett was the chief songwriter and leader of the group, but during *A Saucerful of Secrets* (1968) his deteriorating mental state (Barrett experimented with hallucinogenic drugs and was later diagnosed with schizophrenia) saw the band seek the services of guitarist Dave Gilmour (born 1946). The original

UK#20 Arnold Layne
UK#6 See Emily Play

idea was to have Gilmour play with the band on tour, with Barrett staying on as non-performing songwriter, but this proved an impossibility and Barrett left the group. A series of well-received albums followed as Pink Floyd defined their sound – especially live performances – before they achieved superstardom with 1973's album *Dark Side of the Moon*.

Above: Pink Floyd's original members, from left: Syd Barrett, Rick Wright, Roger Waters and Nick Mason.
Opposite, from left: Nick Mason, Rick Wright, Syd Barrett and Roger Waters, in January 1968.

Procol Harum UK#1 A Whiter Shade of Pale US#5

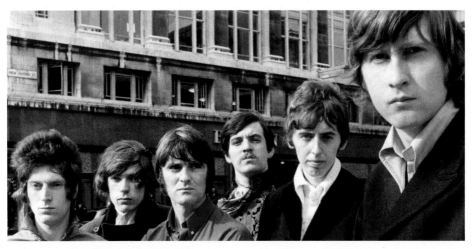

From left: Ray Royer, Matthew Knights, Bobby Harrison, Gary Brooker, Dave Knights and Keith Reid, June 1967.

Procol Harum was another in the wave of 'progressive rock' bands that came out of England in the mid 1960s and helped redefined popular music. Gary Brooker (born 1945), ex-Paramounts, and Keith Reid (born 1946) met through their desire to write together in September 1966. Reid had already completed the lyrics to *A Whiter Shade of Pale* and although he went on to compose the lyrics to every Procol Harum song, he decided to manage the assembled band rather than perform with them. Brooker (piano, organ and vocals) was joined by Matthew Fisher (organ, piano), Ray Royer (lead guitar, violin), Dave Knights (bass) and Bobby Harrison (drums) via a trade advertisement and recorded *A Whiter Shade of Pale* in May 1967. The resulting single was a smash hit in the summer of 1967, reaching #1 in the UK and US#5. Highlighted by Fisher's celestial organ introduction, an 'original adaptation' of the work of Bach and the focus of Fisher's successful 2005 lawsuit for co-authorship, *A Whiter Shade of Pale* was regarded as an instant classic.

Procol Harum continued into the early 1970s with various line-ups, chart success did not match their cult or artistic status.

Richard Harris

Irish actor Richard Harris (1930–2002) had a reputation as a hard-drinking womaniser in the 1960s, but there was no denying his talent as an actor in the right film. Filming the musical *Camelot* (1967), in which he played King Arthur, fired his interest in popular music.

Joining 21-year-old US songwriter Jimmy Webb (*Wichita Lineman, Galveston* and *By the Time I Get to Phoenix*, all for Glen Campbell, and *Up, Up and Away* for The Fifth Dimension) in London, Harris recorded his album, *A Tramp Shining*. *MacArthur Park* was a belated selection from Webb's portfolio but the song's lush production, intriguingly unfathomable lyrics and seven-minute length made it an unlikely million seller in June 1969

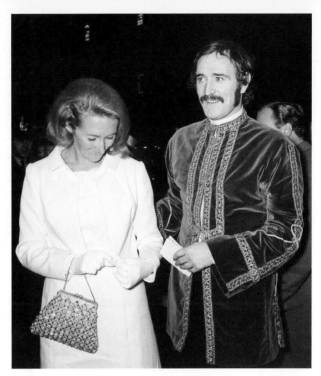

UK#4 **MacArthur Park** **US#2**

(US#2 and UK#4). *MacArthur Park*, which Harris inexplicably pronounces 'MacArthur's Park' during the entire song, is now considered a wonderful example of late '60s pop music opulence.

Richard Harris at the premiere of his film *Camelot,* 1967. Harris was Oscar-nominated for his 1963 performance in *This Sporting Life* but wasted a lot of his career in bad film in the 1970s and 1980s before reclaiming his reputation in the 1992 Oscar-winning western, *Unforgiven*. Known to today's younger generation as Albus Dumbledore from the first two Harry Potter films.

Paul and Barry Ryan

Twins Paul and Barry Ryan (Sapherson) were born in Leeds in 1948; the sons of 1950s' singer Marion Ryan. Signed as a teenage singing duo by Decca in 1965, the pair released a series of singles before Paul decided to concentrate on songwriting and left Barry to do the singing. The pair signed with MGM (their stepfather Harold Davison was a Hollywood producer). In October 1968, *Eloise*, their first single, was a million-seller around the globe, especially in Europe and Australasia reaching #1 in 17 countries (but not the UK, where it reached #2). Heavily orchestrated at a melodramatic 5:41 minutes, *Eloise* captured the mood of the late 1960s beautifully (two decades later, The Damned had the biggest hit of their career with their version of the song).

Though a much vaunted

Hollywood career never eventuated, Barry Ryan turned to photography and continues to sing and tour in Europe. Paul Ryan, whose songs were recorded by Frank Sinatra (*I Will Drink the Wine*, 1971) and Englebert Humperdink (*Love's Only Love*, 1980), died of cancer in 1992, aged 44.

UK#2 Eloise US#86

Paul (left) and Barry Ryan in their flat in North Audley Street, London, November 1968. At age 21, the brothers were riding high with the success of *Eloise*, written by Paul and performed by Barry.

Joe Cocker

Sheffield's Joe Cocker (1944–2014) holds the rare distinction of recording a Beatles' song and improving on the original. His slower version of *With a Little Help from My Friends*, performed in 6/8 time with a heavy rock beat, went to UK#1 in November 1968 and earned Cocker a congratulatory telegram from Paul McCartney. Cocker's star turn at the Woodstock Festival, backed by the Grease Band, consolidated his reputation with US audiences in August 1969 and hits *Delta Lady* (UK#10), *The Letter* (US#7) and *Cry Me a River* (US#11) followed. Cocker toured North America under the direction of Leon Russell in 1970, with the resulting film and live album *Mad Dogs and Englishmen* leaving the singer at the edge of exhaustion. Returning to the road in 1972, Cocker was famously deported from Australia on drugs and assault charges – such are the perils of a rock and roll lifestyle – but this talented and evocative rock singer went on to enjoy a long and successful career.

UK	Title	US
UK#1	With a Little Help from My Friends	US#68
UK#10	Delta Lady	US#69
UK#39	The Letter	US#7
	Cry Me a River	US#11

Mary Hopkin

Born in Wales in 1950, teenager Mary Hopkin was recommended to Paul McCartney by the model Twiggy (real name Lesley Hornby) as a potential recording star for The Beatles' newly-formed production company Apple in 1968. Hopkin had appeared on the talent show *Opportunity Knocks* and McCartney had just the right song for the Welsh lass. He had heard a Russian folk song performed with specially written English lyrics by Gene Raskin at London's Blue Angel Club and was keen to record a pop version.

In September 1968, Hopkin's *Those Were the Days* was a #1 in the US and the UK where, ironically, it knocked *Hey Jude* off the top of the charts. Hopkin followed with Top 10 hits *Goodbye* (written by McCartney, but credited to Lennon-McCartney), *Temma Harbour* and Britain's 1970 Eurovision Contest entrant

Mary Hopkin (left) with model and actress Twiggy, in September 1968.

Knock, Knock, Who's There? before marrying record producer Tony Visconti and retiring in the mid 1970s to raise her family.

Thankfully, the diminutive Hopkin and her distinctive voice were not lost for long and she returned to music at the end of the decade.

UK#1	**Those Were The Days**	**US#1**
UK#2	**Goodbye**	**US#6**
UK#6	**Temma Harbour**	**US#4**
US#2	**Knock, Knock Who's There?**	**US#11**

Jethro Tull

Jethro Tull were formed in Luton in late 1967 by frontman Ian Anderson (born in Scotland, 1947). Wanting to stand out from the pack, Anderson taught himself the flute and assembled a band comprising Glenn Cornick (bass), Martin Barre (guitar) and Clive Bunker (drums). A fusion of blues, folk, jazz and rock, Jethro Tull demonstrated just how far the British pop invasion had come in five short years, conquering North America with albums and live touring rather than pop singles.

As the 1960s drew to a close, the band's album *Stand Up* was a UK#1 and a respectable US#20. Subsequent albums *Benefit* (1970) and *Aqualung* (1971) built their devoted following before 1972's *Thick as a Brick* topped the charts around the world. Jethro Tull proved difficult to categorise over the years. In 1988, they won the Grammy for best heavy metal performance.

Jethro Tull at the Melody Makers Awards, 25 September 1969.
From left: Clive Bunker, Glenn Cornick, Ian Anderson and Martin Barre.

UK#3 **Living in the Past** **US#11**

The Bee Gees

The Bee Gees

Although the Gibb family emigrated to Brisbane, Australia, in the late 1950s, brothers Barry, Robin and Maurice Gibb returned home to England to launch their international music career in 1967.

The success of their single *Spicks and Specks* in Australia earned the group The Bee Gees (named after the initials of 'Brothers Gibb', Brisbane DJ Bill Gates, who discovered the band, and local racing driver Bill Goode, who encouraged the boys by letting them sing on the back of his truck!). Against all odds The Bee Gees, augmented by drummer Colin Petersen and guitarist Vince Melouney, secured a management deal with Robert Stigwood, who immediately resigned his position with Brian Epstein's management company to produce the group.

Writing their own songs, with melodies and harmonies reminiscent of The Beatles (some US radio stations thought their first UK single *New York Mining Disaster* was the 'Fab Four' incognito), The Bee Gees scored a worldwide #1 with *Massachusetts* at the end of 1967. *I've Gotta Get a Message to You* followed

Above: Colin Petersen, Vince Melouney, Barry, Maurice and Robin Gibb.
Opposite: The Bee Gees visit the home of manager Robert Stigwood in Middlesex, September 1968.
From left: Vince Melouney, Colin Petersen, Maurice Gibb, Robin Gibb and Barry Gibb.

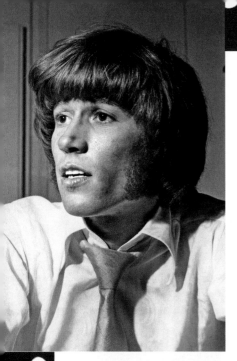

Left: Barry Gibb (born 1947), was the leader and songwriting force behind the Bee Gees. Gibb also wrote hits for other artists, including youngest brother Andy Gibb (*I Just Want to be Your Everything*, 1977), Frankie Valli (*Grease*, 1978), Barbra Streisand (*Guilty*, 1980), Dionne Warwick (*Heartbreaker,* 1982), Dolly Parton and Kenny Rogers, (*Islands in the Stream*, 1983) and Diana Ross (*Chain Reaction*, 1985).

Right: Maurice Gibb (1949–2003) with his first wife, singer Lulu, in 1969. The marriage did not last and Maurice, a multi-instrumentalist who often provided the band's comic relief on stage, battled drugs and alcohol abuse in the 1980s. After helping to reclaim the group's musical legacy in the late 1990s, Maurice died of heart failure aged 53.

Left: Robin Gibb (1949–2012). A complex man with a troubled personal life, Robin had a unique pop voice but struggled with his own demons for much of the 1980s and '90s. He succumbed to cancer, aged 62.

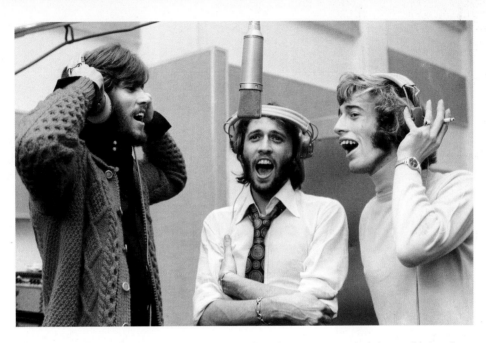

suit in August 1968, but the band was rocked by the deportation of their Australian band members and internal bickering. Robin Gibb separated from his brothers in 1969–70 (his quivering falsetto produced a UK#2 hit with *Saved by the Bell* in 1969) before the brothers reformed and had further international hits with *Lonely Days* (US#3) and *How Can You Mend A Broken Heart* (US#1). The Bee Gees toured extensively but just when they appeared to be an irrelevant musical force, the brothers discovered their groove in the mid 1970s and went on to conquer disco.

The Gibb brothers, newly reunited and back in the recording studio, 3 September 1970. Hard at work on their first group venture in nearly two years, Barry Gibb broke his honeymoon to new wife Linda to join his twin brothers Robin and Maurice in the studio.

		
UK#1	Massachusetts	US#11
UK#1	I've Gotta Get a Message to You	US#8
UK#33	Lonely Days	US#3
	How Can You Mend A Broken Heart	US#1

The Move

Birmingham's The Move, led by bassist Ace Kefford (born 1946) and guitarist Roy Wood (born 1946), was a fashionable Mod quintet in the mid-1960s. The other band members were guitarist Trevor Burton (1949), drummer Bev Bevan (born 1944) and Carl Wayne (1943–2004) who originally shared vocals with the other members.

The Move promoted a mix of pop, psychedelia and classical influences in their music, achieving five Top 10 hits in a row before their classic UK#1 *Blackberry Way* in January 1969. By this stage Kefford had been 'let go', and the band tackled the US as a four-piece.

While international success did not stretch further than Ireland and the British Commonwealth, when Jeff Lynne (born 1947) joined the band in 1970 (Burton and Wayne having also departed), the remaining members morphed into the Electric Light Orchestra (ELO) and future success before Roy Wood left to form glam outfit Wizzard.

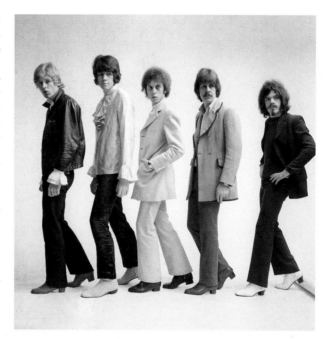

From left: Chris 'Ace' Kefford, Bev Bevan, Trevor Burton, Carl Wayne and Roy Wood in December 1967.

UK#2	**Night of Fear**
UK#5	**I Can Hear the Grass Grow**
UK#2	**Flowers in the Rain**
UK#3	**Fire Brigade**
UK#1	**Blackberry Way**

The Scaffold

Comedy trio The Scaffold emerged from the Merseyside Arts Festival in the early 1960s. Liverpool's John Gorman (born 1937), poet Roger McGough (born 1937) and Mike McGear (born Mike McCartney in 1944; the younger brother of Beatle Paul) performed poetry, comedy sketches and musical numbers around Britain, especially in Scotland, for three years before record success beckoned. McGear's *Thank U Very Much* was a modest hit in 1967 (UK#4) before *Lily the Pink* (the team's reworking of folksong *The Ballad of Lydia Pinkham*) struck gold in November 1968.

A UK#1, cover versions in North America (The Irish Rovers) and Europe (Richard Anthony) robbed the band of some of their international glory, but The Scaffold's version proved a huge hit in Australia, New Zealand, Norway and Malaysia.

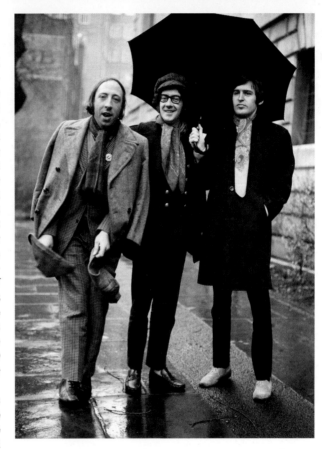

UK#4 Thank U Very Much
UK#1 Lily the Pink

From left: John Gorman, Roger McGough and Mike McGear, January 1968. McGear, the brother of Paul McCartney, changed his surname so as not to cash in on his sibling's popularity.

The Foundations

The Foundations were discovered by property tycoon Barry Class singing in a London basement underneath one of his shops in 1966.

The ages of the group ranged from 19 to 38, with several of the eight-piece band born in the West Indies and Sri Lanka. Not surprisingly, The Foundations produced pop music with a blues/reggae flavour.

Contracted to Pye, *Baby, Now That I Found You* was written by Tony Macauley and John MacLeod, and went to #1 in the UK, and US#9 with Clem Curtis (born in Trinidad, 1940) on vocals.

The following year the band scored another hit with *Build Me Up Buttercup*, written by Macauley and Manfred Mann vocalist Mike d'Abo, with Colin Young (born in Barbados, 1944) on vocals. The song went to UK#2 and US#3, in January 1969, selling more than one million copies.

The Foundations surrounded by children at a Notting Hill playground, November 1969.

| UK#1 | Baby, Now That I Found You | US#9 |
| UK#2 | Build Me Up Buttercup | US#3 |

Marc Bolan

In the mid 1960s, teenager Marc Bolan (born Mark Feld, 1947–1977) was a male model and would-be Mod desperately trying to break into the music industry. After cutting demos of Bob Dylan's *Blowin' in the Wind* and Betty Everett's *You're No Good* in 1965, Feld changed his name to Marc Bolan (the surname is a contraction of Bob Dylan), signed with Decca and released a series of singles that failed to chart.

He played in a group called John's Children in 1967 before forming Tyrannosaurus Rex with percussionist Steve Peregrin Took (1949–1980). The band became folk cult favourites, releasing the album *My People Were Fair and Had Sky in Their Hair. ...But Now They're Content to Wear Stars on Their Brows* (1968), but they fell apart on tour in the US.

Bolan recrafted T.Rex as a boogie band in 1970, and with Mickey Finn

(1947–2003) replacing Took, the band dominated the early decade with ten Top 10 hits in the UK. 1971's *Get it On* (UK#1 and US#10) was Bolan's best effort internationally, but after going solo, US success was still an unrealised goal

Marc Bolan pictured after cutting his first record, *The Wizard*, in October 1965, looking very much like his early idol, Bob Dylan.

when glam's poster boy was killed in a car accident in 1977, two weeks shy of his 30th birthday.

Fleetwood Mac

Fleetwood Mac was formed in August 1967 by drummer Mick Fleetwood (born 1947) and ex-John Mayall's Bluesbreakers' guitarist Peter Green (born Peter Greenbaum, 1946). Bassist John McVie (born 1945) was enticed to the group by giving him a prominent place in the band's name, with slide guitarist Jeremy Spencer (born 1948) completing the blues quartet. Signed by manager Clifford Davis after he caught the band playing only their second gig at London's Marquee Club, teenager Danny Kirwan (born 1950) was added to the group after the band's eponymous debut album (1968). Peter Green's evocative instrumental *Albatross*, which features Kirwan's dream-like guitar work, went to #1 in the UK at the beginning of 1969, and was a Top 10 hit in Europe and Australasia. Tours of the US followed, but the band imploded in the early 1970s and Green

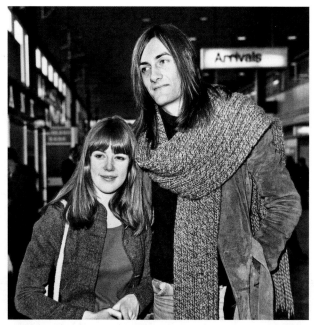

UK#1	**Albatross**	US#104
UK#2	**Man of the World**	
UK#3	**Oh Well**	US#55

and Spencer left the group.

The addition of Christine Perfect (later Christine McVie, born 1943) and American Bob Welch (1945–2012) constituted Fleetwood Mac mark II, but global success did not occur until mark III in 1974, with the addition of American duo Stevie Nicks (born 1948) and Lindsay Buckingham (born 1949).

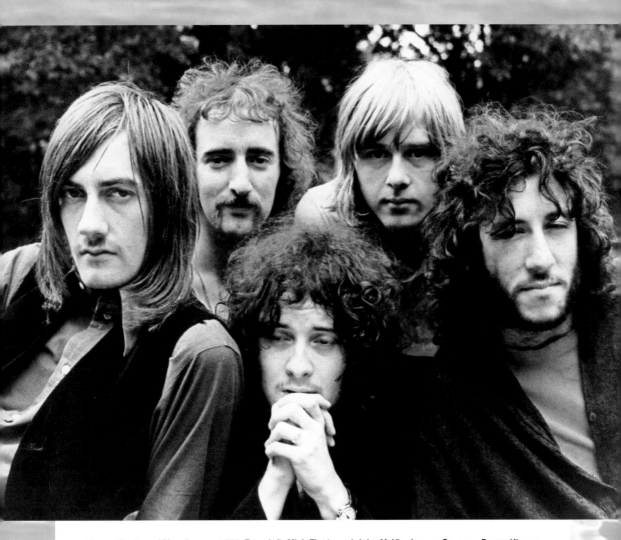

Above: Fleetwood Mac, January 1970. From left: Mick Fleetwood, John McVie, Jeremy Spencer, Danny Kirwan and Peter Green. Opposite: Mick Fleetwood arriving back from a three-month tour of America in 1969 accompanied by his future wife Jenny Boyd, sister of George Harrison's wife Pattie.

David Bowie

David Bowie (1947–2016) had a minor hit with *The Laughing Gnome* in 1967 (UK#6) and then *Space Oddity* in July 1969 where it managed to reach #5 in the UK. When rereleased in the 1970s it made a UK#1 and US#15. The unconventional yet talented Bowie produced a number of critically acclaimed albums in the early 1970s before finding his 'glam' persona Ziggy Stardust in 1972 and going on to conquer North America in the mid 1970s and becoming one of the most influential musicians of the 20th century.

Davie Jones pictured in March 1965. Jones changed his name to David Bowie that year, a great career move given the success of The Monkees' Davy Jones in 1966. His group The Konrads were banned on TV because of the length of their hair before the producer allowed them to appear on condition that they had their hair done by the BBC makeup department.

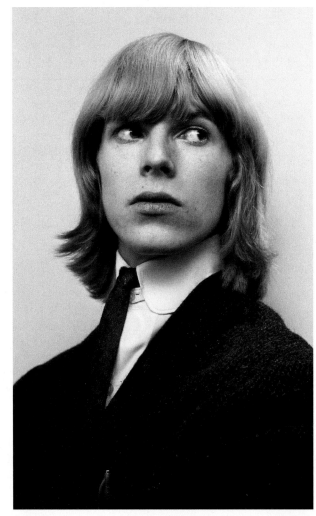

UK#1 Space Oddity US#15

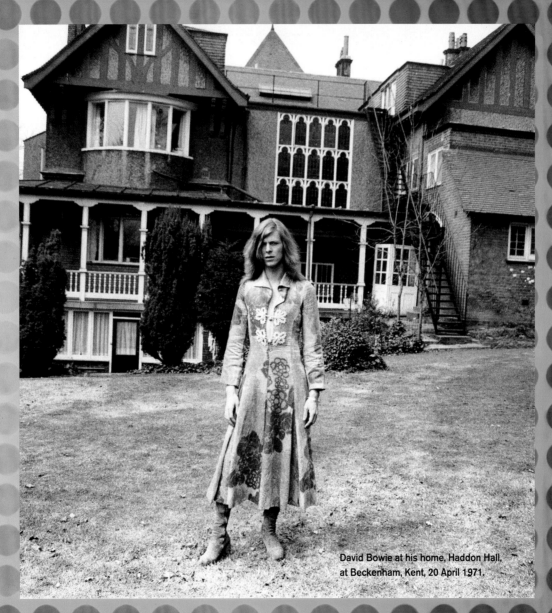

David Bowie at his home, Haddon Hall, at Beckenham, Kent, 20 April 1971.

LED ZEPPELIN

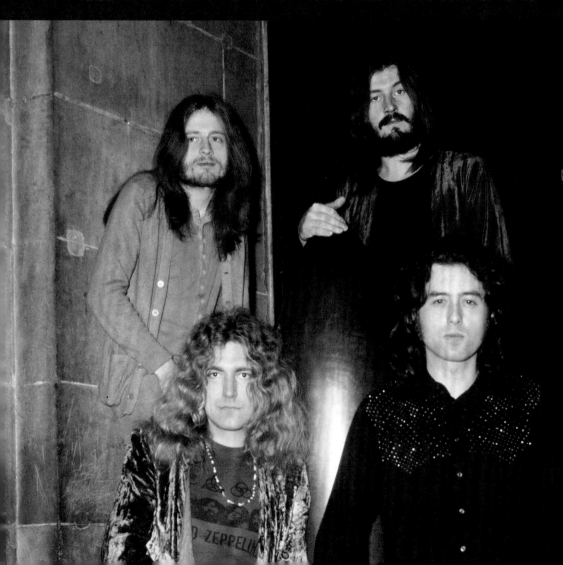

Led Zeppelin

As far as heavy metal is concerned, they don't come any holier than Led Zeppelin. But even this monster of a band, which helped establish a new genre of popular music in the late 1960s, had their pop origins. Founder Jimmy Page (born in Middlesex, 1944) was one of pop's most prominent session men in the early 1960s, playing on recordings by Herman's Hermits, The Who, The Kinks and even The Rolling Stones.

Joining the Yardbirds in 1966, Page partnered Jeff Beck on guitar for a short time, before the band disintegrated in 1968. Starting out to form The New Yardbirds, Page recruited fellow sessionman and producer John Paul Jones (born John Baldwin in Kent, 1946) on bass and relative unknowns John 'Bonzo' Bonham (1948–1980) on drums and vocalist Robert Plant (born in Staffordshire, 1948).

Whole Lotta Love US#4

The band first performed as Led Zeppelin – a pun on 'going down like a lead balloon' suggested by The Who's John Entwistle – on 25 October 1968, and went on to conquer the world.

It was an entire new ballgame for popular music ... after their debut album (*Led Zeppelin I*, in 1969), the band released eight successive #1 albums (including 1976's live album *The Song Remains the Same* in the 1970s, and not one single in the UK, before the band called it a day in 1980 following the death of John Bonham.

Right: Lead singer Robert Plant on stage in June 1969. Plant continues to make music today and is revered as one of the greatest and most influential vocalists in rock and heavy metal.
Opposite: Led Zeppelin in 1970. Back, from left: John Paul Jones, John 'Bonzo' Bonham; front: Robert Plant and Jimmy Page.

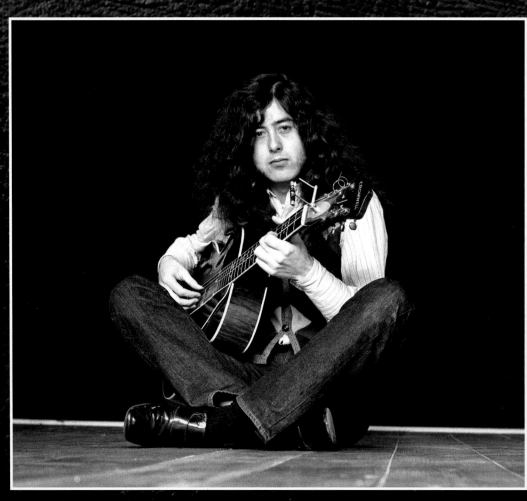

Above: Jimmy Page, 1970. A much in-demand session man in the early 1960s, Page played guitar on the Kinks' *I'm a Lover Not a Fighter* and *I've Been Driving on Bald Mountain*, The Who's *I Can't Explain*, The Rolling Stones' *Heart of Stone*, Them's *Baby Please Don't Go* and *Here Comes the Night*, Petula Clark's *Downtown,* Marianne Faithfull's *As Tears Go By* and Donovan's *Sunshine Superman*.
Opposite: Robert Plant and Jimmy Page on stage at the Royal Albert Hall, 30 June 1969.

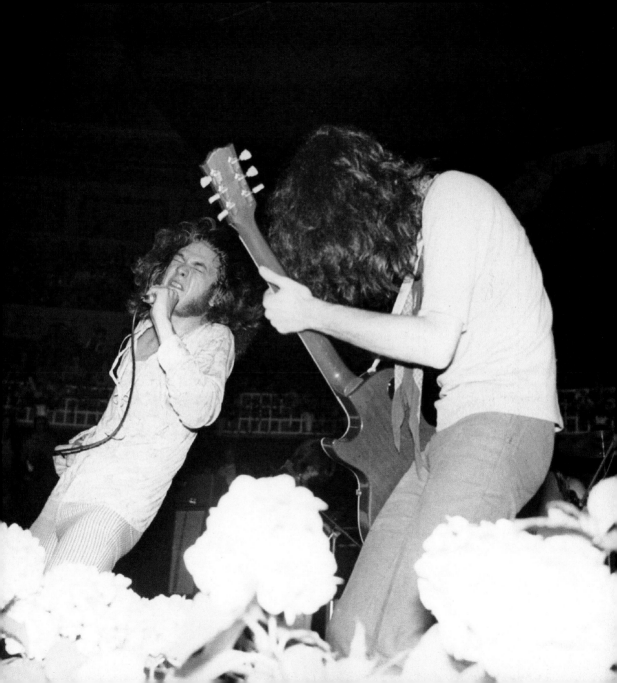

Music Charts 1960–69

19

Origin	Artist and Song	Date 1st #1	Weeks at #1
🇬🇧	**Emile Ford and the Checkmates** – What Do You Want to Make Those Eyes at Me For?	Dec 18	★★★ ★★★
🇬🇧	**Michael Holliday** – *Starry Eyed*	Jan 29	★
🇬🇧	**Anthony Newley** – *Why*	Feb 5	★★★★
🇬🇧	**Adam Faith** – *Poor Me*	Mar 10	★★
US	**Johnny Preston** – *Running Bear*	Mar 17	★★
🇬🇧	**Lonnie Donegan** – *My Old Man's a Dustman*	Mar 31	★★★★
🇬🇧	**Anthony Newley** – *Do You Mind?*	Apr 28	★
US	**The Everly Brothers** – *Cathy's Clown*	May 5	★★★★ ★★★
US	**Eddie Cochran** – *Three Steps to Heaven*	June 23	★★
US	**Jimmy Jones** – *Good Timin'*	July 7	★★★
🇬🇧	**Cliff Richard and The Shadows** – *Please Don't Tease*	July 28	★
🇬🇧	**Johnny Kidd & The Pirates** – *Shakin' All Over*	Aug 4	★
🇬🇧	**Cliff Richard and The Shadows** – *Please Don't Tease*	Aug 11	★★
🇬🇧	**The Shadows** – *Apache*	Aug 25	★★★★★
🇬🇧	**Ricky Valance** – *Tell Laura I Love Her*	Sept 29	★★★
US	**Roy Orbison** – *Only the Lonely (Know How I Feel)*	Oct 20	★★
US	**Elvis Presley** – *It's Now or Never*	Nov 3	★★★★ ★★★★
🇬🇧	**Cliff Richard and The Shadows** – *I Love You*	Dec 29	★★

Origin	Artist and Song	Date 1st #1	Weeks at #1
US	**Marty Robbins** – *El Paso*	Jan 4	★★
US	**Johnny Preston** – *Running Bear*	Jan 18	★★★
US	**Mark Dinning** – *Teen Angel*	Feb 8	★
US	**Percy Faith** – *Theme from 'A Summer Place'*	Feb 22	★★★★★ ★★★★
US	**Elvis Presley** – *Stuck on You*	April 25	★★★★
US	**The Everly Brothers** – *Cathy's Clown*	May 23	★★★★★
US	**Connie Francis** – *Everybody's Somebody's Fool*	June 27	★★
US	**Hollywood Argyles** – *Alley-Oop*	July 11	★
US	**Brenda Lee** – *I'm Sorry*	July 18	★★★
US	**Brian Hyland** – *Itsy Bitsy Teenie Weenie Yellow Polka Dot Bikini*	Aug 8	★
US	**Elvis Presley** – *It's Now or Never*	Aug 15	★★★★★
US	**Chubby Checker** – *The Twist*	Sept 19	★
US	**Connie Francis** – *My Heart Has a Mind of Its Own*	Sept 26	★★
US	**Larry Verne** – *Mr. Custer*	Oct 10	★
US	**The Drifters** – *Save the Last Dance for Me*	Oct 17	★★★
US	**Brenda Lee** – *I Want to Be Wanted*	Oct 24	★
US	**Ray Charles** – *Georgia on My Mind*	Nov 14	★
US	**Maurice Williams and the Zodiacs** – *Stay*	Nov 21	★
US	**Elvis Presley** – *Are You Lonesome Tonight?*	Nov 28	★★★ ★★★

	Artist	Date	Rating
US	**Johnny Tillotson** – *Poetry in Motion*	Jan 12	★★
US	**Elvis Presley** – *Are You Lonesome Tonight?*	Jan 26	★★★★
🇬🇧	**Petula Clark** – *Sailor*	Feb 23	★
US	**The Everly Brothers** – *Walk Right Back / Ebony Eyes*	Mar 2	★★★
US	**Elvis Presley** – *Wooden Heart*	Mar 23	★★★
US	**The Marcels** – *Blue Moon*		★★★
US	**Floyd Cramer** – *On the Rebound*	May 4	★★
🇬🇧	**The Temperance Seven** – *You're Driving Me Crazy*	May 18	★
US	**Elvis Presley** – *Surrender*	May 25	★
US	**Del Shannon** – *Runaway*	June 1	★★★★
US	**The Everly Brothers** – *Temptation*	June 29	★★★
🇬🇧	**Eden Kane** – *Well I Ask You*	July 20	★★
🇬🇧	**Helen Shapiro** – *You Don't Know*	Aug 3	★
🇬🇧	**John Leyton** – *Johnny Remember Me*	Aug 10	★★★
🇬🇧	**Shirley Bassey** – *Reach for the Stars / Climb Ev'ry Mountain*	Aug 31	★★★
🇬🇧	**John Leyton** – *Johnny Remember Me*	Sept 21	★
🇬🇧	**The Shadows** – *Kon-Tiki*	Sept 28	★
US	**The Highwaymen** – *Michael*	Oct 5	★
🇬🇧	**Helen Shapiro** – *Walkin' Back to Happiness*	Oct 12	★
US	**Elvis Presley** – *Little Sister / (Marie's the Name) His Latest Flame*	Oct 19	★★★
🇬🇧	**Frankie Vaughan** – *Tower of Strength*	Nov 9	★★★★
🇬🇧	**Danny Williams** – *Moon River*	Dec 7	★★★
		Dec 28	★★

Ger.	**Bert Kaempfert** – *Wonderland by Night*	Jan 9	★★★
US	**The Shirelles** – *Will You Love Me Tomorrow*	Jan 30	★★
US	**Lawrence Welk** – *Calcutta*	Feb 13	★★
US	**Chubby Checker** – *Pony Time*	Feb 27	★★★
US	**Elvis Presley** – *Surrender*	March 20	★★
US	**The Marcels** – *Blue Moon*	April 3	★★★
US	**Del Shannon** – *Runaway*	April 24	★★★★
US	**Ernie K-Doe** – *Mother-in-Law*	May 22	★
US	**Ricky Nelson** – *Travelin' Man*	May 29	★★
US	**Roy Orbison** – *Running Scared*	June 5	★
US	**Pat Boone** – *Moody River*	June 19	★
US	**Gary U.S. Bonds** – *Quarter to Three*	June 26	★★
US	**Bobby Lewis** – *Tossin' and Turnin'*	July 10	★★★★
			★★★
		Aug 28	★
US	**Joe Dowell** – *Wooden Heart*	Sept 4	★★
US	**The Highwaymen** – *Michael*	Sept 18	★★★
US	**Bobby Vee** – *Take Good Care of My Baby*	Oct 9	★★
US	**Ray Charles** – *Hit the Road Jack*	Oct 23	★★
US	**Dion** – *Runaround Sue*	Nov 6	★★★★★
US	**Jimmy Dean** – *Big Bad John*	Dec 11	★
US	**The Marvelettes** – *Please Mr. Postman*	Dec 18	★★★
US	**The Tokens** – *The Lion Sleeps Tonight*		

🇬🇧	**Cliff Richard and The Shadows** – *The Young Ones*	Jan 11	★★★ ★★★
US	**Elvis Presley** – *Rock-A-Hula Baby / Can't Help Falling in Love*	Feb 22	★★★★
🇬🇧	**The Shadows** – *Wonderful Land*	Mar 22	★★★★
			★★★★
		May 17	★
US	**B. Bumble and the Stingers** – *Nut Rocker*	May 24	★★★★★
US	**Elvis Presley** – *Good Luck Charm*	June 28	★★
🇬🇧	**Mike Sarne with Wendy Richard** – *Come Outside*	July 12	★★
US	**Ray Charles** – *I Can't Stop Loving You*	July 26	★★★★
🇬🇧	**Frank Ifield** – *I Remember You*		★★★
		Sept 13	★★★
US	**Elvis Presley** – *She's Not You*	Oct 4	★★★★★
🇬🇧	**The Tornados** – *Telstar*	Nov 8	★★★★★
🇬🇧	**Frank Ifield** – *Lovesick Blues*	Dec 13	★★★
US	**Elvis Presley** – *Return to Sender*		

62

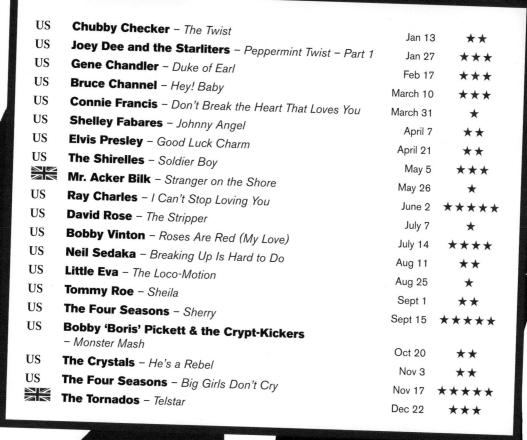

US	**Chubby Checker** – *The Twist*	Jan 13	★★
US	**Joey Dee and the Starliters** – *Peppermint Twist – Part 1*	Jan 27	★★★
US	**Gene Chandler** – *Duke of Earl*	Feb 17	★★★
US	**Bruce Channel** – *Hey! Baby*	March 10	★★★
US	**Connie Francis** – *Don't Break the Heart That Loves You*	March 31	★
US	**Shelley Fabares** – *Johnny Angel*	April 7	★★
US	**Elvis Presley** – *Good Luck Charm*	April 21	★★
US	**The Shirelles** – *Soldier Boy*	May 5	★★★
🇬🇧	**Mr. Acker Bilk** – *Stranger on the Shore*	May 26	★
US	**Ray Charles** – *I Can't Stop Loving You*	June 2	★★★★★
US	**David Rose** – *The Stripper*	July 7	★
US	**Bobby Vinton** – *Roses Are Red (My Love)*	July 14	★★★★
US	**Neil Sedaka** – *Breaking Up Is Hard to Do*	Aug 11	★★
US	**Little Eva** – *The Loco-Motion*	Aug 25	★
US	**Tommy Roe** – *Sheila*	Sept 1	★★
US	**The Four Seasons** – *Sherry*	Sept 15	★★★★★
US	**Bobby 'Boris' Pickett & the Crypt-Kickers** – *Monster Mash*	Oct 20	★★
US	**The Crystals** – *He's a Rebel*	Nov 3	★★
US	**The Four Seasons** – *Big Girls Don't Cry*	Nov 17	★★★★★
🇬🇧	**The Tornados** – *Telstar*	Dec 22	★★★

🇬🇧	**Cliff Richard and The Shadows** – *The Next Time*	Jan 3	★★★
🇬🇧	**The Shadows** – *Dance On!*	Jan 24	★
🇬🇧	**Jet Harris and Tony Meehan** – *Diamonds*	Jan 31	★★★
🇬🇧	**Frank Ifield** – *The Wayward Wind*	Feb 21	★★★
🇬🇧	**Cliff Richard and The Shadows** – *Summer Holiday*	Mar 14	★★
🇬🇧	**The Shadows** – *Foot Tapper*	Mar 28	★
🇬🇧	**Cliff Richard and The Shadows** – *Summer Holiday*	Apr 4	★
🇬🇧	**Gerry & The Pacemakers** – *How Do You Do It?*	Apr 11	★★★
🇬🇧	**The Beatles** – *From Me to You*	May 2	★★★★
			★★★
🇬🇧	**Gerry & The Pacemakers** – *I Like It*	June 20	★★★★
🇬🇧	**Frank Ifield** – *Confessin' (That I Love You)*	July 18	★★
US	**Elvis Presley** – *(You're the) Devil in Disguise*	Aug 1	★
🇬🇧	**The Searchers** – *Sweets for My Sweet*	Aug 8	★★
🇬🇧	**Billy J. Kramer with The Dakotas** – *Bad to Me*	Aug 22	★★★
🇬🇧	**The Beatles** – *She Loves You*	Sept 12	★★★★
🇬🇧	**Brian Poole and The Tremeloes** – *Do You Love Me*	Oct 10	★★★
🇬🇧	**Gerry & The Pacemakers** – *You'll Never Walk Alone*	Oct 31	★★★★
🇬🇧	**The Beatles** – *She Loves You*	Nov 28	★★
🇬🇧	**The Beatles** – *I Want to Hold Your Hand*	Dec 12	★★★★★

63

US	**Steve Lawrence** – *Go Away Little Girl*	Jan 12	★★	
US	**The Rooftop Singers** – *Walk Right In*	Jan 26	★★	
US	**Paul & Paula** – *Hey Paula*	Feb 9	★★★	
US	**The Four Seasons** – *Walk Like A Man*	March 2	★★★	
US	**Ruby & the Romantics** – *Our Day Will Come*	March 23	★	
US	**The Chiffons** – *He's So Fine*	March 30	★★★★	
US	**Little Peggy March** – *I Will Follow Him*	April 27	★★★	
US	**Jimmy Soul** – *If You Wanna Be Happy*	May 18	★★	
US	**Lesley Gore** – *It's My Party*	June 1	★★	
Jap.	**Kyu Sakamoto** – *Sukiyaki*	June 15	★★★	
US	**The Essex** – *Easier Said Than Done*	July 6	★★	
US	**Jan and Dean** – *Surf City*	July 20	★★	
US	**The Tymes** – *So Much in Love*	Aug 3	★	
US	**Little Stevie Wonder** – *Fingertips (pt. II)*	Aug 10	★★★	
US	**The Angels** – *My Boyfriend's Back*	Aug 31	★★★	
US	**Bobby Vinton** – *Blue Velvet*	Sept 21	★★★	
US	**Jimmy Gilmer and the Fireballs** – *Sugar Shack*	Oct 12	★★★★★	
US	**Nino Tempo and April Stevens** – *Deep Purple*	Nov 16	★	
US	**Dale & Grace** – *I'm Leaving It Up to You*	Nov 23	★★	
Belg.	**The Singing Nun** – *Dominique*	Dec 7	★★★★	

19

🇬🇧	**The Dave Clark Five** – *Glad All Over*	Jan 16	★ ★
🇬🇧	**The Searchers** – *Needles and Pins*	Jan 30	★ ★ ★
🇬🇧	**The Bachelors** – *Diane*	Feb 20	★
🇬🇧	**Cilla Black** – *Anyone Who Had a Heart*	Feb 27	★ ★ ★
🇬🇧	**Billy J. Kramer & The Dakotas** – *Little Children*	Mar 19	★ ★
🇬🇧	**The Beatles** – *Can't Buy Me Love*	Apr 2	★ ★ ★
🇬🇧	**Peter & Gordon** – *A World Without Love*	Apr 23	★ ★
🇬🇧	**The Searchers** – *Don't Throw Your Love Away*	May 7	★ ★
🇬🇧	**The Four Pennies** – *Juliet*	May 21	★
🇬🇧	**Cilla Black** – *You're My World (Il Mio Mondo)*	May 28	★ ★ ★ ★
US	**Roy Orbison** – *It's Over*	June 25	★ ★
🇬🇧	**The Animals** – *House of the Rising Sun*	July 9	★
🇬🇧	**The Rolling Stones** – *It's All Over Now*	July 16	★
🇬🇧	**The Beatles** – *A Hard Day's Night*	July 23	★ ★ ★
🇬🇧	**Manfred Mann** – *Do Wah Diddy Diddy*	Aug 13	★ ★
🇬🇧	**The Honeycombs** – *Have I the Right?*	Aug 27	★ ★
🇬🇧	**The Kinks** – *You Really Got Me*	Sept 10	★ ★
🇬🇧	**Herman's Hermits** – *I'm Into Something Good*	Sept 24	★ ★
US	**Roy Orbison** – *Oh, Pretty Woman*	Oct 8	★ ★
🇬🇧	**Sandie Shaw** – *(There's) Always Something There to Remind Me*		
US	**Roy Orbison** – *Oh, Pretty Woman*	Oct 22	★ ★ ★
US	**The Supremes** – *Baby Love*	Nov 12	★
🇬🇧	**The Rolling Stones** – *Little Red Rooster*	Nov 19	★ ★
🇬🇧	**The Beatles** – *I Feel Fine*	Dec 3	★
		Dec 10	★ ★ ★ ★ ★

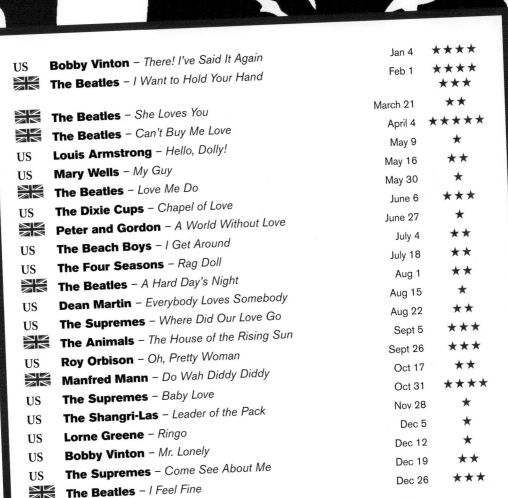

US	**Bobby Vinton** – *There! I've Said It Again*	Jan 4	★★★★
🇬🇧	**The Beatles** – *I Want to Hold Your Hand*	Feb 1	★★★★
			★★★
🇬🇧	**The Beatles** – *She Loves You*	March 21	★★
🇬🇧	**The Beatles** – *Can't Buy Me Love*	April 4	★★★★★
US	**Louis Armstrong** – *Hello, Dolly!*	May 9	★
US	**Mary Wells** – *My Guy*	May 16	★★
🇬🇧	**The Beatles** – *Love Me Do*	May 30	★
US	**The Dixie Cups** – *Chapel of Love*	June 6	★★★
🇬🇧	**Peter and Gordon** – *A World Without Love*	June 27	★
US	**The Beach Boys** – *I Get Around*	July 4	★★
US	**The Four Seasons** – *Rag Doll*	July 18	★★
🇬🇧	**The Beatles** – *A Hard Day's Night*	Aug 1	★★
US	**Dean Martin** – *Everybody Loves Somebody*	Aug 15	★
US	**The Supremes** – *Where Did Our Love Go*	Aug 22	★★
🇬🇧	**The Animals** – *The House of the Rising Sun*	Sept 5	★★★
US	**Roy Orbison** – *Oh, Pretty Woman*	Sept 26	★★★
🇬🇧	**Manfred Mann** – *Do Wah Diddy Diddy*	Oct 17	★★
US	**The Supremes** – *Baby Love*	Oct 31	★★★★
US	**The Shangri-Las** – *Leader of the Pack*	Nov 28	★
US	**Lorne Greene** – *Ringo*	Dec 5	★
US	**Bobby Vinton** – *Mr. Lonely*	Dec 12	★
US	**The Supremes** – *Come See About Me*	Dec 19	★★
🇬🇧	**The Beatles** – *I Feel Fine*	Dec 26	★★★

🇬🇧	**Georgie Fame** – *Yeh Yeh*		
🇬🇧	**The Moody Blues** – *Go Now*	Jan 14	★★
US	**The Righteous Brothers** – *You've Lost That Lovin' Feelin'*	Jan 28	★
🇬🇧	**The Kinks** – *Tired of Waiting for You*	Feb 4	★★
Aust.	**The Seekers** – *I'll Never Find Another You*	Feb 18	★
🇬🇧	**Tom Jones** – *It's Not Unusual*	Feb 25	★★
🇬🇧	**The Rolling Stones** – *The Last Time*	Mar 11	★
🇬🇧	**Unit 4 + 2** – *Concrete and Clay*	Mar 18	★★★
🇬🇧	**Cliff Richard** – *The Minute You're Gone*	Apr 8	★
🇬🇧	**The Beatles** – *Ticket to Ride*	Apr 15	★
US	**Roger Miller** – *King of the Road*	Apr 22	★★★
🇬🇧	**Jackie Trent** – *Where Are You Now (My Love)*	May 13	★
🇬🇧	**Sandie Shaw** – *Long Live Love*	May 20	★
US	**Elvis Presley** – *Crying in the Chapel*	May 27	★★★
🇬🇧	**The Hollies** – *I'm Alive*	June 17	★
US	**Elvis Presley** – *Crying in the Chapel*	June 24	★
🇬🇧	**The Hollies** – *I'm Alive*	July 1	★
US	**The Byrds** – *Mr. Tambourine Man*	July 8	★★
🇬🇧	**The Beatles** – *Help!*	July 22	★★
US	**Sonny & Cher** – *I Got You Babe*	Aug 5	★★★
🇬🇧	**The Rolling Stones** – *(I Can't Get No) Satisfaction*	Aug 26	★★
US	**The Walker Brothers** – *Make It Easy on Yourself*	Sept 9	★★
🇬🇧	**Ken Dodd** – *Tears*	Sept 23	★
🇬🇧	**The Rolling Stones** – *Get Off of My Cloud*	Sept 30	★★★★★
Aust.	**The Seekers** – *The Carnival Is Over*	Nov 4	★★★
🇬🇧	**The Beatles** – *Day Tripper / We Can Work It Out*	Nov 25	★★★
		Dec 16	★★★★★

65

			Date	Stars
🇬🇧	**Petula Clark** – *Downtown*		Jan 23	★★
US	**The Righteous Brothers** – *You've Lost That Lovin' Feelin'*		Feb 6	★★
US	**Gary Lewis & The Playboys** – *This Diamond Ring*		Feb 20	★★
US	**The Temptations** – *My Girl*		March 6	★
🇬🇧	**The Beatles** – *Eight Days a Week*		March 13	★★
US	**The Supremes** – *Stop! In the Name of Love*		March 27	★★
🇬🇧	**Freddie and the Dreamers** – *I'm Telling You Now*		April 10	★★
🇬🇧	**Wayne Fontana & The Mindbenders** – *Game of Love*		April 24	★
🇬🇧	**Herman's Hermits** – *Mrs. Brown, You've Got a Lovely Daughter*		May 1	★★★
🇬🇧	**The Beatles** – *Ticket to Ride*		May 22	★
US	**The Beach Boys** – *Help Me Rhonda*		May 29	★★
US	**The Supremes** – *Back in My Arms Again*		June 12	★
US	**Four Tops** – *I Can't Help Myself (Sugar Pie, Honey Bunch)*		June 19	★★
US	**The Byrds** – *Mr. Tambourine Man*		June 26	★
🇬🇧	**The Rolling Stones** – *(I Can't Get No) Satisfaction*		July 10	★★★★
🇬🇧	**Herman's Hermits** – *I'm Henry VIII, I Am*		Aug 7	★
US	**Sonny & Cher** – *I Got You Babe*		Aug 14	★★★
🇬🇧	**The Beatles** – *Help!*		Sept 4	★★★
US	**Barry McGuire** – *Eve Of Destruction*		Sept 25	★
US	**The McCoys** – *Hang On Sloopy*		Oct 2	★
🇬🇧	**The Beatles** – *Yesterday*		Oct 9	★★★★
🇬🇧	**The Rolling Stones** – *Get Off of My Cloud*		Nov 6	★★
US	**The Supremes** – *I Hear a Symphony*		Nov 20	★★
US	**The Byrds** – *Turn! Turn! Turn!*		Dec 4	★★★
🇬🇧	**The Dave Clark Five** – *Over and Over*		Dec 25	★

🇬🇧	**The Spencer Davis Group** – *Keep On Running*	Jan 20	★
🇬🇧	**The Beatles** – *Michelle*	Jan 27	★★★
US	**Nancy Sinatra** – *These Boots Are Made for Walkin'*	Feb 17	★★★★
US	**The Walker Brothers** – *The Sun Ain't Gonna Shine Anymore*	Mar 17	★★★★
🇬🇧	**The Spencer Davis Group** – *Somebody Help Me*	Apr 14	★★
🇬🇧	**Dusty Springfield** – *You Don't Have to Say You Love Me*	Apr 28	★
🇬🇧	**Manfred Mann** – *Pretty Flamingo*	May 5	★★★
🇬🇧	**The Rolling Stones** – *Paint It, Black*	May 26	★
US	**Frank Sinatra** – *Strangers in the Night*	June 2	★★★
🇬🇧	**The Beatles** – *Paperback Writer*	June 23	★★
🇬🇧	**The Kinks** – *Sunny Afternoon*	July 7	★★
US	**Georgie Fame and the Blue Flames** – *Getaway*	July 21	★
🇬🇧	**Chris Farlowe** – *Out of Time*	July 28	★
🇬🇧	**The Troggs** – *With a Girl Like You*	Aug 4	★★
🇬🇧	**The Beatles** – *Yellow Submarine / Eleanor Rigby*	Aug 18	★★★★
🇬🇧	**Small Faces** – *All or Nothing*	Sept 15	★
US	**Jim Reeves** – *Distant Drums*	Sept 22	★★★★★
US	**Four Tops** – *Reach Out I'll Be There*	Oct 27	★★★
US	**The Beach Boys** – *Good Vibrations*	Nov 17	★★
🇬🇧	**Tom Jones** – *Green, Green Grass of Home*	Dec 1	★★★★
			★★★

66

	Artist – Song	Date	Rating
US	**Simon & Garfunkel** – *The Sound of Silence*	Jan 1	★★
🇬🇧	**The Beatles** – *We Can Work It Out*	Jan 8	★★★
🇬🇧	**Petula Clark** – *My Love*	Feb 5	★★
US	**Lou Christie** – *Lightnin' Strikes*	Feb 19	★
US	**Nancy Sinatra** – *These Boots Are Made for Walkin'*	Feb 26	★
US	**Barry Sadler** – *The Ballad of the Green Berets*	March 5	★★★★★
US	**The Righteous Brothers** – *(You're My) Soul And Inspiration*	April 9	★★★
US	**Young Rascals** – *Good Lovin'*	April 30	★
US	**The Mamas & the Papas** – *Monday, Monday*	May 7	★★★
US	**Percy Sledge** – *When A Man Loves A Woman*	May 28	★★
🇬🇧	**The Rolling Stones** – *Paint It Black*	June 11	★★
🇬🇧	**The Beatles** – *Paperback Writer*	June 25	★★
US	**Frank Sinatra** – *Strangers In The Night*	July 2	★
US	**Tommy James and the Shondells** – *Hanky Panky*	July 16	★★
🇬🇧	**The Troggs** – *Wild Thing*	July 30	★★
US	**The Lovin' Spoonful** – *Summer in the City*	Aug 13	★★★
🇬🇧	**Donovan** – *Sunshine Superman*	Sept 3	★
US	**The Supremes** – *You Can't Hurry Love*	Sept 10	★★
US	**The Association** – *Cherish*	Sept 24	★★★
US	**Four Tops** – *Reach Out, I'll Be There*	Oct 15	★★
US	**? & the Mysterians** – *96 Tears*	Oct 29	★
US	**The Monkees** – *Last Train to Clarksville*	Nov 5	★
US	**Johnny Rivers** – *Poor Side Of Town*	Nov 12	★
US	**The Supremes** – *You Keep Me Hangin' On*	Nov 19	★★
🇬🇧	**The New Vaudeville Band** – *Winchester Cathedral*	Dec 3	★★★
US	**The Beach Boys** – *Good Vibrations*	Dec 10	★
US	**The Monkees** – *I'm a Believer*	Dec 31	★★★★
			★★★

19

US	**The Monkees** – *I'm a Believer*	Jan 19	★★★★
🇬🇧	**Petula Clark** – *This Is My Song*	Feb 16	★★
🇬🇧	**Engelbert Humperdinck** – *Release Me*	Mar 2	★★★
			★★★
US	**Nancy Sinatra and Frank Sinatra** – *Somethin' Stupid*	Apr 13	★★
		Apr 27	★★★
🇬🇧	**Sandie Shaw** – *Puppet on a String*	May 18	★★★
🇬🇧	**The Tremeloes** – *Silence Is Golden*	June 8	★★★
🇬🇧	**Procol Harum** – *A Whiter Shade of Pale*		★★★
		July 19	★★★
🇬🇧	**The Beatles** – *All You Need Is Love*		
US	**Scott McKenzie** – *San Francisco (Be Sure to Wear Flowers in Your Hair)*	Aug 9	★★★★
		Sept 6	★★★★★
🇬🇧	**Engelbert Humperdinck** – *The Last Waltz*	Oct 11	★★★★
🇬🇧	**Bee Gees** – *Massachusetts*	Nov 8	★★
🇬🇧	**The Foundations** – *Baby Now That I've Found You*	Nov 22	★★
🇬🇧	**Long John Baldry** – *Let the Heartaches Begin*	Dec 6	★★★★
🇬🇧	**The Beatles** – *Hello, Goodbye*		★★★

US	**The Buckinghams** – *Kind of a Drag*	Feb 18	★★
🇬🇧	**The Rolling Stones** – *Ruby Tuesday*	March 4	★
US	**The Supremes** – *Love Is Here and Now You're Gone*	March 11	★
🇬🇧	**The Beatles** – *Penny Lane*	March 18	★
US	**The Turtles** – *Happy Together*	March 25	★★★
US	**Nancy Sinatra and Frank Sinatra** – *Somethin' Stupid*	April 15	★★★★
US	**The Supremes** – *The Happening*	May 13	★
US	**Young Rascals** – *Groovin'*	May 20	★★★★
US	**Aretha Franklin** – *Respect*	June 3	★★
US	**The Association** – *Windy*	July 1	★★★★
US	**The Doors** – *Light My Fire*	July 29	★★★
🇬🇧	**The Beatles** – *All You Need Is Love*	Aug 19	★
US	**Bobbie Gentry** – *Ode to Billie Joe*	Aug 26	★★★★
US	**Box Tops** – *The Letter*	Sept 23	★★★★
🇬🇧	**Lulu** – *To Sir With Love*	Oct 21	★★★★★
US	**Strawberry Alarm Clock** – *Incense and Peppermints*	Nov 25	★
US	**The Monkees** – *Daydream Believer*	Dec 2	★★★★
🇬🇧	**The Beatles** – *Hello, Goodbye*	Dec 30	★★★

🇬🇧	**Georgie Fame** – *The Ballad of Bonnie and Clyde*			
🇬🇧	**Love Affair** – *Everlasting Love*	Jan 24	★	
🇬🇧	**Manfred Mann** – *Mighty Quinn*	Jan 31	★★	
Israel	**Esther and Abi Ofarim** – *Cinderella Rockefella*	Feb 14	★★	
🇬🇧	**Dave Dee, Dozy, Beaky, Mick & Tich** – *The Legend of Xanadu*	Feb 28	★★★	
🇬🇧	**The Beatles** – *Lady Madonna*	Mar 20	★	
🇬🇧	**Cliff Richard** – *Congratulations*	Mar 27	★★	
US	**Louis Armstrong** – *What a Wonderful World / Cabaret*	Apr 10	★★	
🇬🇧	**Gary Puckett & The Union Gap** – *Young Girl*	Apr 24	★★★★	
🇬🇧	**The Rolling Stones** – *Jumpin' Jack Flash*	May 22	★★★★	
🇬🇧	**The Equals** – *Baby, Come Back*	June 19	★★	
🇬🇧	**Des O'Connor** – *I Pretend*	July 3	★★★	
US	**Tommy James and the Shondells** – *Mony Mony*	July 24	★	
🇬🇧	**Crazy World of Arthur Brown** – *Fire*	July 31	★★★	
US	**The Beach Boys** – *Do It Again*	Aug 14	★	
🇬🇧	**Bee Gees** – *I've Gotta Get a Message to You*	Aug 28	★	
🇬🇧	**The Beatles** – *Hey Jude*	Sept 4	★	
🇬🇧	**Mary Hopkin** – *Those Were the Days*	Sept 11	★★	
		Sept 25	★★★	
🇬🇧	**Joe Cocker** – *With a Little Help from My Friends*		★★★	
US	**Hugo Montenegro** – *The Good, the Bad and the Ugly*	Nov 6	★	
🇬🇧	**The Scaffold** – *Lily the Pink*	Nov 13	★★★★	
		Dec 11	★★★	

US	**John Fred & His Playboy Band** – *Judy in Disguise (With Glasses)*	Jan 20	★★
		Feb 3	★
US	**The Lemon Pipers** – *Green Tambourine*	Feb 10	★★★★★
US	**Paul Mauriat** – *Love Is Blue*	March 16	★★★★
US	**Otis Redding** – *(Sittin' On) The Dock of the Bay*	April 13	★★★★★
US	**Bobby Goldsboro** – *Honey*	May 18	★★
US	**Archie Bell & the Drells** – *Tighten Up*	June 1	★★★
US	**Simon & Garfunkel** – *Mrs. Robinson*	June 22	★★★★
US	**Herb Alpert** – *This Guy's in Love with You*	July 20	★★
US	**Hugh Masekela** – *Grazing in the Grass*	Aug 3	★★
US	**The Doors** – *Hello, I Love You*	Aug 17	★★★★★
US	**Young Rascals** – *People Got to Be Free*	Sept 21	★
US	**Jeannie C. Riley** – *Harper Valley P.T.A.*	Sept 28	★★★★★
🇬🇧	**The Beatles** – *Hey Jude*		★★★★
		Nov 30	★★
US	**Diana Ross & the Supremes** – *Love Child*	Dec 14	★★★★
US	**Marvin Gaye** – *I Heard It Through the Grapevine*		★★★

19

	Artist – Song	Date	Rating
🇬🇧	**Marmalade** – *Ob-La-Di, Ob-La-Da*		
🇬🇧	**The Scaffold** – *Lily the Pink*	Jan 1	★
🇬🇧	**Marmalade** – *Ob-La-Di, Ob-La-Da*	Jan 8	★
🇬🇧	**Fleetwood Mac** – *Albatross*	Jan 15	★★
🇬🇧	**The Move** – *Blackberry Way*	Jan 29	★
US	**Amen Corner** – *(If Paradise Is) Half as Nice*	Feb 5	★
US	**Peter Sarstedt** – *Where Do You Go To (My Lovely)?*	Feb 12	★★
US	**Marvin Gaye** – *I Heard It Through the Grapevine*	Feb 26	★★★★
Jam. 🇬🇧	**Desmond Dekker & The Aces** – *Israelites*	Mar 26	★★★
🇬🇧	**The Beatles with Billy Preston** – *Get Back*	Apr 16	★
		Apr 23	★★★
US	**Tommy Roe** – *Dizzy*		★★★
🇬🇧	**The Beatles** – *The Ballad of John and Yoko*	June 4	★
🇬🇧	**Thunderclap Newman** – *Something in the Air*	June 11	★★★
🇬🇧	**The Rolling Stones** – *Honky Tonk Women*	July 2	★★★
US	**Zager and Evans** – *In The Year 2525 (Exordium and Terminus)*	July 23	★★★★★
US	**Creedence Clearwater Revival** – *Bad Moon Rising*	Aug 30	★★★
🇬🇧	**Jane Birkin and Serge Gainsbourg** – *Je t'aime... moi non plus*	Sept 20	★★★
US	**Bobbie Gentry** – *I'll Never Fall in Love Again*	Oct 11	★
US	**The Archies** – *Sugar, Sugar*	Oct 18	★
		Oct 25	★★★★
Aust.	**Rolf Harris** – *Two Little Boys*		★★★★
		Dec 20	★★★
			★★★

BRITISH CHARTS

69

US	**Tommy James & the Shondells** – *Crimson and Clover*	Feb 1	★ ★
US	**Sly and the Family Stone** – *Everyday People*	Feb 15	★ ★ ★ ★
US	**Tommy Roe** – *Dizzy*	March 15	★ ★ ★ ★
US	**The 5th Dimension** – *Aquarius/Let the Sunshine In*	April 12	★ ★ ★
			★ ★ ★
🇬🇧	**The Beatles** – *Get Back*	May 24	★ ★ ★ ★ ★
US	**Henry Mancini** – *Love Theme from 'Romeo and Juliet'*	June 28	★ ★
US	**Zager and Evans** – *In the Year 2525*	July 12	★ ★ ★
			★ ★ ★
🇬🇧	**The Rolling Stones** – *Honky Tonk Women*	Aug 23	★ ★ ★ ★
US	**The Archies** – *Sugar, Sugar*	Sept 20	★ ★ ★ ★
US	**The Temptations** – *I Can't Get Next To You*	Oct 18	★ ★
US	**Elvis Presley** – *Suspicious Minds*	Nov 1	★
US	**The 5th Dimension** – *Wedding Bell Blues*	Nov 8	★ ★ ★
🇬🇧	**The Beatles** – *Come Together / Something*	Nov 29	★
US	**Steam** – *Na Na Hey Hey Kiss Him Goodbye*	Dec 6	★ ★
US	**Peter, Paul & Mary** – *Leaving on a Jet Plane*	Dec 20	★
US	**Diana Ross & the Supremes** – *Someday We'll Be Together*	Dec 27	★

About the Author:
Alan J. Whiticker is a writer and publisher, and is the author of 'Speeches that Defined the Modern World' (2016), 'Crimes that Changed the World' (2016), 'The Classics: The Greatest Hollywood Films of the 20th Century' (2015) and 'Classic Albums: The Vinyl that Made a Generation' (2018).

Acknowledgements:
My sincere thanks to Simon Flavin at Mirrorpix, and Vito Inglese, Paul Mason, Lisa Tomkins and David Scripps for their invaluable help with researching and preparing photographs; I am also indebted to Fiona Schultz at New Holland Publishers for her faith in this project and the hard work of Simona Hill, Susie Stevens and Andrew Davies. Lastly, to my wife Karen for indulging me the time spent on this book.

This edition published in 2018 by New Holland Publishers Pty Ltd
First published in 2014 by New Holland Publishers Pty Ltd
London • Sydney • Auckland

131–151 Great Titchfield Street, London WIW 5BB, United Kingdom
1/66 Gibbes Street, Chatswood, NSW 2067, Australia
5/39 Woodside Ave, Northcote, Auckland 0627, New Zealand

www.newhollandpublishers.com

A record of this book is held at the British Library and the National Library of Australia.

ISBN 9781760790752

Group Managing Director: Fiona Schultz
Publisher: Alan Whiticker
Editor: Simona Hill
Designer: Andew Davies
Production Director: James Mills-Hicks
Printed in China by Easy Fame (Hong Kong) Limited

10 9 8 7 6 5 4 3 2 1

Keep up with New Holland Publishers on Facebook
www.facebook.com/NewHollandPublishers